D0509533

AMERICAN PAINTING

AMERICAN PAINTING

THE TWENTIETH CENTURY

by
BARBARA ROSE

SKIRA

RIZZOLI
NEW YORK

First published 1969

New updated edition 1986

© 1986 by Editions d'Art Albert Skira S.A., Geneva

Published in the United States of America in 1986 by

Rizzoli INTERNATIONAL PUBLICATIONS, INC.
597 Fifth Avenue/New York 10017

All rights reserved. No part of this book may be reproduced
in any manner whatsoever without permission of
Editions d'Art Albert Skira S.A.
89 Route de Chêne
1208 Geneva
Switzerland

Library of Congress Catalog Card Number: 85-43548

ISBN 0-8478-0716-9

Printed in Switzerland

CONTENTS

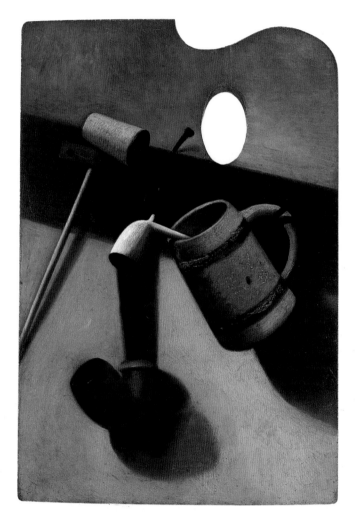

John F. Peto (1854-1907).
Palette, Mug and Pipes, c. 1890.
Oil on wooden palette. $(13^1/_2 \times 9^1/_2'')$
Meredith Long Gallery, Houston, Texas.

INTRODUCTION
THE POLARITIES OF AMERICAN ART

The term "life" as used in art is something not to be
held in contempt, for it implies all of existence, and
the province of art is to react to it and not to shun it.
Painting will have to deal more fully and less oblique-
ly with life and nature's phenomena before it can
again become great.

Edward Hopper, "Art and Life,"
Reality, Spring, 1953.

At times the bewildering variety of subjects, images and techniques employed by Americans
during the relatively brief history of American painting suggests that the heterogeneous visual cul-
ture created by waves of immigrants has no sense of continuity or clear-cut aesthetic allegiances. Yet
on further examination, one finds certain thematic threads that run through the history of American
art, uniting successive generations of artists in terms of their basic concerns and aspirations. The
European and especially French conception of art as essentially a decorative object that gave plea-
sure was contrary to the perception of American artists. Americans felt that art should either be
intimately related to life as the democratic masses lived it; or, on the other hand, that painting should
provide an exalted spiritual if not religious experience transcending the purely mundane. Two
important differences between American and Europe determined the unique course American art
would take: one was the absence of court art in the United States; the other was the lack of a tradition
of monumental religious painting resulting from the prohibition of images of the deity of the dominant
Protestant religion.

Indeed, one could make the claim that the democratic ethos, which naturally preferred genre
painting and "realism" of all sorts, together with the intense religiosity of a nation initially founded
as a haven for persecuted Puritans and others seeking religious tolerance, determined the kind of art
Americans would ultimately produce. On the one hand, democratic taste liked art that looked hard
to do, and had a practical relationship to life. The popularity of *trompe-l'œil* painting depended on
its seemingly magical ability to reproduce reality–to fool the eye into believing illusion *was* reality.
Thus, the literal interpretation of the work of art as an actual object inspired artists to make paintings
resemble real objects so closely as to cause confusion between fact and fiction. The literalist spirit of
trompe-l'œil still-life painters working around 1900 such as John Peto, William Harnett and John
Haberle with their emphasis on detailed factual information expressed one side of the American
character. This was the tendency to eschew metaphor and symbol in favor of objective, literal inter-
pretations of phenomena. It is a tendency best expressed in the philosophy of Pragmatism, the only
entirely American contribution to philosophic inquiry. According to the pragmatic view, one begins
with concrete data rather than with an abstract theorem, with verifiable fact as opposed to metaphysi-
cal speculation. As a philosophy, Pragmatism is entirely consonant with realism in its many forms,
including the literal approach to art as nothing more than a category of material object. Among the

American *trompe-l'œil* painters, perhaps Haberle made the strongest statement of literalism in art by painting a clock in the shape of a clock, building out the stretcher to three-dimensional actual depth, and identifying the whole image with the entire field. The result was that there was no background to signify that this was an illusion rather than the thing itself. Later, Georgia O'Keeffe would paint *Lake George Window*, which similarly identified the flattened image of the window with the entire field of the canvas. Composing by dividing up the surface into simple flat areas, rather than by adding small elements that rhymed visually with one another, was the method taught to O'Keeffe and Arthur Dove early in the century by Arthur Wesley Dow, who based his theories of composition on Japanese art. The increasing influence of the philosophy and aesthetics of Japan, which faces the West Coast of America as Europe faces its East Coast, also explains many differences between American and European painting in the twentieth century.

The popularity of ''color field'' painting in the fifties and sixties among artists like Barnett Newman, Mark Rothko, and their many followers among the younger generation, echoes the simple, flat chromatic zones used by O'Keeffe and Dove as much as it reflects Matisse's approach to color as a field. Newman's decision to eliminate internal shapes and part-to-part relationships, in favor of dividing the canvas with luminous bands of color, created a new form of pictorial structure, as radical in its way as Jackson Pollock's ''all-over'' poured paintings. Like Newman's color-field abstractions, Pollock's looping interwoven skeins of thrown and dripped paint did not depict shapes in a conventional European manner. Moreover, we can see that treating the canvas as a field to be filled rather than as a background against which to depict shapes has its precedence in O'Keeffe's abstractions rather than in Cubism or European abstract art.

Newman was an abstract painter, but the artist who most immediately understood the novelty of his art was not. In his first American *Flag*, painted in 1954, Jasper Johns lined up in methodical order the bands Newman used to divide his canvas into color zones. By choosing to paint the representation of a familiar object, Johns continued the *trompe-l'œil* tradition by creating ambivalence regarding whether the work was a painting or a common object. In later paintings, Johns made his debt to these painters of literalist illusions even more obvious: inscribed on the surface of a work titled *The Cup We All Race 4* is the name ''Peto,'' an allusion to an earlier *trompe-l'œil* work Peto painted with the same title. Even recent works by Johns, such as *Untitled*, 1984, continue to refer to the subtle play between illusion and reality, art and life, of paintings like Peto's *Palette, Mug and Pipes*, in which familiar objects from the studio are painted on an actual wooden palette, and cast shadows are used to heighten illusionistic effects. In Johns' painting, the two drawings depicted appear attached to the background of the studio wall by what looks like pieces of tape; but the ''tape,'' like Peto's hooks and tacks, is a painted illusion. Paintings like Peto's *Palette* and Haberle's *Clock*, which are literally shaped, are the precursors of the ''shaped'' canvases that followed in the wake of Johns' *Flag*, a painting of an object that was literally the same shape as what it represented. The use of literal objects in paintings by Robert Rauschenberg, as well as of pigment and materials that were literally reflective became dominant concerns of Pop and minimal artists in the sixties. Frank Stella's celebrated dictum ''what you see is what you see'' was interpreted as meaning that art was a strictly material object, holding no pretention to a metaphysical dimension. This new literalist definition of art, particularly of abstract art, which Kandinsky, Kupka and Mondrian had originally seen as an expression of metaphysical order and cosmic consciousness, is understandable within the empirical framework of American Pragmatism.

Jasper Johns (1930). Untitled, 1984. Encaustic on canvas. (50 × 34'')
Leo Castelli Gallery, New York.

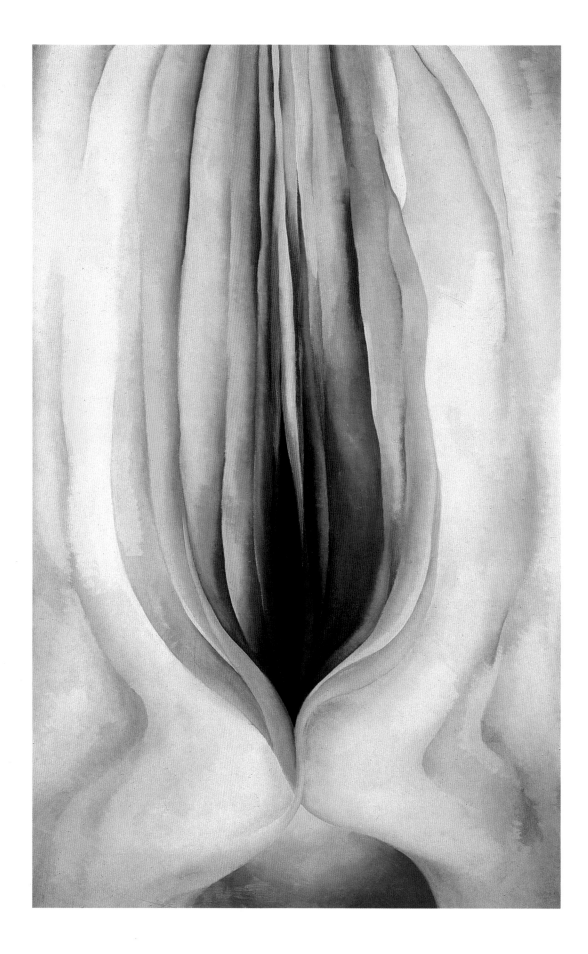

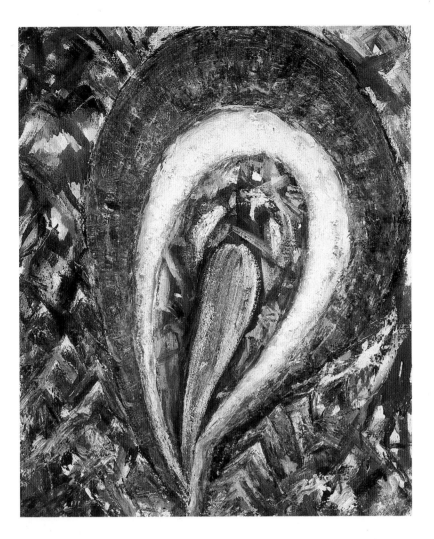

◁ Georgia O'Keeffe (1887-1986).
Grey Line with Black, Blue and Yellow, c. 1923.
Oil on canvas. (48 × 30″)
Museum of Fine Arts, Houston, Texas.

Bill Jensen (1945).
Shangri-La, 1981-1983. Oil on linen. (24 × 20″)
Washburn Gallery, New York.

The other major source of the iconography and content of American art is the opposite of Pragmatist literalism: it is the religious philosophy of Transcendentalism, the pantheistic nature worship of writers like Thoreau and Emerson, who saw the deity identified with natural creation. As opposed to utilitarian Pragmatism, visionary Transcendentalism was an idealist metaphysical view of the world. Many of its concepts were derived from Oriental religions like Zen Buddhism and occult Theosophy, a spiritual philosophic movement founded by the English mystic Annie Besant which profoundly influenced Kandinsky and the early abstract artists. This strong mystical force can be felt in the works of Dove and O'Keeffe early in the century; we find it later in the art of Mark Tobey, who joined the Bahai spiritualist movement, in the paintings of Jackson Pollock, who began as a disciple of the Hindu teacher Krishnamurti, and in the visionary paintings of Barnett Newman, a student of Martin Buber and the Hebrew Cabbala. Recently, younger painters like Bill Jensen switched from abstract art to organic motifs like the burgeoning womb-like form in *Shangri-La*, reminiscent in both form and content of Georgia O'Keeffe's masterful *Grey Line with Black, Blue and Yellow*, painted some fifty years earlier. The urge to paint immaterial images suggesting infinity and other spiritual concepts certainly diminished after the sixties, which focussed on literal materials, novel techniques, mass production and industrial fabrication. However, during the eighties a number of artists such as Brice Marden, Jake Berthot and Porfirio di Donna painted metaphysical abstractions, whereas others have used explicit religious imagery. Among the artists most involved in spiritual content is Sam Francis, who commuted for some time between Los Angeles and Japan.

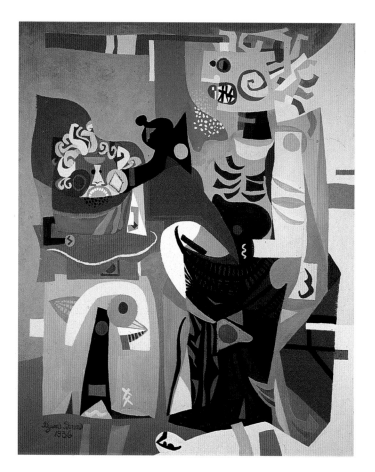

Byron Browne (1907-1961).
Mother and Child, 1936. Oil on canvas. (60 × 48″)

Arthur B. Carles (1882-1952).
Still Life with Silver Luster Vase, c. 1929.
Oil on canvas. (35³/₄ × 31¹/₂″)
Washburn Gallery, New York.

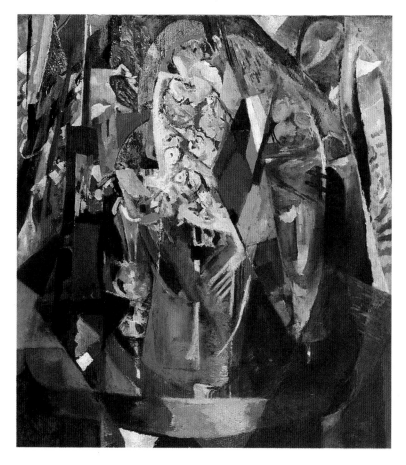

Sam Francis (1923). Untitled L.A., 1982. Acrylic on canvas. ($36^{1}/_{2} \times 72''$)

Other constants in American art include a continuing interest in American Scene painting and urban genre, as well as a fascination with machinery as abstract form. The influence of European artists such as Fernand Léger and Piet Mondrian, exiled in New York during World War II, as well as the consistent awareness of Matisse and Picasso, both of whom were shown by photographer Alfred Stieglitz at his Gallery 291 before World War I, has continued. After the opening of the Museum of Modern Art in New York in 1929, the works of the European modern masters were available to American artists, even if they could not travel abroad. Painters like Philadelphia born Arthur B. Carles, who had a strong academic background in old master techniques, and Byron Browne, a member of the American Abstract Artists, founded in 1936 by modernists who banded together to promote Cubism and Constructivism in America, drew on both Picasso's Cubism as well as Matisse's Fauvism in early attempts to synthesize the two. Until World War II actually brought European artists to New York as refugees, they were a small group of experimenters, mocked by the masses who preferred American Scene painting, which continued the genre tradition of the Ashcan School.

George L.K. Morris (1905-1975).
Indian Composition, 1938.
Oil on canvas. ($69^3/_4 \times 53^3/_4$″)
Washburn Gallery, New York.

Some of the modernists like George L.K. Morris, who had studied in Paris with Léger and was influenced by Hélion as well, tried to paint Cubist paintings with American subjects. Morris's *Indian Composition* is the abstraction of a male torso that refers to the colors and forms found in native American Indian art. Earlier, Hartley, O'Keeffe, Dove and other painters had looked to the art of native Americans for inspiration. More recently, artists like Peter Young and Alan Shields have been influenced by Indian crafts and rituals, and Navajo rugs have had a strong impact on abstract painting. In 1984, Fred Brown, who is half black and part Seminole Indian, paid homage to *Geronimo with His Spirit* in an expressionist figurative work that recalls the brilliant palette of Fauvism and the primitive distortions of the German Expressionists, which became relevant once again in American painting of the eighties. An increased sensitivity to history, particularly American history, encouraged artists not only to deal with historical subject matter, but also to look critically at some of its less glorious chapters. The treatment of minorities and in particular the massacre of native tribal populations which permitted the Europeans to colonize the continent were subjects treated by artists, just as they also used American folklore as a source of inspiration.

The dichotomy between European sophistication and American naïveté was apparent to artists and critics throughout the century, although the European acknowledgment of what Irving Sandler

Frederick Brown (1945). Geronimo with His Spirit, 1984. Oil on linen. (80 × 80″)
Marlborough Gallery, New York.

Ralston Crawford (1906).
Havana Harbor No. 3, 1948.
Oil on canvas. (36 × 30″)
Robert Miller Gallery, New York.

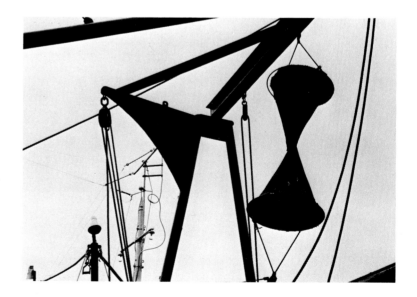

Ralston Crawford (1906).
Ship's Rigging, 1948.
Vintage gelatin silver print. (11 × 14″)
Robert Miller Gallery, New York.

termed "the triumph of American painting" in his study of Abstract Expressionism gave increasing confidence to the artists who built on their legacy. This dichotomy was most deeply felt during the thirties, the decade in which Regionalism, the realist style that exalted the life of provincial America, dominated, while a minority of avant-garde artists took European "high art" styles that disdained genre and narrative as mere illustration.

During the Depression, mass taste–*vox populi*–triumphed. Many Americans turned their backs on abstract art once they returned home from Europe. Thomas Hart Benton, Marsden Hartley, Andrew Dasburg, Joseph Stella, Max Weber, Alfred Maurer, are but a few formerly abstract artists who painted representational subjects during the thirties. At the same time, a new appreciation of "painterly" painting, of sensuous surfaces revealing the intimate touch of the painter which left visible brushstrokes evoking a tactile response, was growing. Painters who attempted to imbue American art with a European sophistication and sense of nuance and detail were, however, a minority unappreciated except perhaps by other artists. Arthur B. Carles, for example, who died of alcohol poisoning in 1952, was virtually unknown except among his colleagues, such as John Marin and Hans Hofmann, who appreciated his sensitivity to color. Marin wrote of Carles "that he had beautiful color sense–which he put down in flowing streams" and called him "a real lover of paint." The move away from the hard edges and polished impersonal surfaces that characterized most of early American modern painting was, of course, the turning point for the New York School. Several leading members of the group that came to be known as the Abstract Expressionists–i.e. Hans Hofmann, Arshile Gorky and Willem de Kooning–had studied art in Europe. Like John Graham, a Russian born painter who preached the gospel of Cubism in New York in the thirties, they had firsthand experience with old master paintings and were excellent draftsmen. Jackson Pollock, too, studied the old masters and copied their compositions in notebooks he filled during his years of apprenticeship. However, he did not travel and he studied them mainly in reproduction.

The fact that the American experience of art has been, until recently, largely secondhand, i.e. through reproduction, has decisively influenced its styles, images and techniques. It is hardly exaggerating to say that American art "born young into a late time," according to critic Sadakichi Hartmann, was born under the sign of photography and mechanical reproduction. Even the epic landscape painting of the nineteenth-century Hudson River School and their Western counterparts was often based on chromolithographs if not actually on photographs. Such sources would explain their sharp-focus realism as well as their lack of visible brushstrokes or broken color–a major difference between American and European landscape painting.

Inspired by photographs, American artists tended to imitate the slick uniform surface and cropped compositions of photography. Since its invention in 1839, photography, perhaps because it records facts and real images in a manner reassuring to the mechanistic side of the American mentality, has played an important role in American art. A number of important painters, including Charles Sheeler, Ralston Crawford and Robert Rauschenberg, were also photographers, and used photographs as a basis for their works. Sheeler sometimes virtually copied his own photographs in paintings, whereas Crawford merely used them as a point of departure, sometimes taking the photograph of a specific place after he had painted it. In any event, his vision of flattened, silhouetted shapes is obviously conditioned by his experience as a photographer.

The experience of images filtered through reproduction surely accentuated the literalist polarity of American art. On the other hand, for all the Pop artists who revelled in reproductions, many American modernists from Marsden Hartley to Ad Reinhardt, who succeeded in making his "black" paintings so dark they could not be reproduced, resisted photography or mechanical replication.

For them, art remained a spiritual revelation, a transcendental emotional experience, not a verifiable fact. This current of antagonism to the machine age and industrial expansion, which reveals a deep suspicion of the notion of progress among Americans, can be felt both in Marsden Hartley's small panel painting of a classical New England 1937-1938 *Church at Head Tide* as well as in Donald Sultan's recent large-scale *Accident*. Both paintings are coincidentally painted on masonite, revealing a typically American willingness to experiment with surfaces as well as media and techniques,

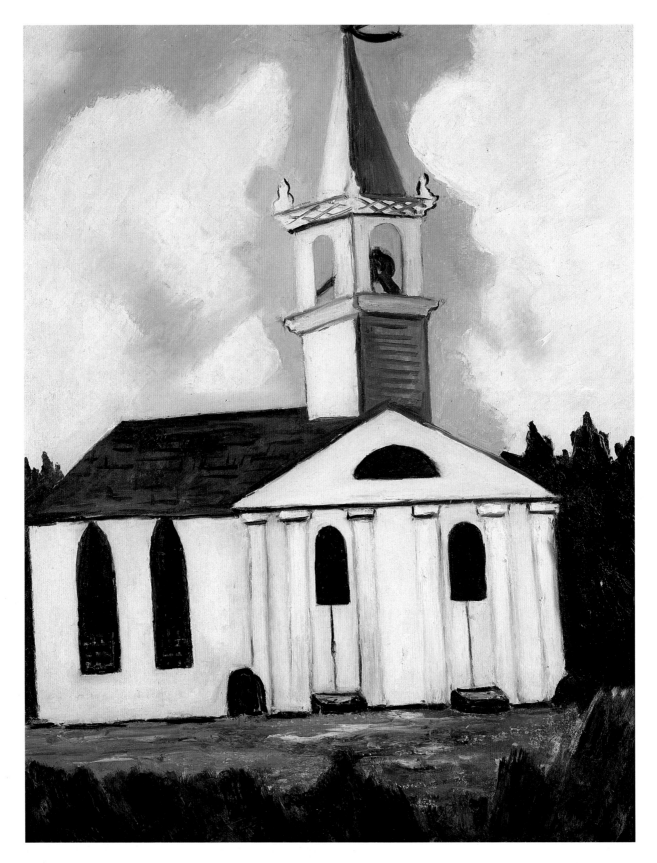

Marsden Hartley (1877-1943). The Church at Head Tide, 1937-1938.
Oil on masonite. (28 × 22″)

Donald Sultan (1951). Accident, July 15th, 1985.
Latex and tan on vinyl tile over masonite. (96 × 96″)

PEGASUS FINE BOOKS & CDS
1855 SOLANO AVE

BERKELEY, CA 94707
(510) 525-6888

B 43189 08/24/2004 01:13 PM

00001 1 Used Book 10.00 10.00

 1 Subtotal: 10.00
 Tax: 0.88
CLERK Total Due: 10.88
 Bank Card 10.88

 Thank You!
Merchandise may be exchanged with
receipt for store credit only
within 7 days.

cal interpretations of the American Scene depicted in a subjective and ecision to renounce Cubism and take the humble images of American led his attachment to basic truths. The choice of a church as a subject spirituality within the American tradition. Yet the church is abandoned, he light of redemption. Similarly, Sultan's industrial landscape, unlike images of the Cubist-Realists and later of the Pop artists, is overcast eference to the technological catastrophe at the Three Mile Harbor e to creating a major nuclear disaster, is interpreted as a menacing nplexity of the imagery, attention to detail and dark enigmatic state-ment mark the re-emergence of a critical dimension lacking in recent American art and herald the awakening of an historical consciousness capable of evaluating and conceivably synthesizing the traditional polarities of the American consciousness.

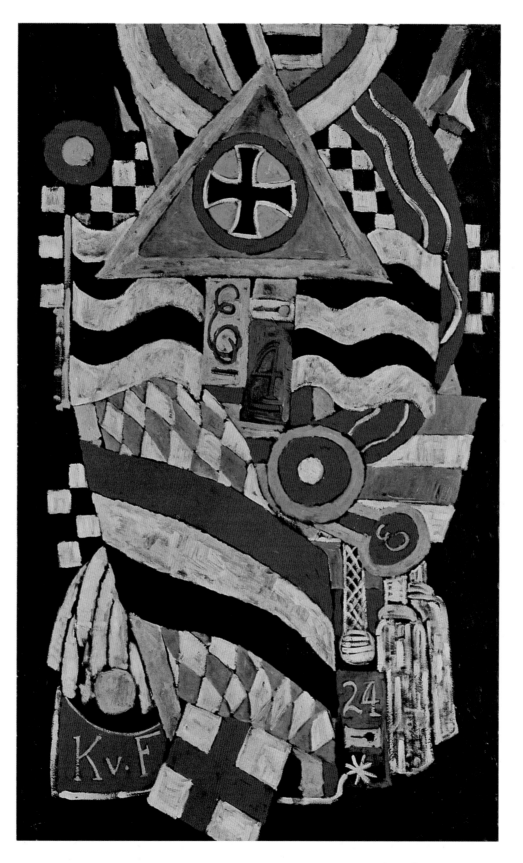

Marsden Hartley (1877-1943). Portrait of a German Officer, 1914. ($68^1/_4 \times 41^3/_8''$)
The Metropolitan Museum of Art, New York. The Alfred Stieglitz Collection, 1949.

THE ARMORY SHOW AND ITS AFTERMATH

Although the success of the Armory Show in 1913–in terms of the thousands who jammed the exhibition, the glut of publicity and criticism, and the general aura of sensationalism that accompanied it–was unprecedented in the history of American art, the exhibition itself was more a *succès de scandale* than a *succès d'estime*. America was not, as it had vainly been hoped by some, immediately transformed into a nation of art lovers by virtue of its exposure to the greatest modern art. On the contrary, the crowds that flocked to the 69th Infantry Regiment Armory were looking for shock and titillation more often than for enlightenment or genuine aesthetic experience. The attitude of most Americans toward the hundreds of Post-Impressionist, Fauve and Cubist works in the show was that modernism was some kind of "new-fangled" crackpot invention of deranged minds; others like Royal Cortissoz, the leading critic of the time, were quick to detect a foreign conspiracy in the invasion of "Ellis Island art," as Cortissoz termed the new styles.

Many of the exhibition's original supporters, like William Glackens, had high expectations in the beginning for the showing American realism could make when set against European art; but they were depressed by the results of the confrontation, which only confirmed any suspicions that native American art might look immature and pale by comparison with the skilled technique and advanced ideas of the Europeans. For Europe, unlike America–a country according to one writer "born young into a late time"–had a long unbroken tradition of painting dating back to the Renaissance. Europe also had established state academies where the traditional skills and art theories, of which the majority of Americans were almost completely ignorant, were transmitted from one generation to the next.

Unfortunately, the discontinuities between advances in form and technique painfully exposed by the Armory Show continued to plague American art for several decades afterward. Moreover, this discontinuity, which prevented the logical progress toward a modern style that had taken place in Europe when post-Impressionism made a smooth and gradual transition to Cubism, was aggravated not only by the lack of a firmly established academic tradition but by the isolation in which American artists necessarily were forced to work. To better their lot, some banded together for mutual protection and understanding, forming a few loose-knit groups like the Eight. Occasionally artists organized themselves more formally. In fact it was such an artists' group, the Association of American Painters and Sculptors, which planned the International Exhibition of Modern Art, as the Armory Show was officially known.

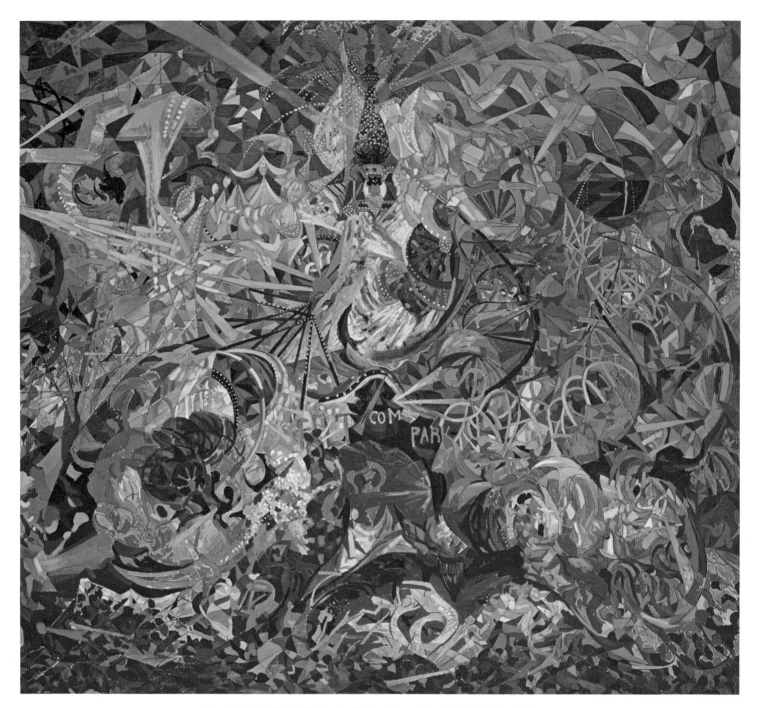

Joseph Stella (1877-1946). Battle of Lights, Coney Island, 1913. (75³/₄ × 84″)
Yale University Art Gallery, New Haven, Connecticut. Gift of the Société Anonyme.

The Armory Show obviously did not win the hoped for wide patronage for American art; on the contrary, it established even more securely the priority of the Europeans. But there were some gains: a few more converts to modernism like Stuart Davis were made; a few collectors like Duncan Phillips and Katherine Dreier, herself a budding artist who exhibited in the Armory Show, gained new insights; a few writers and critics became more sympathetic to modernism. Because the show was organized as a kind of capsule history of the new art, some notion of the continuity of the modern

tradition and its roots may have been inferred by a few sensitive minds. Probably the most important single achievement of the Armory Show was the least evident. The circulation throughout America of many new images, through reproductions on post cards, in pamphlets sold at the exhibition and in reviews, caused Americans for the first time to become nationally conscious of such a queer thing as modern art.

Well represented at the Armory Show were members of the two most important groups of artists, the "Ashcan School," and those who exhibited at the modern art gallery known as 291, after its address on Fifth Avenue. These unofficial coteries were held together by the personal magnetism and evangelical sense of mission of two men, themselves artists, who defined the aesthetic stance of the group in general. Obviously one of these focal personalities was Robert Henri, teacher, writer, and leading member of the Ashcan School, if not its public standard bearer. At his own school near what is now Lincoln Center in New York, where John Sloan, George Bellows, Yasuo Kuniyoshi, Walt Kuhn and others studied, Henri preached a down-to-earth realism based on the objectivity of Dutch genre, the somber palette of Spanish tonal painting, and Manet's broad painterliness. To this traditional mixture Henri added the "slashing brushstroke" and vivid highlights of the Munich School. Such a formula, unfortunately, sometimes lapsed into the facile bravura and surface glitter of Salon painting, in imitation of the worst aspects of Sargent's manner, which had become extremely fashionable in America.

An opponent of art for art's sake as gutless and cerebral, Henri contended that an ugly subject might make a beautiful painting, providing that the brushstrokes were emphatic and lively enough to be suggestive of movement and vitality. Many of Henri's ideas regarding the virtue of a "lively" style remind one of certain passages in the writing of Henri Bergson, in which the French philosopher described the necessity for transmitting the *élan vital* or the life force in art. On the other hand, Henri's demand for direct experience and an art based on the observation of life links him prophetically to the pragmatist aesthetic articulated in the 1930's by the American philosopher, John Dewey. Henri's "realism," however, was relative; it was not based on the careful study of anatomy or the traditional canons of painting and plastic form creation that made Eakins an outstanding realist within the convention defined by Courbet and the French realists. The realism of Henri and the Ashcan School was largely a superficial affair; it was fundamentally more indebted to journalistic illustration than to fine art. Of the members of the Ashcan School, in fact, only Prendergast, America's first post-Impressionist, Glackens, a late convert to Impressionism, and Davies, an anachronistic romantic whose interest in Redon led him to organize the Armory Show, seemed to have much knowledge of or interest in modernism.

The exact opposite was true of that other circle of artists, which had as its center the enigmatic genius of photography, Alfred Stieglitz. American artists who showed at 291, Stieglitz' attic gallery on lower Fifth Avenue, were brought into direct contact with the European modernists whose work Stieglitz imported from Europe—many well before the Armory Show. So advanced was Stieglitz' taste, in fact, that he gave Brancusi his first show anywhere in the world! That 291 the gallery, as well as Stieglitz' publication *Camera Work* (which first printed Gertrude Stein, among other experimental writers) were equally dedicated to photography as an art form and modernism as an art style was natural, since it was precisely the invention of photography that tolled the death knell for realism. For if a photograph could capture reality that much more completely and accurately than the human eye and hand guiding a paint brush or chisel, what was the point of the painter or sculptor attempting to challenge the photographer in recording reality? Ironically, it was also the use of photographs to illustrate newspaper stories that put the artist-journalists of the Eight, like Sloan, Glackens, Henri and Luks out of work, and caused them to concentrate on painting rather than on illustration.

The polarity established between Henri and the realists on the one hand, and Stieglitz and the modernists on the other was in a sense the first twentieth-century recapitulation of the Whistler-Eakins art for art's sake vs. art for life's sake dichotomy. This opposition would express itself again in the split between American Scene painting and geometric abstraction in the thirties and forties, and later in the opposition between Pop art and hard-edge or color abstraction in the sixties. So

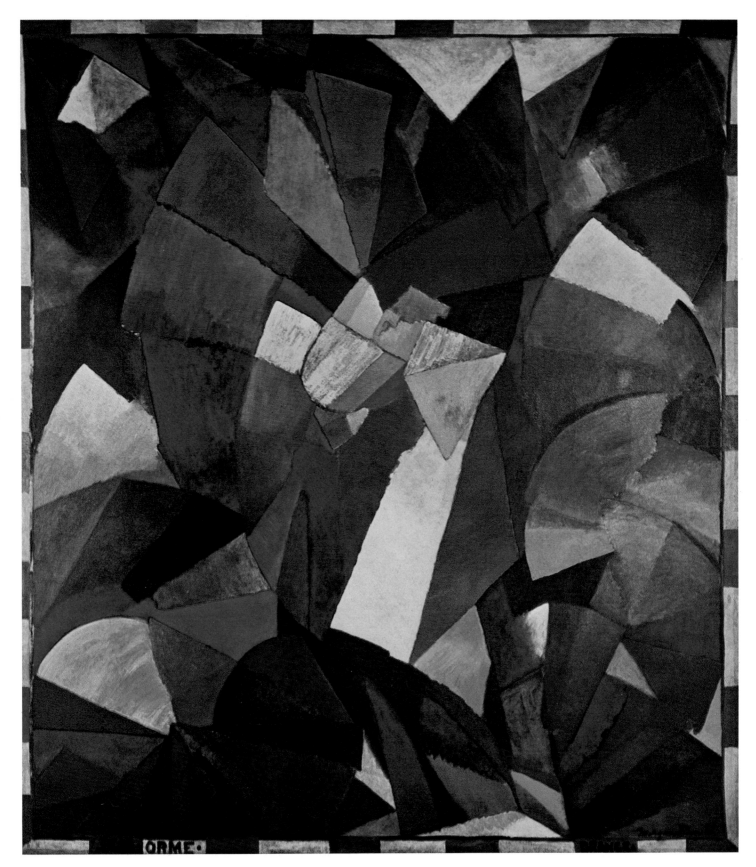

Morgan Russell (1886-1953). Synchromy in Orange: To Form, 1913-1914. (135 × 123″)
Albright-Knox Art Gallery, Buffalo, New York. Gift of Seymour H. Knox.

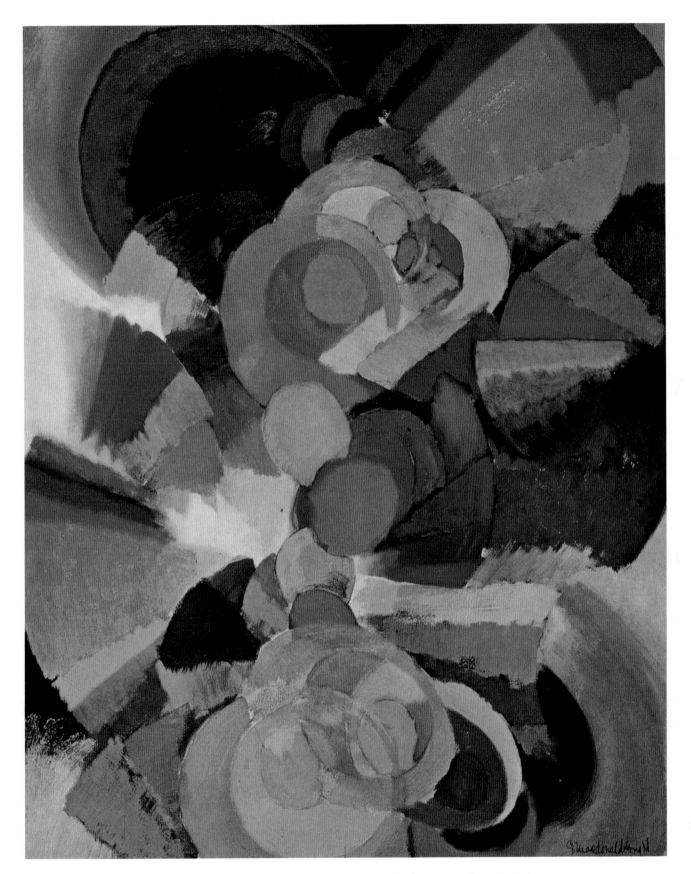

Stanton Macdonald-Wright (1890-1973). Abstraction on Spectrum (Organization 5), 1914. (30 × 24″)
Nathan Emory Coffin Memorial Collection, Des Moines Art Center, Des Moines, Iowa.

chronic is this schism, in fact, that one might see it as an unavoidable recurrent polarization in American art, brought into play each time a clash between democratic and elite taste might occur.

That several of the artists who regularly visited 291 used straight-edged, sharply illuminated forms, close-up views and strong light-dark contrasts, as well as enlargements and "cropped" compositions may be at least partially explained by their constant exposure to the formal values of photographs. The most obvious and irrefutable case of course is that of Charles Sheeler, a great photographer and an interesting and influential painter, who is still better known for his painting of factories and skyscrapers than for his photographs of the same subjects. Sheeler's reduction of forms to their pure geometric volumes clearly connects his painting to his photography; in fact, we know that his photographs frequently served as points of departure for his paintings, particularly in his later work. In the thirties, Ben Shahn would likewise base paintings on scenes he had photographed.

Although the artists he most faithfully supported were the American-born landscape painters John Marin, Marsden Hartley, Arthur Dove, and Georgia O'Keeffe, whom he married in 1924, Stieglitz showed virtually all of the outstanding early American modernists. His eye, in fact, seems close to having been infallible. Besides the four painters just mentioned, he also exhibited the work of Alfred Maurer, a sensitive painter of still lifes in a style that married Fauvist color to Cubist composition; Max Weber, who produced the first Cubist painting by an American in 1909; and Gaston Lachaise, whose art challenged Puritanism with its honest and explicit eroticism. The art of the painters and sculptors who exhibited at 291 had this in common: it was intense, direct, and committed to the idea that art in itself and as itself represented a spiritual reality as potent, actual, meaningful as the material world. The relationship of this group of artists to European art was a complex affair. With the exception of O'Keeffe, all had travelled to Europe, and some had undoubtedly read Kandinsky's influential essay *Concerning the Spiritual in Art*, which appeared in an English translation around the time of the Armory Show. Yet in general their art had only a tangential relationship to the bright color art of the Fauves, or in Hartley's case, to the sharp angularity of the German Expressionists. In fact, they pointedly had no interest in becoming European artists. Like the members of the Ashcan School, they wished to express a distinctly American vision. What was remarkable and significant then about Dove, O'Keeffe, Marin and Hartley, above all, was their equal commitment to their experience as Americans as well as to the frankness and uninhibited freedom of modernism.

The painters and sculptors who exhibited at 291 were the first modern American artists. Often they did not look to European art for inspiration, but to sources outside fine art–to popular art, or applied art. Weber studied the vividly painted dolls of the Hopi Indians called Katchinas and copied the repetitive geometric patterns of restaurant floors. Hartley was interested in the decorative embroidery and archaic symmetry of Coptic textiles.

While the members of the Ashcan School recorded their observations of reality in a blunt urban art, the group who found Stieglitz such an inspiring moral force turned away from Puritanism toward another American tradition–Transcendentalism, the nature philosophy of Emerson and Thoreau. Wishing to capture the sensual core of life as it was expressed in nature, they looked for subjects not at the outside world, but within themselves, to their own dreams and imagination. While Henri, Sloan and the rest of the realists tried to elevate the lives of "quiet desperation" led by most Americans into a suitable because authentic theme for art, Dove, Marin, O'Keeffe and Hartley examined natural forms, searching for equivalents of their deepest inner experiences; in this search, they looked, as Thoreau and Emerson had, to nature for salvation. O'Keeffe and Dove observed natural forms like plants, clouds, and rocks, simplifying their shapes to conform with the demands of art. Like Thoreau himself, all eventually left the city: Marin to live among the evergreens and fishing boats of Maine; O'Keeffe to find peace of mind in New Mexico; Dove to anchor his houseboat on Long Island Sound; and Hartley to wander back and forth across country, to Mexico and Canada, only to settle finally near his New England birth place.

Each developed a very personal vision of the American landscape. In a sense the artists who exhibited at 291 and later at Stieglitz' other galleries, the Intimate Gallery and An American Place, were forced to paint landscapes as a result of their ambition and intensity. This was so because any

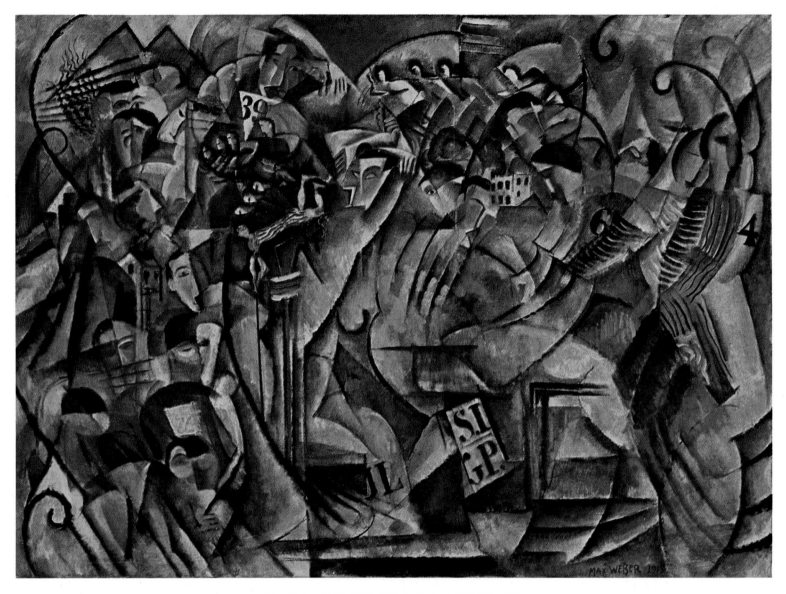

Max Weber (1881-1961). Athletic Contest, 1915. (40 × 60")
The Metropolitan Museum of Art, New York. George A. Hearn Fund, 1967.

art tied to human life in America had to take the form of genre, given that the democratic experience did not demand the glorification of heroes. "Heroic" themes for an American artist could never be related to classical or even Renaissance anthropomorphic humanism; the only truly "heroic" subject for an American artist had been and would continue to be the epic grandeur of the American landscape. Even when American art attained its fullest flowering, in the works of the Abstract Expressionists, its images evoked not the figure or still-life themes of Cubist painting, but the "sublime" force of nature. To the degree that the works of both groups are tied to nature, there is some connection, however vague, between Dove, O'Keeffe, Hartley and Marin, the first artists to paint American subjects in a modern style, and the Abstract Expressionists. One such similarity is that the Abstract Expressionists, like the artists who exhibited at 291, thought in terms of symbolic equivalents of natural forces and inner states.

That Alfred Stieglitz was one of the great revolutionaries in the history of American art is without question; that his vision was a prophecy of the future is becoming equally clear. Stieglitz and those

around him, including writers like Lewis Mumford, Waldo Frank and Paul Rosenfeld, were aware of the deadening effects of industrialism and urbanization. As a photographer, Stieglitz was determined to subordinate the machine (in his case the camera) to man's domination. Most importantly, he and the artists around him, in their dedication to the poetic and the spiritual, in opposition to the literal and the material, voiced a minority point of view. Dedicated to restoring the primacy of the instincts denied by a repressive Puritanism, they emphasized the direct, the sensuous, the organic, and the intuitive in their art. These were unusual but not unprecedented ideas in America: they had been espoused earlier by nineteenth century titans like the architect Louis Sullivan and the poet Walt Whitman in their writings.

Elizabeth McCausland, one of the few critics who understood the mission of 291, described the spirit of Stieglitz, Marin, Dove and O'Keeffe as a passionate, emotional romanticism, a commitment to honest work and craftsmanship as well as to inner freedom. For Marsden Hartley, who had his first exhibitions there, 291 was the place new values were established, as well as a sympathetic group spirit that allowed a few personalities to find their individual means of expression. Hartley remembers the day he saw the drawings of a young Texas art teacher, a student of Arthur Wesley Dow who taught an advanced method of design based on Notan, the light-dark patterning of Oriental art. "There was no name on these drawings," Hartley recalled, "and there has never been a name on any of the paintings that have followed, for this artist believes also, as I do, that if there is any personal quality, that in itself will be signature enough, and we have seen a sequence of unsigned pictures over a given space of years permeated with an almost violent purity of spirit." Many American artists felt and feel as Hartley did about Georgia O'Keeffe's work, so that to this day the paintings of many of America's greatest modernists bear no signature other than their extreme stylistic individuality. This dedication to individuality Hartley refers to is not only true of O'Keeffe and himself, but of the majority of American artists, who do not care for schools or theories. Typical of their point of view is John Marin's dismissal of the complexities of Cubist theory: "In the seethe of this, in the doing of that, terms, abstract, concrete, third dimension, fourth dimension–bah. Don't bother me." Because of this lack of involvement with theoretical matters and academic standards, American paintings often have a crude directness and unstudied spontaneity which is part of their fresh quality. On the other hand, this point of view had its limitations, too; it probably explains why Americans did not fully master the mechanics of analytic Cubism until they were able to assimilate them to something quite different from Cubism in the forties. Even around the time of the Armory Show, the American artist preferred action to words. He was dedicated, not to the slow process of artistic evolution within an established tradition, but to expressing his individuality at all costs–which may be seen as the only positive result of the isolation in which he was condemned to work. For in America there were no artists' cafés or free academies where everyone went to draw and converse. Communication was difficult, especially for those artists who lived in remote parts of the country.

Despite many obstacles, however, Stieglitz accomplished at 291 what the Armory Show had not: he showed Americans and Europeans together and proved that American artists could be modernists without sacrificing the originality or specifically American quality of their work. Even more important, the shows he carefully selected proved, as the more heterogeneous group of artists at the Armory Show perhaps had not, that Americans could stand up to European art on the level of quality. For Stieglitz, quality, not nationality, was the sole criterion. This explains why, while 291 was open from 1908 to 1917, Stieglitz showed such diverse works as Rodin and Picasso drawings, Japanese prints, Toulouse-Lautrec lithographs, Cézanne watercolors, Negro sculpture, and children's art, as well as paintings by Matisse, Picabia and Severini and photographs by himself, Steichen and other leading photographers. Paintings by Americans such as Max Weber and Stanton Macdonald-Wright, who had learned the essentials of Cubism in Paris, and works by Oscar Bluemner, Arthur B. Carles, Samuel Halpert, and Abraham Walkowitz, who were also aware of the new liberation of color and design required by modernism, were exhibited at 291 as well. By far the most significant exhibitions in terms of their originality, however, were those of John Marin, Marsden Hartley, Arthur Dove, and Georgia O'Keeffe.

Hartley's intense, brooding quality was evident even in the early colorful works he based on the closely knit "stitch" stroking of the Italian Impressionist Segantini. Later he painted deserted farms in Maine with a somber directness reminiscent of Ryder's dark palette, heavy impasto and forceful patterns based on natural formations. During his stay in Berlin in 1914, Hartley came into contact with the artists connected with the Blue Rider group. From that point on, he was decisively affected by the Expressionist distortions and their deliberately primitive drawing. Although he retained the embroidery-like stroke of his early landscapes, he began to paint abstractions based on religious symbols or still-life arrangements commemorating his friendship with a young German officer whose initials, K. v. F., appear in one of these Berlin paintings. Like many American artists, Hartley returned to the United States when World War I broke out. For a brief period he painted calm pastel abstractions, flirting with the decorative flatness of synthetic Cubism. In their rigorous two-dimensionality these paintings resembled those of Man Ray, an American Cubist who eventually left his native country (probably because of overt American hostility to modern art) to settle permanently in Paris, where he gave up painting to devote himself to making "rayographs," abstract images photographically recorded on sensitized paper.

In the twenties, Hartley returned to a moody Expressionist style characterized by rich, dark colors outlined boldly in black. In these intense, dramatic works, as in his Berlin paintings, Hartley orients his stiffly hieratic images frontally; now, however, he accentuates the awkwardness and crudity of his drawing to an even greater degree to extract the most expressive statement from them. The paintings of the teens had been explicitly flat, but the New Mexico landscapes and still lifes of flowers and fruit Hartley painted in the twenties and thirties are plastically modeled into tense muscular forms. Toward the end of his life, Hartley, like Max Weber, who gave up Cubism to paint mystical Jewish themes, became exceedingly inward and spiritual. His paintings of New England fishermen done shortly before his death in 1943 express an intense religiosity. Some, like the *Fishermen's Last Supper–Nova Scotia*, even refer directly to religious paintings.

The denseness and opacity of Hartley's oils was in diametric contrast to the light, airy landscapes and cityscapes of John Marin, many of whose finest paintings are done in the transparent medium of watercolor. In fact, even in his earliest watercolors, done around 1887–hazy, tonal landscapes reminiscent of Whistler–Marin emphasized atmospheric qualities. Later on in Europe, he continued to paint brightly lit, atmosphere-drenched views of Alpine hillsides, Venetian canals and French cathedrals in a style that seemed to have more in common with the reticence of Chinese landscape painting than with the Fauves and Cubists he exhibited with in the Salon d'Automne of 1907, 1908 and 1909.

In Paris, Marin met his friend from student days at the Pennsylvania Academy, Arthur B. Carles, whose brilliantly colored still lifes and landscapes, flat space and free technique showed an obvious acquaintance with the art of Matisse and Derain. Carles was part of the sophisticated milieu of the American expatriates, Gertrude Stein, hostess to Picasso and Matisse, and her brother Leo, one of the first Americans to write approvingly of modern art. He introduced Marin to the photographer Edward Steichen; Steichen in turn brought Stieglitz to visit Marin's studio in Paris in 1909. The outcome of this meeting was a two-man exhibition of Marin and Alfred Maurer held at 291 later that year. Maurer, who had rejected Whistler's tonal painting for the intense, fully saturated palette of Fauvism was called the "Knight of the Burning Pestle" in a review by James Huneker, one of the leading art critics of the time, while Marin was seen as the "master of mists." Together, according to Huneker, they made "an interesting duet in fire and shadow." Fortunately, Marin had a stronger character and a happier and more productive life than the tragic Maurer, who took his own life in 1932, after a beleaguered career and virtually no recognition–the fate of many a misunderstood and ignored American modernist.

A year before his return to the United States in 1911 Marin painted several watercolors of the Brooklyn Bridge. The search for an explicitly American theme might in fact be seen as an indication of a new feeling of identification with his homeland. Between 1912 and 1914, Marin painted many scenes of lower Manhattan, filling the page with a nervous tremulous image executed with a few rapid energetic brushstrokes. Beginning in 1914, Marin spent his summers in Maine. But whether painting

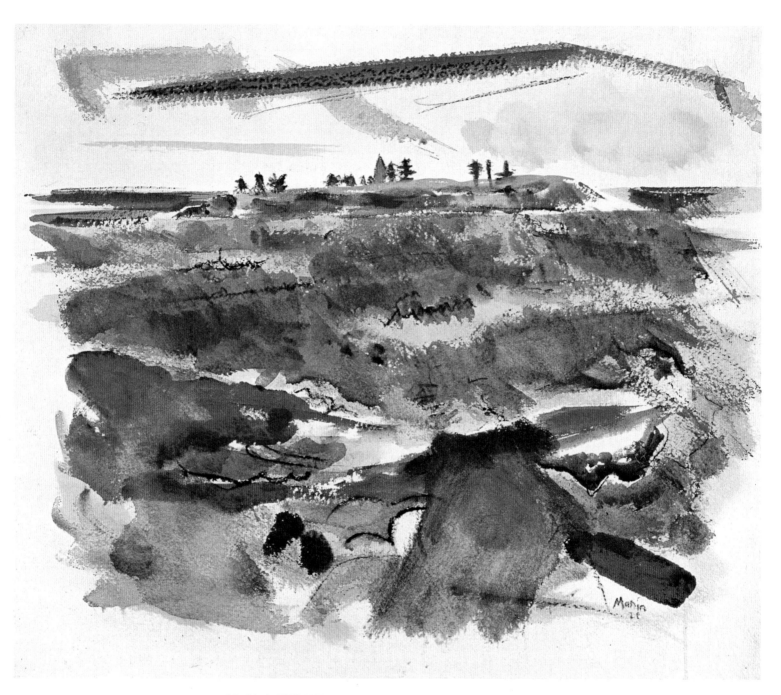

John Marin (1870-1953). Off Stonington, 1921. Watercolor. ($16^3/_8 \times 19^1/_2''$)
The Columbus Gallery of Fine Arts, Columbus, Ohio. Ferdinand Howald Collection.

the city or the Maine coast, Marin creates a similar world–a heaving, churning life-filled world in which literally nothing is settled, a world in which bright reflections bounce off choppy waves, and even buildings and bridges seem to bend in the wind. Capturing the electric, restless quality of urban life in America in his cityscapes, Marin sees Manhattan as he sees Maine, flooded with light and surrounded by water. One of America's greatest, if not its greatest marine painter, Marin is so enthralled by the lively movement of water that he often paints even New York as seen from the river, an island jutting abruptly from the water like some great blocky mountain of stone.

In at least one respect Marin was different from most American artists: alone among the painters of his day, Marin, perhaps because of his apparent appreciation of the delicate, elliptical quality of Oriental landscapes, was able to appreciate that what was left out–the spaces between forms designating air–was often more important than the airless, heavy-handed clutter typical of most American paintings. Marin's openness thus stands as a happy antidote to the many over-worked American paintings of the period which are too full of details, narrative incident and laborious filling in. Marin understood, probably from Cézanne's example, when a few well placed lines and transparent patches of color would suffice to abbreviate a fuller picture.

Formally, Marin's paintings owe something to both Futurism and Cubism, although strictly speaking they are neither Futurist nor Cubist works. From Futurism he borrows the slanting angular "lines of force" we see in Demuth's and Joseph Stella's paintings as well. These oblique lines, which he uses almost as masts around which to hang his airy forms, lend structural coherence as well as tension and energy to his compositions. From analytic Cubism he acquires the habit of floating his image buoyantly in the center of the canvas rather than pinning it to the frame, which he often re-echoes within the canvas as an internal rectangle that binds the explosive energies within together in a stable unity.

Marin's delicacy and sensitivity were not quite matched by Arthur Dove. Dove's color sense and bold patterning, however, are sufficient to distinguish him as a painter of an extraordinarily potent image and original lyrical vision of nature. A subscriber to the theory of synaesthesia promoted by the Symbolists, Dove believed that he could paint forms that would equal sounds, like his *Fog Horns*, which are supposed to depict visually the sound of fog horns. Like Kandinsky, Dove believed as well that colors and forms could be the equivalents of musical harmonies; to this end he, like Kandinsky, alternated rhythmic patterns, staccato and lento passages, in visually melodic–if one can use such a contradiction in terms–harmonies. Although there are many similarities between Dove's early work and Kandinsky's Expressionist styles, the only painting by Kandinsky that Dove was likely to have seen was the single Kandinsky landscape in the Armory Show, which was bought by Stieglitz for $500. (One of the main criticisms of the Armory Show, in fact, was that the German and Austrian Expressionists were badly represented, and the Futurists, who quit in a moment of pique because they could not have their own booth, were not represented at all.)

Often Dove's free, spreading forms with their haloes of modulated colors are like the bursting forth of natural forms as they bud and grow. In Dove's pantheistic universe, even the inanimate is invested with life. Along with Max Weber and Abraham Walkowitz, Dove was one of the first abstract artists, not only in America, but in the world. His earliest abstract works have been dated 1910, the same year that Kupka and Kandinsky painted their first abstractions. Although Dove studied in France and Italy from 1908 to 1910, there is little or no reason to think he could have seen their works.

As his paintings were dissimilar from Cubist works, Dove's collages of bits and pieces of real materials were unlike Cubist collages. Contrasted with Cubist collage, they were bolder, freer, and more literal–a shape representing a shirt sleeve was literally a shirt sleeve, a piece of fabric being sewn on a sewing machine was literally a piece of fabric. They were different from Cubist collage, too, in that the shapes were generally larger and more irregular. In his paintings Dove used these simple large shapes to advantage to create sharply silhouetted patterns, his organically twisting and undulating forms carrying the eye across the surface in a strong rhythmic movement.

As Dove's aureoles and gently rolling motifs are based directly on nature, so are Georgia O'Keeffe's forms. Where Dove emphasizes flat patterning and sharp color contrasts, however, O'Keeffe never ceased to model her forms with light and shadow, giving them a sculptural plasticity and volume that she interprets as a ripely voluptuous swelling. O'Keeffe's compositions are monumental far beyond their actual dimensions. They are particularly impressive because of the assured manner in which she fills the pictorial field with a few dramatically placed austere, uncompromising forms. She achieves a sense of scale that is also beyond the size of her paintings by relating small elements to large forms, causing the latter to appear all the more vast by comparison. In one of her finest paintings, done during the first summer she spent in New Mexico, *Black Cross, New Mexico,*

Arthur G. Dove (1880-1946). Holbrook's Bridge, Northwest, 1938. (25 × 35")
Collection Roy R. Neuberger, New York.

1929, the great wooden cross of the Penetenti, an American Indian sect, looms dramatically in the foreground, asymmetrically dividing the canvas, its massiveness heightened by the relative smallness of the rolling hills in the distance.

In O'Keeffe's paintings, nature and things seen are always the point of departure, even if they are flattened, simplified, changed in color or otherwise interpreted by the unique sensibility of the artist. O'Keeffe transforms nature by ordering, smoothing out, regularizing–a word that seems more accurately descriptive of what she does than idealizing, which might raise a false issue of classicism with regard to a painter who is essentially a romantic, for all the severity and cleanness of her forms. Uninterested in atmospheric effects, O'Keeffe creates images that are as static and monumental as Marin's are fluctuating and evanescent. No classicist, still she rigorously constructs solid forms that suggest the durable and the timeless. For this reason, perhaps, her luminous Southwestern skies are filled with unmoving clouds, painted as solidly and opaquely as if they were made of marble. Hills, mountains, clouds, animal skulls and bones (a *vanitas* or *memento mori* motif common in O'Keeffe's work of the thirties)–all are painted with the same patient craftsmanship, brushstrokes blended together until they are barely if at all visible.

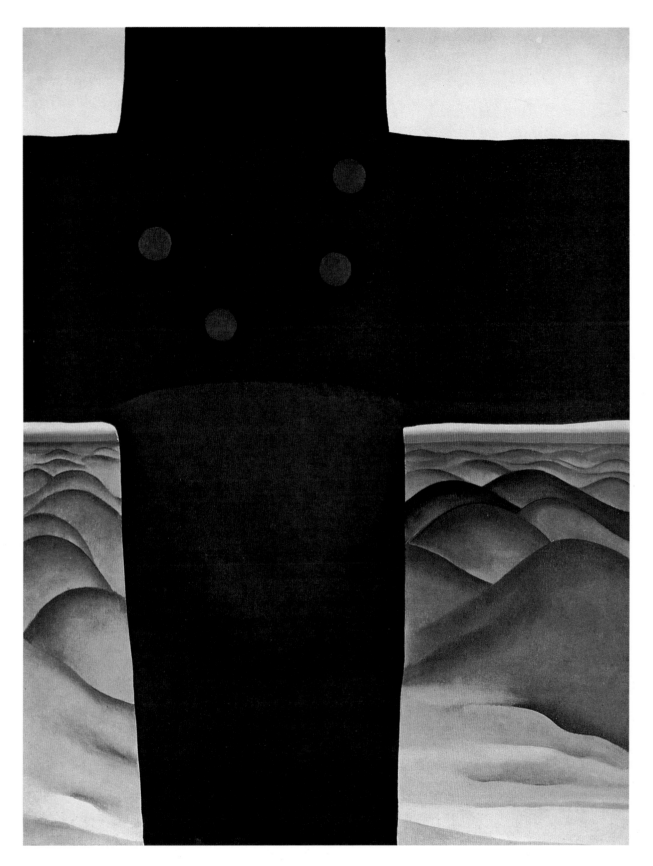

Georgia O'Keeffe (1887-1986). Black Cross, New Mexico, 1929. (39 × 30^1/$_{16}$'')
Courtesy of The Art Institute of Chicago, Chicago, Illinois. Art Institute Purchase Fund.

Still a powerful and important painter in extreme old age, O'Keeffe continued to work on a new large scale with the same resoluteness that had characterized her work since 1940, when she bought the house she lived in at Albiquiu, New Mexico, whose patio she has painted so often. O'Keeffe is a painter of such imagination that she can give the humblest subject a sense of mystery. Her paintings of animal skeletons, although not her best work, nevertheless have a haunting quality that invites an attitude of mystical contemplation. O'Keeffe seems constantly in touch with life's deepest secrets. Even a simple farmhouse, reduced to its elementary geometry, has a mysterious evocative presence when O'Keeffe paints it.

In a letter to a friend, O'Keeffe described the effect on her of the strange colors of the New Mexico twilight: "I climbed way up on a pale green hill and in the evening light–the sun under the clouds–the color effect was very strange–standing high on a pale green hill where I could look all around at the red, yellow, purple formations–miles all around–the colors all intensified by the pale grey green I was standing on." The colors she describes are her own colors too: mysterious combinations of the muted and the fiery.

Frequently in her New Mexico works, among which are her masterpieces, O'Keeffe emphasizes the vastness and the emptiness of the American landscape, paying homage in a sense to the spaciousness and generosity of the physical environment. Yet she lived in the city for some time too, painting skyscrapers in New York with the same care and craft she devoted to landscape. Although she was never officially part of the group who came to be known as the Precisionists because of their emphasis on fine workmanship and precise detail, O'Keeffe had much in common with them, specifically in her reductions of volumes to their simplest geometry, her lucid hard-edged forms, and her ability to monumentalize even the most ordinary subject. The Precisionists, or Cubist-Realists as they are more appropriately called, used Cubist methods of composition and reduced forms to simple geometry to interpret basically realistic subjects, and were more closely tied to European art than O'Keeffe, who never traveled to Europe. Although their themes were recognizably if not self-consciously American–the anonymous grain elevators, silos and factories that Lewis Mumford had singled out to praise for the honest quality of their modest simple forms–most of the Precisionists could not have painted without the example of Cubism as a point of departure. But the Cubist style Precisionism has most in common with is not the severe manner of Braque and Picasso, with its careful analysis of forms, but the "epic" Cubism of Gleizes and Metzinger, who, like the Futurists, painted urban themes in a style far more conservative than the radical art of Braque and Picasso. Weber's Cubist abstractions of 1912-1915, for example, with their repetitive forms and urban themes are obviously related to "epic" Cubism.

Not the analysis of forms, but their reduction and simplification was the aim of the Precisionists. The Precisionists, who included Charles Sheeler, Charles Demuth, Morton Schamberg, Preston Dickinson, and Ralston Crawford, to name the most prominent, searched, like Joseph Stella, whose work is also allied to theirs, for specifically American themes. They were the first artists perhaps to realize that the European grand manner could only produce an empty rhetorical art in America. In order to be true to their experience, they felt they would have to renounce any pretensions to grandeur, paint in a modest, careful style, and choose banal everyday themes. Like the pop artists who came after them, the Precisionists painted humble subjects–simple common objects or the machinery of American industry. Because craftsmanship was fast disappearing in the country where mass production was invented, they made a fetish of good careful workmanship and simple, well-made forms. Demuth admitted he learned his respect of craftsmanship from Marcel Duchamp; Sheeler, on the other hand, studied the clean, precise forms of the household objects and furniture made by the Shakers, an early American religious community, who saw the integrity of craftsmanship as a metaphor for moral integrity.

Like the majority of American artists, the Precisionists looked not to the major Cubists but to the minor figures in the movement, Gleizes, Picabia and Duchamp, all of whom were in New York around the time of the Armory Show–Gleizes to visit, Picabia to take up residence for some time, and Duchamp to remain, become an American citizen, and until his death in 1968, to be perhaps the most

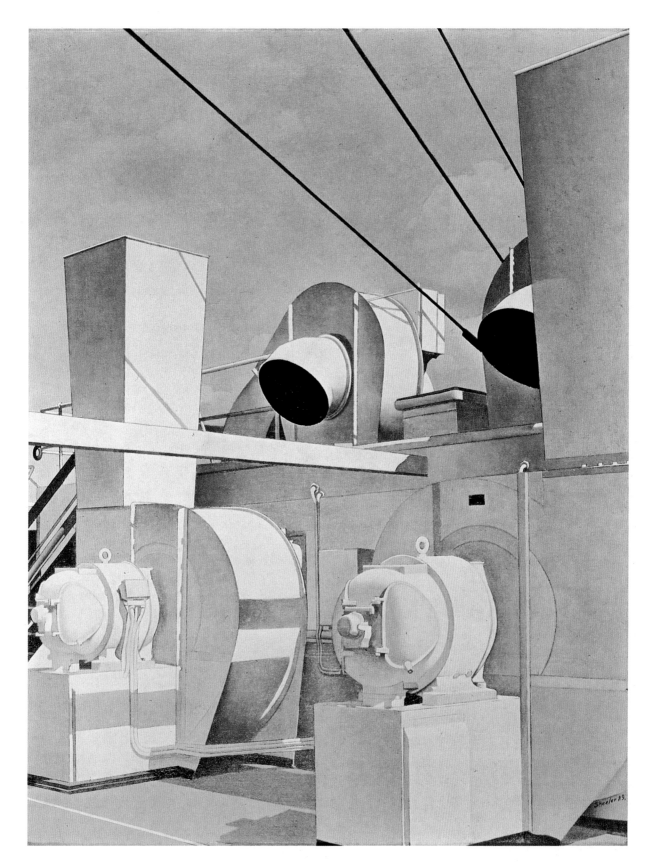

Charles Sheeler (1883-1965). Upper Deck, 1929. ($29 \times 21^3/_4''$)
Courtesy of the Fogg Art Museum, Harvard University, Cambridge, Massachusetts. Louise E. Bettens Fund Purchase.

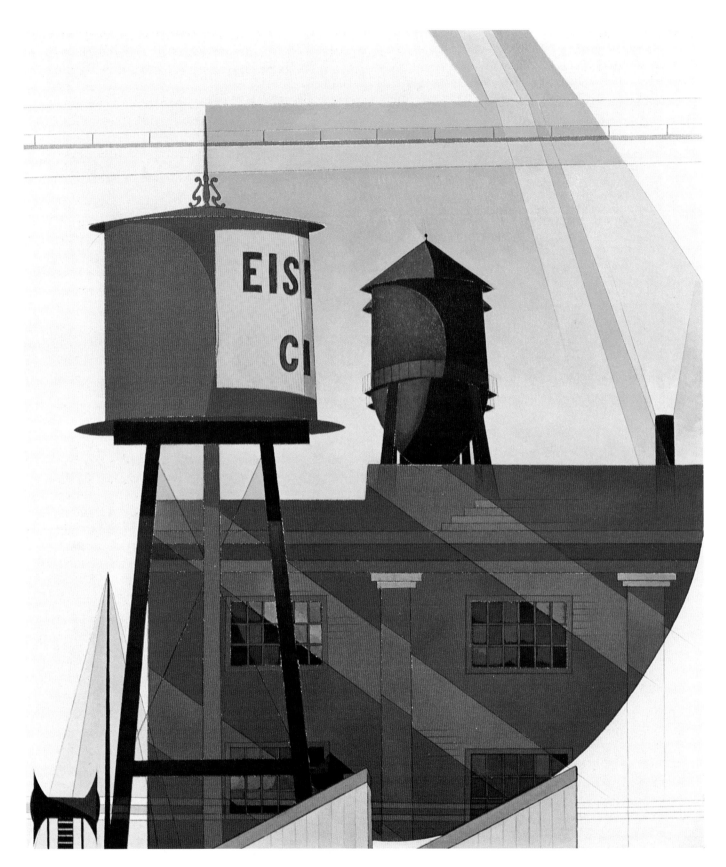

Charles Demuth (1883-1935). Buildings Abstraction, Lancaster, 1931. ($27^7/_8 \times 23^5/_8$″)
From the Collection of the Detroit Institute of Art, Detroit, Michigan.

decisive single influence on the course of modern American art. Because his complex and controversial career has offended so many critics who admire traditional painting, Duchamp's contribution has not yet been assessed for its true importance. The star attraction of the salon maintained by the wealthy bibliophile and art collector, Walter Arensberg, Duchamp launched Dada in New York a year before it exploded in Zurich in 1916. He also painted machines reduced to elementary geometric volumes like his *Chocolate Grinder* of 1914. Their hard-edged mechanical style in turn provided the model for the first Precisionist paintings by Demuth, Sheeler, and Schamberg, painted shortly afterward. Later he served as an advisor to both Katherine Dreier, whose Société Anonyme, founded in 1920, was the first public collection of modern art in the United States, as well as to Peggy Guggenheim, who brought the best of European art to New York during World War II.

Creating scandals like submitting a standard urinal signed R. Mutt to the 1917 exhibition of the Society of Independent Artists, Duchamp constantly attacked aesthetic norms and canons of taste, extending the limits of art until it encroached upon everyday life. An aristocratic chess-playing aesthete who renounced painting in 1918 as a "dead" anachronism, Duchamp was more than anyone a symbol of the avant-garde for American artists, a concrete link between Paris and New York. The organizer of Dada events, Surrealist manifestations and environments, Duchamp attended every important avant-garde spectacle from the moment he and John Sloan proclaimed Greenwich Village an independent republic from the top of the Washington Square Arch to recent Happenings. His presence was a constant reminder of the connection between the Parisian avant-garde and the embattled and struggling New York experimenters. As the *éminence grise* of the New York art scene for half a century, Duchamp re-emerged as one of its heroes in the 1960's when painters like Jasper Johns and his progeny of pop artists took new interest in Duchamp's verbal and visual Dada punning. And one cannot overlook either the influence his literal use of industrial materials in *The Bride Stripped Bare by her Bachelors, Even* has had on the object makers of the sixties.

The Precisionists were indebted to Duchamp not only for their forms but for their iconography as well. Duchamp's claim that the only art America had produced were her plumbing and her bridges inspired Morton Schamberg to make a "sculpture" of a piece of plumbing and title it "God" long before the minimal artists of the sixties began making art that looked like industrial objects, or using simple clean forms reminiscent of the banal architecture and objects painted by the Precisionists. Since early in the century there has been the feeling among many artists that to make an authentic statement American art had to confine itself to the most standard forms and humble themes, because these were characteristic of the American experience. Duchamp, of course, was not the only one to make a negative assessment of American culture. For several decades following the Armory Show, Americans were to suffer from what amounted to a cultural inferiority complex whenever they saw themselves in relation to the European tradition. And this was inevitable, because despite the protestations of chauvinists like the American Scene painters, American art continued to live in the shadow of the School of Paris until the end of World War II, when it suddenly exploded as a great international force, and America became the leading power in world art as well as in world affairs.

The *détente* which followed the outbreak of World War I in Europe, causing many leading European artists like Derain and Matisse to take more conservative positions, had its effect on American artists as well. Abstract art was abandoned by former abstractionists such as Weber, Hartley, Maurer, Charles Burchfield, Thomas Hart Benton, Joseph Stella, and Andrew Dasburg. Of the dozens of abstract American artists, only Dove remained committed to abstraction in the twenties and thirties. In fact one of the difficulties in writing a history of the period between World War I and the Depression is that so much of the work was destroyed. Dasburg, Burchfield, Maurer, and Patrick Henry Bruce were some of the American artists who destroyed most if not all the work they produced during those years. The effect of the war and the lack of public interest in modernism seemed to create a general loss of conviction in abstract art that caused artists to desert its practice in droves. Since they had never been abstract artists, the Precisionists were in a better position to progress in their work. There is something to be said for even the minor Precisionist painters such as Niles Spencer, Louis Lozowick and George Ault; but the paintings of Charles Demuth stand out from the

others because of their elegant formality, and their surer grasp of the elements of Cubism. Demuth's subtle color sense and light touch, both especially remarkable in his many exquisite watercolors, distinguish his work. Moreover, the relatively shallow space his forms inhabit and their frontality identify Demuth clearly as a modernist, whereas, on the other hand, the other Cubist-Realists, with the exception of O'Keeffe and Joseph Stella, neither of whom was strictly speaking a Precisionist, continued to depict the deep space of traditional painting. If one compares works by Sheeler and Demuth, for example, it becomes immediately apparent that Sheeler is by far the more conventional artist. The lively, reflective, enamel-like quality of Demuth's surfaces make Sheeler's nearly mono-chrome palette look drab by comparison, for none of the Precisionists was the sensitive colorist Demuth was.

Related to Precisionism in terms of subject and style was one of the most interesting and bizarre figures in American painting, the Italian émigré Joseph Stella. Although he settled in New York in 1896, Stella made frequent trips to Europe. On one of these trips he must have come into direct contact with Futurism, because he first exhibited as an Italian Futurist. Like other poets and artists seeking an ''epic'' theme which would transcend the banality of the democratic experience, he focused on the Brooklyn Bridge as the symbol of America's power and creativity.

Like the Futurists, Stella sought to capture the dynamism and energy of modern urban life, locking its fragments into place with Futurist ''lines of force.'' His shattered planes, like the figures in Severini's mad ballrooms, dance across the fractured surface of Stella's dazzling Cubist paintings like *Coney Island* with a whirling convulsive momentum. In the twenties, Stella's depictions of the bridges and structures of the New York skyline were more severely and statically organized along the lines of Precisionism. His late work, on the other hand, became, like the late paintings of Hartley, Weber and O'Keeffe, increasingly mystical, romantic and symbolic. Yet as full as they are of hermetic mean-ings, arcane references, and religious overtones, the simplified shapes of Stella's decorative flowers and exotic birds still contain references to Precisionist simplification.

Although Cubism was fully understood by few if any Americans working during the two decades after the Armory Show, a handful of American artists in Paris had a better grasp of its essentials. Attracted to the same neo-Impressionist color theories that inspired Delaunay to transform Cubism into a primarily lyrical statement about light and color, the Paris-based Americans, Stanton Mac-donald-Wright and Morgan Russell developed an American (in the sense that American painters created and named it) form of ''orphic'' Cubism. Macdonald-Wright and Russell called their self-proclaimed movement *Synchromism*, which means ''with color.'' Synchromism, then, was Cubism with color.

Macdonald-Wright was the brother of the distinguished American art critic, Willard Huntington Wright, who lost his objectivity in his enthusiasm for Synchromism, and predicted the end of painting and the beginning of a pure disembodied art of color and light, in which colors and forms could be ''played'' like music on special instruments. An intellectual and a theoretician like his brother, Macdonald-Wright used color with sensitivity in his superimposed transparent planes, which alter-nate complementary colors like blue and orange in harmonic combinations. But like the majority of American artists, Macdonald-Wright did not understand that the basis of Cubism was a reformulation of pictorial depth within a shallower space more like the space of a bas-relief than the three-dimen-sional space of fully modeled forms. Consequently his Synchromist abstractions represent a com-promise–like virtually all the Cubist work done by Americans between the Armory Show and the Depression–with modernism; although their forms are abstract and their colors freely chosen from the extended spectrum of neo-Impressionism, their spatial organization is almost the same as that in old master paintings. This was not as true of the opaque color volumes of Morgan Russell, and it was totally untrue of the flat, highly structured compositions of Patrick Henry Bruce, whose suicide after his return from Paris to New York in 1936 was one of the greatest losses suffered by American art in a generally depressing period.

Mixing a primary red with pastel blues, lavenders and white, Bruce, who like Max Weber had studied with Matisse, used Matisse's device of employing black and white as colors, rather than as

chiaroscuro. The lack of any genuine connection of American art to the classical tradition felt by many was experienced in a particularly painful way by Bruce, who nonetheless sought a stable, architectonic order, and a geometric severity based on emphasizing the horizontal and vertical elements that repeat and reinforce the framing edges. Because of this, his paintings have an authentic monumentality lacking in the many disjointed and cluttered simulated Cubist works being produced by any number of "semi-abstract" American artists, who still believed that a fundamentally illustrational or academic art could be given a superficially modern look by applying a few of the conventional surface effects of the Cubist formula.

Unlike most of his contemporaries in that he destroyed himself and his work rather than swerve from his course as a modernist, Bruce was an extremist. His colleagues at home in the United States, on the other hand, searched for the middle of the road, for compromises between abstraction and representation, between formal values and illustrational subject matter, between modernism and academicism. Most of these efforts by artists like Henry Lee McFee, Maurice Sterne, Alexander Brook, Bernard Karfiol, et al., to adapt Cubism to American subjects were dismal, tentative affairs, as is usually the case in the first attempts of provincial schools to assimilate a mainstream style. Cubism was as French as the Renaissance was Italian; and the efforts of Americans to master its underlying premises resulted in the same kind of misconceptions of Cézanne, Picasso and Braque as those exhibited by provincial Renaissance masters in their often ludicrously misunderstood imitations of Raphael, Michelangelo and Leonardo. As the provincial Renaissance masters copied engravings and works by minor masters of the style, so, too, did the American Cubists look to reproductions and the work of less complex and developed painters rather than to those who had created Cubism. For the true Renaissance, the Americans would have to wait until the School of Paris masters themselves made their homes in New York, as the provincial centers of the Renaissance awaited the arrival of a traveling Italian.

Charles E. Burchfield (1893-1967). Church Bells Ringing, Rainy Winter Night, 1917. Watercolor. (30 × 19″)
The Cleveland Museum of Art, Cleveland, Ohio. Gift of Mrs. Louise M. Dunn in memory of Henry G. Keller.

THE CRISIS OF THE THIRTIES

In 1929, the year the stock market crash plunged America into a bitter Depression, John Cotton Dana wrote that when he thought of American art, he thought of "tableware, cutlery, table linen, chairs and tables; draperies and wall papers; houses, churches, banks, office buildings and railway stations; medals and statues; books, journals, signs and posters; lamp-ware, clocks and lamps; carpets and rugs; laces, embroideries and ribbons; vases and candlesticks, etchings, engravings, drawings–and paintings." Significantly, Dana, organizer of the first museum show of a living American painter (a Max Weber exhibition at the Newark Museum in 1913), put paintings last in his listing of American art objects. He was not alone in this negative attitude toward American painting. For the general public as for many artists as well, painting, as opposed to the minor arts of craft and design, which had their roots in a solidly established indigenous popular tradition, represented a distinctly European and imported form. One explanation of the reluctance to accept painting as an American art may have been that, as opposed to the minor arts which served some purpose, painting was useless, and hence of little interest to utilitarian Americans.

There were other obstacles to the development of fine arts in America which had to be overcome before American painting could develop. First of all, there was the Puritan work ethic, which caused people to see art as a form of play, at best irrelevant and at worst immoral. As a new country, always forced to devote its best energies to economic development, America had created a work rather than a leisure-oriented culture. Lacking an aristocracy, America had no tradition of cultivated amateurs who could hand down a love of the arts from generation to generation. Few Americans had either the time or the money to devote to art. Collectors were generally newly rich and wished therefore to use art to gain immediate social status; because more status and a higher pedigree were attached to older art and to European art, this is what they collected, to the neglect of American painting. One of the few exceptions to this rule was Gertrude Vanderbilt Whitney, a wealthy sculptress who founded the Whitney Museum of American Art in 1914, an event which signaled the first public acknowledgement of a consciousness that American art had a history and possibly even a future.

In his assessment of the state of American art at the beginning of the period in which the country would be transformed from a rural agricultural society to a fully industrialized world power, Dana maintained that the principal obstacle to the progress of American art was economic. If the money were available, he reasoned, the art would surely follow, as it had when the Medici poured money

into art. Dana was, of course, at least partially correct in his diagnosis of what was ailing American art. For it was virtually impossible for an American artist to live from art at that point. Those who tried, subsisted literally on the edge of starvation–to the extent that an artist like Max Weber was for a time forced to camp out in 291. Indeed, the lives of the American vanguardists had more of the desperation of the lower depths than the color of *la vie de bohème*. Many, like the abstractionist John Covert, renounced painting altogether; others, like Gerald Murphy, a Cubist still-life painter, remained in Europe where the climate was more favorable to the practice of modern art.

The embattled role of modernism in America was both exacerbated and alleviated by the events of the Depression years. On the one hand, the surge of popular feeling that characterizes any such period of social upheaval and change demanded the expression of popular taste in art. Although government patronage did not exclude abstract art, it was heavily weighted in favor of more conservative and academic styles. The few museums, such as the Whitney, which showed American art, quickly capitulated to the demands for a sentimental, socially-oriented art that seemed expressive of the events of the time. Artists, too, like the American Scene painters, turned their backs on apolitical abstraction in favor of themes that addressed themselves to the immediate social and political realities. Others, like the Magic Realists, created a kind of buckeye Surrealism by painting American subjects in a bizarre fantastic manner.

Certain developments, however, like the emergence of a strong personality like Stuart Davis to take up the banner of abstraction after the Armory Show, aided its development. One might also mention the increased contact between Americans and the European avant-garde, including the spread of Synchromist theories of form and color by Arthur B. Frost on his return to New York in 1914 from Paris where he had known Macdonald-Wright and Morgan Russell. The gradual influx of Europeans that coincided with Hitler's closing of the Bauhaus in 1933, as well as the awareness of a common goal among American abstract artists themselves, which led to the foundation of the group who exhibited together as the American Abstract Artists in 1936, were also important. All these factors contributed to providing a firmer base for modernism in America. Most importantly, however, abstract artists also benefited, although not as much as American Scene painters, social realists and magic realists, from the far-reaching government program in the arts instituted by the Roosevelt Administration.

The original government art agency, created in 1933 to give artists work instead of just handing them a "dole," was modeled on the system of government patronage developed in Mexico. In a letter to Roosevelt urging him to set up such a program, the muralist George Biddle wrote: "The Mexican artists have produced the greatest national school of mural painting since the Italian Renaissance. Diego Rivera tells me that it was only possible because Obregon allowed Mexican artists to work at plumber's wages in order to express on the walls of the government buildings the social ideals of the Mexican revolution. The younger artists of America are conscious as they never have been of the social revolution that our country and civilization are going through; and they would be very eager to express these ideas in a permanent art form if they were given the government's cooperation."

With the example of the Mexicans and the Renaissance fresco painters in mind, Biddle maintained "that our mural art with a little impetus can soon result, for the first time in our history, in a vital national expression." Roosevelt was slightly less convinced than Biddle; disturbed by Diego Rivera's portrait of Lenin in the mural Rivera was painting at Rockefeller Center (later covered over by the Rockefeller family), Roosevelt said that he did not want "a lot of young enthusiasts painting Lenin's head on the Justice Building." Rivera's presence in the United States helped to draw attention to the art of the Mexican muralists, for which the Americans already felt considerable enthusiasm, since it appeared to solve the crisis plaguing American art: how to create an epic national style not necessarily incompatible with modernism, but not slavishly devoted to French models either.

Edward Bruce, a painter as well as a lawyer, was appointed director of the Public Works of Art Project. Regional directors were also appointed in order to spread the government commissions all over the country. Nearly 4,000 artists produced over 15,000 works of art during the five months of 1933 that the Public Works of Art Project functioned. Naturally, government patronage did a great

deal to solidify the position of the Regionalist and American Scene painters, because these were the artists commissioned to paint mural projects and to decorate the new public buildings in Washington such as the Justice Department and the U.S. Post Office. Selected for these commissions were American Scene painters Thomas Hart Benton, George Biddle, John Steuart Curry, Rockwell Kent, Reginald Marsh, Henry Varnum Poor, Boardman Robinson, Eugene Savage, Maurice Sterne and Grant Wood. All of these artists painted in a more or less realistic style whose sculptural illusionism was badly adapted to wall decoration. Many were influenced by the Mexican mural painters. Typical of the grandiose themes chosen were Boardman Robinson's pseudo-classical Menes, Moses and Hammurabi executed for one of the entrances to the Justice Building. Needless to say, neither the accomplishment of the Renaissance masters nor even those of the contemporary Mexicans were approached by such artists.

Of the several New Deal programs in the arts, the most important by far was the art project of the WPA. From 1935 to 1939, the Federal Art Project of the WPA provided work for thousands of artists.

Patrick Henry Bruce (1881-1937). Painting, 1930. (35 × 45³/₄″)
Collection Whitney Museum of American Art, New York.

The director of the WPA Art Project was Holger Cahill, a critic and authority on American folk art and former Museum of Modern Art curator. The great project inaugurated by Cahill to catalogue, classify and illustrate the minor arts in America, the Index of American Design, not only gave work to many artists hired to illustrate it, but drew attention to the high level of accomplishment achieved by American craftsmen. Obviously some artists like Peter Blume, whose early style was deliberately naive and primitive, and Grant Wood, who also cultivated an ingenuous manner, must have been impressed with the greater attention given to craft and simple folk art in the thirties, which seemed to many critics like Dana and artists like Sheeler to be the authentic art of America.

Over 2,000 murals were painted by artists commissioned by the United States government during the Depression. Most were mediocre compromises with academicism in a heavy-handed dull illustrational style that had neither the authority of academic art nor the unpretentious charm of illustration. Two of the few exceptions were Willem de Kooning's modest sketch for a Williamsburg housing project that was never executed, and perhaps the single substantial work to come out of the program, Arshile Gorky's mural *Aviation: Evolution of Forms Under Aerodynamic Limitations*, painted for the Administration Building at Newark Airport. Interestingly enough, Gorky's ten-panel work was not a true mural painting at all, but a series of oil on canvas easel pictures. Like Stuart Davis's *History of Communication* painted for the 1939 World's Fair in New York and Thomas Hart Benton's project for a cycle illustrating American history, Gorky's idea was to paint an epic theme, only he chose to do so as a pure abstraction. Painted in 1935-1936, the panels, which were destroyed during the war and exist only in sketches, took note of the special conditions of mural painting, even if actually they were nothing but an extended easel painting. Unlike the American Scene muralists, Gorky believed that the "architectonic two-dimensional surface plane of walls must be retained in mural painting." He found this a problem, since he wanted to represent the "unbounded space of the skyworld of aviation." Finally he decided to represent forms as if seen from an air view to achieve the desired degree of flatness, since seen from above, all objects look flat.

Artists accepted for the WPA program on the basis of an examination which certified their training and skill as painters were assigned to execute murals in various public places like bus and train stations, post offices, banks, schools and radio stations. Those whose styles were not appropriate to such commissions were attached to the easel painting project, and received an average of $95.00 a month to live on. In this way, many of the greatest modern American artists, such as Arshile Gorky, Willem de Kooning, Ad Reinhardt, Mark Rothko, Adolph Gottlieb and David Smith were assured of a living. For the first time, they were allowed to focus all their energies on their art and to paint full time. The importance of this possibility cannot be overemphasized. Jackson Pollock, for example, worked on the easel painting project as long as it was in operation, from 1935 to 1943. In those years, he was free to explore a number of styles, both representational and abstract, ranging from Benton's neo-Baroque style to an expressionist manner inspired by the Mexican muralists Orozco and Siqueiros, both of whom visited the United States and impressed Pollock with their virile monumental forms. By the time the WPA ceased to function, however, Pollock had begun seriously to study the Cubism of Picasso and the automatism of a Surrealist like André Masson, eventually to combine the two in paintings of mythic themes that seem, despite their obvious debt to French art, to be wholly original inventions.

Although the quality of the work produced by the WPA art project was not high in most instances, the program had many positive consequences. It allowed artists to paint full time, to think in ambitious terms about decorating large spaces, to feel themselves to be accepted members of society, rather than useless Bohemian outsiders in a utilitarian materialistic culture. Traveling shows organized by the WPA brought art to remote places in the country, where many had never seen a real painting or sculpture before. Like the publicity attending the Armory Show, the WPA program helped to disseminate art images throughout the country and to stimulate general interest in art among people who had never had the time or inclination to think about art before.

Despite the opportunity to devote themselves to painting, however, most abstract artists were in a desperate situation, not only in terms of little money and non-existent sales, but in terms of the

limited and discontinuous development of modernism in the United States. Unable to believe in the sentimental, story-telling art of the American Scene painters, they could not look to the American tradition of realism either. As a result, they began to draw their inspiration directly from the works of the School of Paris painters they could see at A. M. Gallatin's Gallery of Living Art, installed at New York University, at the Museum of Non-Objective Painting founded by Solomon R. Guggenheim in 1937 to house his astonishing collection of works by Kandinsky, and at the Museum of Modern Art, where, beginning in 1929, the greatest European modern masters were exhibited. Realizing that their own tradition was not strong enough to build on alone, young American artists began to study the modernists like Picasso and Braque as the American Scene painters were studying the Old Masters in an attempt to emulate their forms and techniques. One must see both these efforts–that of the modernists to assimilate the advances of the School of Paris, and that of the Regionalists to imitate the compositions and meticulous detail of the Old Masters–as related, and as equally desperate reactions to the widespread feeling that the American tradition in and of itself was inadequate to create a monumental style or a grand manner. For the aspiration toward a heroic style, a grand manner that could in its ambition and achievement rival the finest creations of European art, was the single common denominator among the heterogeneous groups of artists working in America during the Depression.

This aspiration is perhaps the most persistent and important single characteristic distinguishing artists of the thirties from earlier twentieth-century American artists who were dedicated to an intimate personal art, rather than to achieving a public style. There was the general feeling, although there was not yet the means to realize such a feeling, that it was time for American art to come of age, to take its place among the great national schools. But the maturation of American art that took place in the thirties in the context of massive social, political and economic unrest and change was a painful and slow process, which extracted an enormous price from the artists engaged in it. Often, they were discouraged.

Lee Krasner, who later married Jackson Pollock, one of the original members of the American Abstract Artists, recalls a meeting Gorky called in his Union Square studio in the late thirties. "We must admit we are defeated," she remembers Gorky saying to a group of avant-garde artists which included the young Willem de Kooning, who had arrived a decade earlier from Holland. Gorky's solution was that, since in his estimation none of them alone was capable of producing a masterpiece, they should pool their talent and create a collective work of art. Although the project never materialized, Gorky and his friends eventually found the courage to paint their own masterpieces; after the moment of crisis passed they gained confidence in their own abilities to take up where the School of Paris left off.

Although there were few links between the first wave of American modernists and the painters of the fledgling New York School, Gorky's friendship with Stuart Davis constituted one such point of contact. Davis, who had exhibited several small watercolors in the Armory Show as a nineteen-year-old prodigy, was the first American artist programmatically to set out to master the formal basis of Cubism, as opposed to merely imitating its surface look, and to marry it to specifically American subjects. Disenchanted with Ashcan School realism and with the teaching of Robert Henri with whom he had studied, Davis rejected Henri on the grounds that he had brushed aside the old academic practices without laying the groundwork for a new tradition. This was an important realization because the search for a tradition within which to work was the great quest for all American artists during the thirties, including Davis. An outspoken maverick, Davis, however, refused to take the easy way, to work either within the by that time firmly established Ashcan School approach as it was being updated by John Sloan, Kenneth Hayes Miller and Yasuo Kuniyoshi at the Art Students League; or to attempt, like the Regionalists, to create an eclectic style marrying illustrational subject matter to academic technique. Davis admitted he did not "spring into the world fully equipped" to paint as he wished. Even so, by the time America entered World War I, the precocious Davis was already painting Cubist abstractions. Like so many Americans including abstractionists like Arthur Dove and Ad Reinhardt, Davis started out as a cartoonist and an illustrator. Because he was trained as a Henri

student to wander about the city sketching his impressions, Davis developed a special feeling for urban subjects early in his life. For him, as for artists as wildly divergent as Joseph Stella and Franz Kline (as well as European painters like Léger), the city, with its bright lights, frantic tempo and powerful structures, was the modern theme *par excellence*.

During the twenties, Davis painted a number of abstract paintings based on labels of commercial products, which in many ways were prototypes for pop art. Like the Precisionists, he sought to imbue unpretentious banal themes with a paradoxical monumentality. The flat, hard-edged forms of the work of Demuth surely influenced Davis during this period. In paintings like *Lucky Strike* (1921), an abstract arrangement based on the label of a package of cigarettes, Davis first used the numbers and letters he would eventually blow up as the dominant decorative motifs of his later paintings. Davis's first entirely abstract paintings, however, were the "egg beater" series of 1927. In their flat planes, sharp silhouettes and clean mechanical angles and curves, they were clearly related to the purist abstractions of Léger and the geometric painters working in Europe. But in their brash boldness and directness, they have a quality one can begin to speak of as typically American.

In the years following the Armory Show, Davis became the most articulate American spokesman for abstract art. In 1935 the Whitney Museum daringly held an exhibition devoted to abstract painting in America; for the catalogue, Davis wrote an essay on the origins of abstraction in America. He credited the Armory Show with introducing abstract art to the country at large and with breaking the hold of the Academy over American artists, thus freeing them to express themselves in whatever idiom they chose. A dedicated abstractionist, Davis maintained that "Art is not and never was a mirror reflection of nature. All efforts at imitation of nature are foredoomed to failure." He described the relationship of art to nature as parallel lines that never meet. Abstract artists "never try to copy the uncopiable but will seek to establish a material tangibility in our medium which will be a permanent record of an idea or emotion inspired by nature." According to Davis, the most important question one could address to a painting was: "Does this painting, which is a defined two-dimensional surface, convey to me a direct emotional or ideological stimulus?" Davis had understood, as few if any American painters before him, the degree to which "the process of making a painting is the art of defining two-dimensional space on a plane surface." Most American artists were still vainly trying to capture the illusion of three dimensions, copying the natural world rather than seeing, as Davis had learned from the Cubists, that the painting itself represented an autonomous and self-referential reality.

In fact, the issue of painting from nature generally was somewhat confused at this time since the Regionalists and American Scene painters did not paint from nature at all, but instead derived their forms and compositions from older art or sometimes from photographs. Thus Benton copied Correggio and Michelangelo, Grant Wood looked to Holbein, John Steuart Curry created grotesque parodies of Rubens, and Ben Shahn got his inspiration from photographs and poster design. A score of other artists including the leading abstractionists worked from reproductions in European art journals like *Cahiers d'Art*. Only a very few "realists" like John Sloan, Edward Hopper and Milton Avery actually painted from nature, simplifying and editing their impressions to create a plastic unity missing in the randomness of nature. This is one reason their work stands apart in terms of its high quality and sense of conviction from the great majority of twentieth-century American realists.

Despite the greater popularity of realism with the public and with museums, Davis never swerved from his course as an abstract artist. On a trip to Paris in 1928-1929, he began using figurative elements again; but these were flattened now into two-dimensional decorative patterns. Returning from Paris to New York, he said he could "spike the disheartening rumor that there were hundreds of talented young modern artists in Paris who completely outclassed their American equivalents"; he thought now on the contrary that "work being done here was comparable in every way with the best of the work over there by contemporary artists." Davis's enthusiasm helped to keep up the flagging spirits of his friends in New York like his young neighbor Ad Reinhardt, and the Cubist painter David Smith, soon to renounce painting to become the greatest sculptor in the history of American art. In fact, Davis finally came to regard working in New York as a positive advantage,

Stuart Davis (1894-1964). Swing Landscape, 1938. ($85^{1}/_{2} \times 173^{1}/_{2}''$)
Indiana University Art Museum, Bloomington, Indiana.

because New York was the commercial hub of modern life, the center of the incredible energy and dynamism that was fast making America one of the most powerful nations in the world.

Like many American artists during the thirties, Davis was politically active in liberal causes, but he found time to paint a number of large-scale public murals. His best known, a mural painted for radio station WNYC, gave him the opportunity to express his passion for jazz visually in a composition of musical symbols. Jazz, one of the great creative forces in American life, inspired not only Davis as well as Mondrian, who also responded to the "hot" rhythms of boogie-woogie, but artists of the forties and fifties as well, who saw their painterly improvisations as in some way related to the musical improvisations of "cool" jazz.

Perhaps the most accurate way to describe Davis is as an abstract American Scene painter. His jagged shapes, loud colors and syncopated rhythms were visual equivalents for the sights and sounds of urban life in America. In the forties, probably under the inspiration of Matisse, Davis brightened his palette and created even bolder and more complex decorative patterns, culminating in his highly sophisticated abstractions of the fifties and sixties, in which popular imagery is combined with a highly refined sense of color and form.

Davis's example that American subjects could be painted in an advanced modernist style was an important one for many younger artists, who were on the verge of despairing that such a union was possible. Davis was very much present on the scene in downtown New York in the late thirties. With his loud sportshirts, didactic style, and lively intelligence, he was a constant inspiration to younger artists like Gorky, who wrote an article about him in 1931, naming him among those creating "the distinctive art of this century." Significantly, Davis was the single American in the list which included Léger, Picasso, Kandinsky and Miró–clearly the idols of the intense young painters setting out to create their own painting culture with which they hoped to challenge the European titans.

Andrew Wyeth (1917). April Wind, 1952. (20 × 26″)
Wadsworth Atheneum, Hartford, Connecticut.

According to Davis, the Armory Show was the most decisive moment in his career. He was, of course, not the only American artist to be affected by exposure to Cubism in the Armory Show, although its impact on his work is more evident than it was on the work of other American artists like Walt Kuhn, George Bellows, Guy Pène du Bois and Edward Hopper, who like Davis also exhibited in the Armory Show. Although none became an abstract artist, all began to simplify forms, reducing them to pure geometric volumes, by means of which heads became spheres, arms and legs cones, houses boxes, and trees cylinders. Yet these simplifications had but passing relationship to the formal transformations of Cézanne with his flat faceted planes because they retained their sculptural sense of three-dimensionality. For Davis, as for Dove, O'Keeffe, Hartley, Marin and Maurer, reality was a point of departure; whereas, for the more earthbound realists, unwilling or unable to give their imagination free play, it remained a terminal point as well.

Indeed one of the most prominent features of American taste appears to be its literal-mindedness. The intuitive and subjective were often scorned in favor of the factual and the objective. To such a taste one might attribute the enormous vogue of a painter like Andrew Wyeth, whose photographic style literally reproduces the natural world, down to the last fine hair and blade of grass. Like Hopper and Burchfield, Wyeth paints themes of loneliness and desolation, but his work depends far more on literary anecdotes than on their more poetic images. Because his detailed style requires a high degree of skill not possessed by the ordinary layman, it has been much applauded and appreciated by the general public, whose respect for the evidence of hard work amounts to an aesthetic prejudice in America.

Other painters whose styles are little more than illustrational reformulations of academic painting are Jack Levine and Philip Evergood. Both artists, like Ben Shahn, achieved a great deal of

Philip Evergood (1901-1973). The Jester, 1950. (61 × 78″)
From the Collection of Mr. and Mrs. Sol Brody, Philadelphia, Pennsylvania.

recognition in the forties while the best American painting, completely unknown to the general public, was being done in sordid lofts below Fourteenth Street. That same public which applauded Wyeth's dry technical art in the fifties and sixties also enjoyed the rich story-telling content of Levine's and Evergood's work. Both Levine and Evergood were livelier and juicier painters than Wyeth; but like him and like so many of their contemporaries, they also tried to base their work on art historical precedents. Levine's *Three Graces* is a lumpish proletarian reformulation of the great classical pagan theme that occupied so many aristocratic Renaissance and Baroque artists. Evergood's religious symbolism created a complex iconography with Surrealist overtones, although his style was considerably modernized under the influence of the German Expressionist Max Beckmann, who, like the Dada master George Grosz, came to live and work in America where they inspired many socially conscious artists like Evergood.

One group of artists active in the thirties turned realism inside out to create highly eccentric images in a style allied to American Scene painting, Precisionism and ultimately to academic Surrealism. The bizarre style of such artists as Peter Blume, Ivan Albright, Louis Guglielmi, Eugene Berman and George Tooker came to be known as Magic Realism. Carrying their personal fantasies to extremes in weirdly distorted images, Albright painted rotting and decaying figures and still lifes and Blume depicted strange juxtapositions in various forms of oddly suspended animation in works like *South of Scranton*. Other painters who created an idiosyncratic personal version of reality with few external references to the actual world in a style that was nominally realistic were Edwin Dickinson and Morris Graves. Although Dickinson's technique, like that of the magic realists, was related to the academic surrealists like Dalí who had great skill in recording visual data but little ability to transform it formally, his images were intensely romantic in an almost nineteenth-century sense. Like Albright's scabrous creatures, Dickinson's misty figures looking as if they were covered with cobwebs evoke a sense of decadent morbidity. Morris Graves, on the other hand, a Northwest Coast painter interested in Vedanta, specialized in depicting mysterious birds who seem to serve as mystical metaphors for the secrets of nature. In some respects, one can see the development of such idiosyncratic styles and hermetic images as yet another consequence of the isolation in which the American artist traditionally worked.

Isolation *per se* is the dominant theme of Edward Hopper's work. But Hopper is a sufficiently profound artist to have been able to generalize the sense of loneliness and alienation felt by many Americans into a universal theme. Unlike the magic realists, Regionalists and American Scene painters, Hopper did not attempt to revive the techniques of past epochs like the Renaissance or the Baroque; instead he set his mind to developing a severe laconic style compatible with his homely imagery and content. Like the magic realists, however, Hopper often casts a chill over his figures, frozen as if for eternity in their rigid fixed poses. In Hopper's work, each stroke counts, and serves to depict a form with economy and conviction. There is no surplus of effort, no surfeit of detail to please the literal minded. Hopper, unlike the majority of American realists of the thirties, would not compromise with the sentimental. His lonely office workers, aging couples and desolate filling stations speak of the depressing banality of the democratic experience; but they do so with a poignancy and compassion that elevate their subjects to dimensions far beyond their petty sufferings.

Hopper's painterly style, in which broad masses of light and shadow are juxtaposed to create a firmly constructed world of solid, massive shapes, distinguishes him as an outstanding American painter. His modest pictures, in renouncing any claim to the heroic, nonetheless create a very stable and permanent world. In Hopper's treatment of banality, however, there is none of the ironic mocking of the Precisionists, or even the double-edged treatment given American themes by Grant Wood, but a real feeling for the ordinary working people who eat in cafeterias and all-night snack shops and live in furnished hotel rooms, whose life is brightened by no great moments or dramatic climaxes, a genuine empathy for those who find their few moments of comfort or amusement sunning themselves on simple porches or taking in a movie. Even an empty room for Hopper can be a theme pregnant with meaning. In Hopper's painting, the American Scene at last achieves dignity and relevance to the human condition in general.

Jack Levine (1915). The Three Graces, 1965. (72 × 63″)
The Honorable and Mrs. William Benton, Southport, Connecticut.

Hopper was, like all the best American artists of the twentieth century, acutely aware of the standard set by French art, but he was also committed to making a statement about America. Surely his art owes a debt to Manet, although he far preferred Eakins' art to that of any Frenchman. As a young man, Hopper had made several trips to Europe, but he recalled that when he was in Paris in 1906, he for the first time had heard of Gertrude Stein, but not of Picasso. After painting a series of pointillist pictures, he gave up what he deemed to be a French style. By the time he exhibited *Sailing*, a solidly constructed painting of a yacht, however, in the Armory Show, he was a committed realist, devoted to the reconstruction of the natural world through formal intelligence. "The question of nationality in art is perhaps unsolvable," Hopper wrote in the introduction to the catalogue of his 1933

Edward Hopper (1882-1967). House by the Railroad, 1925. (24 × 29'')
Collection, The Museum of Modern Art, New York.

Edward Hopper (1882-1967). Tables for Ladies, 1930. (48¼ × 60¼")
The Metropolitan Museum of Art, New York. George A. Hearn Fund, 1931.

retrospective at the Museum of Modern Art. Maintaining that "A nation's art is greatest when it most reflects the character of its people," he called for an end of the domination of American art by French art, which he felt was like the subservient relationship of Roman art to Greek culture. "If an apprenticeship to a master has been necessary," he announced, "I think we have served it. Any further relation of such a character can only mean humiliation to us. After all, we are not French and never can be and any attempt to be so is to deny our inheritance and to try to impose upon ourselves a character that can be nothing but a veneer upon surface."

Although Hopper preached independence from French art and a greater awareness of the American tradition, others took a more extreme position and demanded the total rejection of all foreign influences. The leader and most voluble member of this faction was surely Thomas Hart

Benton whose populism, nationalism and isolationism made him the hero of all who would turn the clock back to earlier, simpler times, when America was a rural society not yet engaged in world politics, or in the search for an international style. Born in Neosho, Missouri, Benton eventually turned against urban culture, as well as modernist aesthetics on the grounds that they were both symptoms of decadence. He wished to create an epic style of bulging muscular forms based on the Old Masters, which would take as its great theme nothing less than the history of America. In order to make an authentic statement Benton felt the artist had to draw on his own experience; and the American experience, he believed, was tangibly different from that of the French. Painting the wheatfields and rolling hills of his beloved Midwest, Benton advised American artists to use subjects drawn from the regions where they were born, as Southern and Midwestern writers were devoted to the regions in which they lived.

As the ranks of American artists swelled, it was natural that the East Coast monopoly on American culture could not last. Artists came out of the West, the Midwest and the South, and they brought with them new themes and new ways of looking at the world. Today these differences are often smoothed over as young artists from the interior of the country are quickly assimilated to the New York scene; even so, certain areas still continue to produce a strong regional style with characteristics recognizably different from the New York School. Examples of such current regional schools are the Chicago school of figure painters, the San Francisco funk artists, and the Los Angeles school of abstract artists includes some of the strongest and most original artists working in America today.

In the thirties, however, these regional schools had not developed, and the values of the East still dominated American art. Benton and other artists like Grant Wood and John Steuart Curry resented this domination. Calling themselves Regionalists, they set out to use the subject matter of American history to create a heroic, monumental, public style of painting. To this end they painted American heroes like John Brown, Paul Revere, and George Washington in works they believed proclaimed themselves as "made in USA."

Most of the Regionalists, whose numbers were once quite substantial, have been forgotten, and for good reason, since they painted in a dead provincial manner that pandered to the worst elements of popular taste and did nothing to add to the development of American art. The three exceptions were Benton himself, Wood, and Charles Burchfield, a painter who never identified himself as a Regionalist, but whose paintings of the barren life of small towns in America became associated with Regionalism because of their themes.

Benton, a theoretician of some consequence, claimed that his aim was to achieve a "compact, massive and rhythmical composition of forms in which the tactile sensations of alternate bulgings and recessions shall be exactly related to the force of the line limiting the space in which these activities take place." Drawing, for Benton, was the foundation for painting; consequently he was not particularly sensitive to color, and he often created garish and discordant combinations of a flamboyant–and as the success of his paintings proved–popular vulgarity. Through the use of a bold contouring line, Benton hoped to achieve that sense of plasticity and sculptural volume he appreciated in the paintings of the past, which he accurately saw that Cubism, in its development of a shallow pictorial space, had discarded.

But Benton's anti-modernism and anti-intellectualism were deliberately cultivated; his rejection of modern art was not made in ignorance but in conscious awareness of the goals of the modernist, which he ultimately judged antithetical to the needs of a democracy. A former Synchromist who turned against abstractionism as an alien and imported style akin to treason in politics, Benton and his friend and apologist Thomas Craven feared the influence of Communists and homosexuals, which in some manner was associated in their minds with the decadence of modern art. Although it may seem extreme and even amusingly "camp" today, Benton's steadfast position summed up the serious feelings of many Americans who saw their old values and ways of life being swept away, and were determined to make a last stand against internationalism, whether in politics or in art.

Benton happily accepted the term Regionalism, first applied to a group of Southern writers who wrote about local affairs, as an accurate description of his goals. He saw his art and that of the other

Regionalists as part of the countrywide revival of Americanism that ensued after the defeat of Woodrow Wilson and his internationalist policies. The new consciousness of American history brought about by the flood of historical writing that appeared during the thirties created a climate in which an art based on self-consciously American themes would flourish. In this context, Benton claimed that the art of the Regionalists "symbolized aesthetically what the majority of Americans had in mind–America itself." He claimed that "The fact that our art was arguable in the language of the street, whether or not it was like, was proof to us that we had succeeded in separating it from the hothouse atmosphere of an imported, and for our country, functionless aesthetics." Sick of what he termed "aesthetic colonialism," Benton attributed much of the success of the Regionalists to the fact that they worked all over the country. He himself, for example, returned to Kansas City to settle.

Thomas Hart Benton (1889-1975). Cradling Wheat, 1938. (31 × 38")
City Art Museum, St. Louis, Missouri.

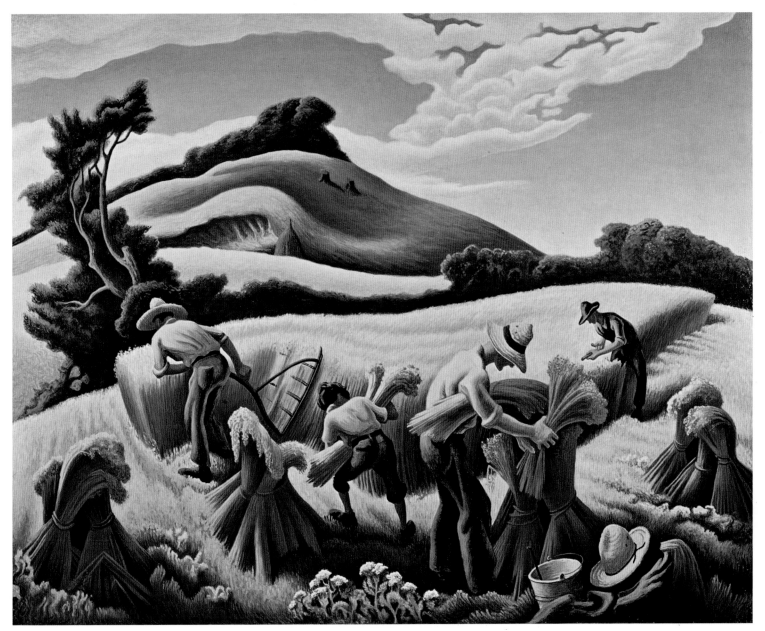

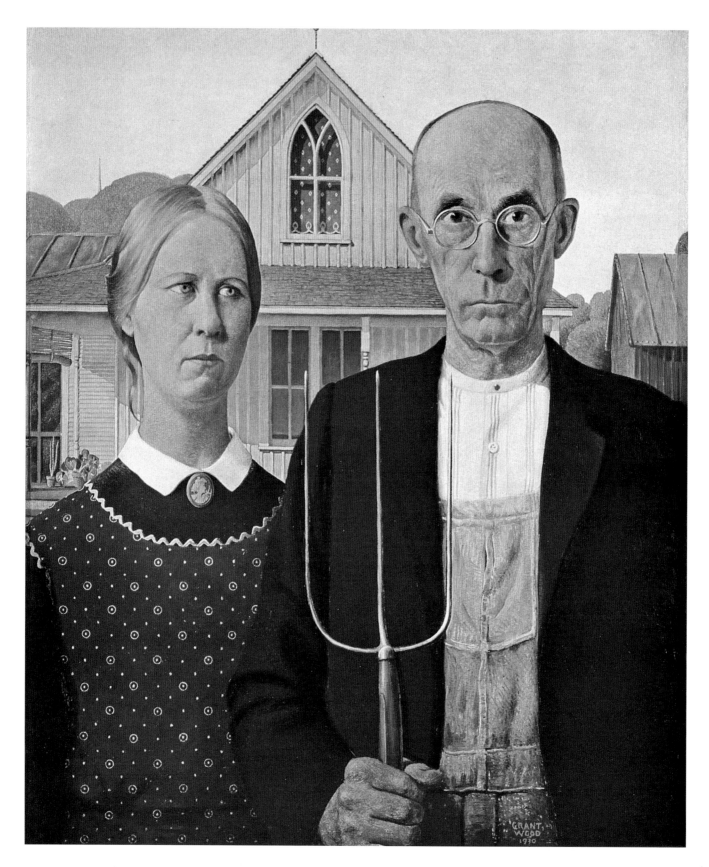

Grant Wood (1892-1942). American Gothic, 1930. ($29 \times 24''$)
Courtesy of The Art Institute of Chicago, Chicago, Illinois.

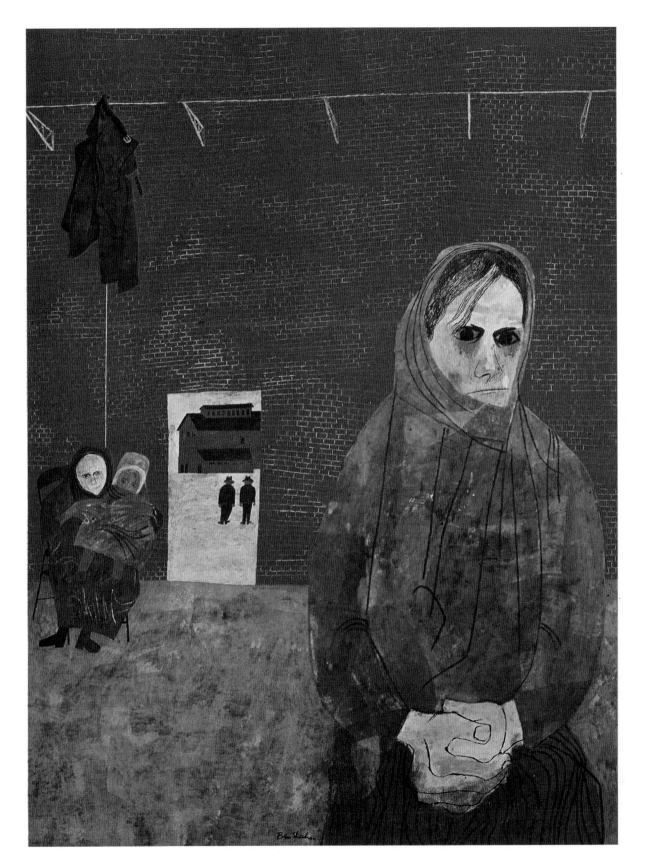

Ben Shahn (1898-1969). Miners' Wives, 1948. (48 × 36'')
Philadelphia Museum of Art, Philadelphia, Pennsylvania.

Benton's most important public commissions, however, were painted in New York. They were a series of murals glorifying American life in its various aspects for the New School for Social Research and for the library of the old Whitney Museum of American Art. In these crowded paintings of the typical images of American popular culture, massive muscular figures create a space quite at odds with the flatness demanded by decorative mural art. In their hyper-plasticity, they seem about to burst forth from the compartments that contain them. As art, they are redeemed mainly by the energy and vitality which they express, rather than by any specifically pictorial values.

Grant Wood's slick surface and meticulously detailed technique differed considerably from Benton's style, with its broadly generalized forms, although Wood was as devoted to the depiction of deep space as Benton. Although they are always discussed in relationship to Regionalism, Wood's hard-edged works, his reduction of forms to geometric volumes, and his insistence on craftsmanship really relate his work more closely to Precisionism. The irony of paintings like *American Gothic* or his owl-eyed *Daughters of the American Revolution* daintily and myopically sipping tea seems to have been missed by his contemporaries. But now in the light of pop art, one can see that there is already a certain satirical element present in Wood's treatment of American themes.

Charles Burchfield was a better painter than the Regionalists, but his view of life and choice of themes was related to theirs. In an essay on Burchfield's work, his friend Edward Hopper wrote that from "the boredom of everyday existence in a provincial community, he has extracted a quality that we may call poetic, romantic, lyric or what you will." Since Burchfield, like Hopper, wished to make poetry of the prosaic, it was natural that Hopper should feel close to Burchfield's art. Both rejected the hard surface and linear quality of the Regionalists and American Scene painters in favor of a fluid painterly style, in which edges are not drawn but created by broadly applied strokes of paint which model and define form. Their styles are quite different, however, in the contrast of Burchfield's drab color and dryness as compared with Hopper's appreciation of light and a rich surface.

Unlike Hopper, Burchfield did not confine himself simply to depicting what he saw objectively and with detachment. Burchfield's views of empty streets and deserted railroad stations always have something rather askew about them, as if the houses and towns were haunted or inhabited by restless spirits. Burchfield, whose early paintings were based on plant motifs, was primarily a landscape painter, and even somewhat of an expressionist in his exaggeration of fantasy and mood. Like Benton, Burchfield also lived in the Midwest (in Salem, Ohio), but as opposed to Benton's grandiose evocations of American history and his attempt to create an American myth out of rural life in America, Burchfield created a more modest introverted art based on his own private obsessions and fantasies about the ominous forces of nature in their more destructive aspect.

Although he painted brightly colored pictures in his youth, Burchfield's later paintings were characterized by a somber, almost monochromatic palette of greys and browns which seem totally in keeping with the dilapidated and decaying subjects he painted. In fact one might see the prevalence of decaying subjects in American art of the thirties as a symbolic acknowledgment that certain aspects of American life and the American landscape were literally decaying and disappearing, falling apart, as in a sense the society itself was changing under the economic pressure of the Depression.

While the Regionalists painted the countryside and small towns, the city was painted by the urban realists whose styles had much in common with theirs in that they, too, attempted to emulate Old Master technique but ended by having far more in common with popular illustration. Artists like Reginald Marsh, Raphael Soyer, Isabel Bishop and Ben Shahn continued the Ashcan School tradition of searching the city for picturesque themes. They painted tired office workers, street scenes, and Bowery bums in a style that revived many of the characteristics of academic painting, such as foreshortening, chiaroscuro, perspective. Some even attempted to use Renaissance techniques like tempera in the hope of making paintings as great as those of the Renaissance. Unfortunately, all they usually achieved was a pastiche of the styles of the past. The center for this academic illustrational painting was the Art Students League, where John Sloan was the director and Thomas Hart Benton was one of its most influential teachers.

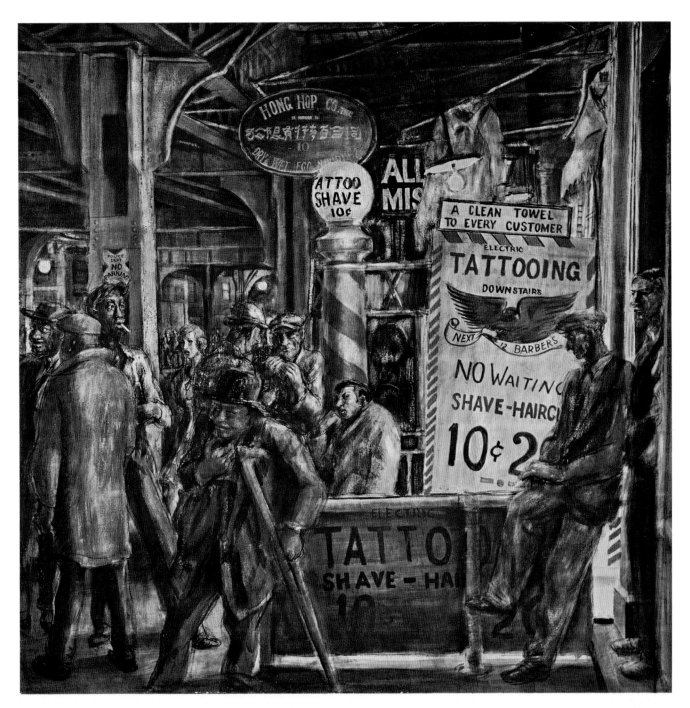

Reginald Marsh (1898-1954). Tattoo and Haircut, 1932. ($46^1/_2 \times 47^7/_8$")
Courtesy of The Art Institute of Chicago, Chicago, Illinois.

It was here that a young painter from Cody, Wyoming, who was destined to revolutionize not only American painting but world art, came in 1929 to study with Benton. Yet even if one did not know that Jackson Pollock was Benton's student, one look at the raw vigor of Pollock's churning landscapes of the thirties would reveal his debt to Benton and to Benton's notion of Baroque realism. Pollock, however, did not fear French art as Benton did, and eventually his appreciation for Ryder gave way to an even greater love of Picasso. Although Pollock's purpose finally came to be the internationalization

of American art, during the thirties he was much closer to the American Scene ambiance at the Art Students League than to the growing enclave of experimenters who banded together for mutual encouragement and conversation at Greenwich Village hangouts like Romany Marie's or the Jumble Shop. Eventually Pollock did become part of the group that included de Kooning and Gorky through his friend, the mysterious Russian émigré, John Graham, and through his future wife, Lee Krasner, herself a gifted abstract painter who transmitted her early understanding of Picasso and Matisse to Pollock.

Although Graham left only a small body of work, during the late thirties he was a significant figure in New York avant-garde circles, because he seemed to understand Cubism better than anyone else. In a treatise on aesthetics written in 1937, called *System and Dialectics of Art*, Graham wrote: "No technical perfection or elegance can produce a work of art. A work of art is neither the faithful nor distorted representation, it is the immediate unadorned record of an authentic intellecto-emotional REACTION of the artist set in space." For Graham, the creation of space was the essence of painting: "This authentic reaction recorded within the measurable space immediately and automatically in terms of brush pressure, saturation, velocity, caress or repulsion, anger or desire which changes and varies in unison with the flow of feeling at the moment, constitutes a work of art."

Graham's text must surely have been known to Pollock, de Kooning and Gorky, all of whom were at formative stages in their work when it was published; in many respects it provides the key to the radical reformulation of pictorial values they were engaged in. Graham's dismissal of technique, the absolute *sine qua non* of academic painting, gave comfort to those still struggling to acquire the means they needed to make the paintings they wished to create. Furthermore, it seems clear in many respects, Graham's insistence on expressive content and the automatic record of gesture, his call for speedy execution and authentic reaction, set the stage for the initial "action painting" phase of Abstract Expressionism.

A brilliant, eccentric bibliophile and collector, Graham was a legendary figure who filled his East Hampton home with volumes of occult literature which also must have impressed young artists like Pollock. Along with Hans Hofmann, Josef Albers and Piet Mondrian, three great Europeans who escaped Hitler to take refuge in America, Graham was one of the main channels through which the mainstream of European painting flowed into the United States. Although he was a Picasso imitator in his Cubist works, unlike most, he understood what he imitated, and was able to teach what he knew to his young friends. Graham also understood what the Surrealists were doing in Europe. There are passages in his book which describe Surrealist automatism, a practice of spontaneous form or image creation based on free association, long before any Surrealists arrived in the United States. Graham's insistence on the psychological content of images, which caused him to announce that an artist's "reaction to a breast differs from his reaction to an iron rail or to hair or to a brick wall," surely influenced both Gorky and de Kooning, who were making ambiguous emotional images that could be interpreted in a number of different ways.

Unlike his young friends, however, who dedicated themselves with increasing conviction to the cause of abstractionism, Graham turned away from Cubism around 1940 to create a mystical re-presentational art with academic Surrealist overtones. Gorky, de Kooning and Pollock, on the other hand, became yet more enthusiastic in their appreciation of Picasso, although they were just as wary as the American Scene painters of remaining true to their own experience, which they could see was qualitatively different from that of a European like Picasso.

Although even the early work of Pollock, de Kooning and Gorky looks radically unlike traditional art, all three were united in their desire to graft American art to the European mainstream, as part of a great tradition many centuries old. All studied the Old Masters and copied their drawings and paintings. From Benton, Pollock learned to appreciate El Greco and Michelangelo, making drawings after their work. In fact the flickering quality and loaded surface of Pollock's early work often recalls El Greco. De Kooning admired Ingres, and the agile graceful line he developed reveals how close in certain respects his drawing is to that of Ingres. Gorky, on the other hand, schooled himself by studying the modern masters like Cézanne as well as Ingres.

This attention to drawing is important to remark, because the early work of all three is dominated by the tension between painting and drawing, which are still quite separate entities in their respective works of the thirties. De Kooning's brilliant quicksilver line darts in and out, creating contours which model but sometimes lose the form they bound allowing it to seep through to adjoining areas. Gorky, too, begins to loosen the Cubist grid he has inherited from Picasso; influenced by Kandinsky, he starts to create loosely flowing contours, in which forms melt and bleed into one another and drawing becomes an element discontinuous from painting. Pollock, in his profound struggle to wrest order from chaos, begins to marry painting and drawing in tumultuous images of storm and holocaust, in which paint is thickly brushed on to a surface without regard to creating closed contours or shapes. At the same time, he was turning out endless pen sketches of monstrous personages contorted, superimposed and intertwined like the mythic beasts of some medieval manuscript.

For these artists, the American Scene was too narrow and parochial a theme for great painting. Their conception of the grand manner and a heroic style was not grounded in a sentimental notion of grandeur or in a nostalgic longing for the past, but in a genuine appreciation of the masters, old and new, whose art they wished to rival in terms of its plastic values and its universal content. They educated themselves in Cubism, but found the geometric style of late Cubism dominant in Europe in the thirties too narrow and constraining. And so they began to paint images that literally burst their linear confines, spilling over into one another and destroying the regularity of geometry. Their attempt to break down the rigid structure of Cubism in favor of a more fluid space and a broader, more painterly style affected other young abstract artists, too, like Richard Pousette-Dart, Giorgio Cavallon, George McNeil and John Ferren, who were also struggling to create convincing abstractions in the thirties.

The uphill battle of this group was greatly aided by the appearance of Europeans, either as visitors or as refugees. Matisse, Miró and Léger were all in America during the thirties and forties —Matisse to paint his murals for the Barnes Foundation; Miró to work at Stanley William Hayter's Atelier 17, an etching shop transferred from Europe to New York during World War II where Pollock and Motherwell also worked; and Léger to paint a never-completed mural for the French Line. The presence of the geometric painter, Jean Hélion, whose precise purist forms influenced Reinhardt, Ferren and conceivably Stuart Davis, was also an important stimulus to the development of abstract art in America.

Although Matisse apparently did not meet any of the younger American artists during his brief visit, his work became an important influence, even if that influence remained more or less underground until the fifties and sixties, when American painting became primarily a color art. The presence of an early Matisse of bathers in the lobby of the Valentine Gallery also made an impression on the small group of avant-garde artists because of its large scale, high color, and bold simplifications. It suggested the possibility of a decorative painterly style on a scale Americans were not ready to attempt for another decade.

In the thirties, however, Milton Avery at least seemed to be aware of Matisse's emphasis on color and decorative patterning, which he adapted into a highly personal and more intimate style of figure and landscape painting. Avery claimed to "strip the design to essentials." His attitude toward nature was somewhere in between that of Davis and that of Hopper, although he had no interest in specifically American or urban themes; his was a quiet bucolic style rather, although he asserted that "the facts do not interest me as much as the essence of nature." Avery's restrained landscape and figure studies, with their emphasis on color relationships and flatness were an inspiration to two young men destined to become perhaps the greatest colorists in the history of American painting, Mark Rothko and Adolph Gottlieb. When Avery died in 1965, Rothko reminisced about Avery's relationship with younger painters such as himself who often visited him in his studio. "We were, there, both the subjects of his paintings and his idolatrous audience," Rothko remembered. "The walls were always covered with an endless and changing array of poetry and light." Of Avery's limited repertoire of intimate themes, Rothko wrote that Avery painted "his living room, Central Park, his wife Sally, his daughter March, the beaches and mountains where they summered; cows, fish, heads, the flight of

Arshile Gorky (1904-1948). Self-Portrait, 1929-1936. ($55^1/_2 \times 34''$)
Courtesy M. Knoedler & Co., Inc., New York, Paris, London.

Willem de Kooning (1904). Seated Woman, about 1940. (54 × 36″)
Collection Mrs. Albert M. Greenfield, Philadelphia, Pennsylvania.

Milton Avery (1893-1965). Seated Girl with Dog, 1944. (44 × 32″)
Collection Roy R. Neuberger, New York.

birds; his friends and whatever world strayed through his studio; a domestic, unheroic cast." Avery was an exception among American artists of his generation in his rejection of the public world of social art for the private world of the family. According to Rothko, Avery's seemingly modest arrangements of color and light "far from the casual and transitory implications of their subjects, have always a gripping lyricism, and often achieve the permanence and monumentality of Egypt."

Color and light, which would come to be the subject of Rothko's work, were also the basis for the art of Hans Hofmann and Josef Albers, two German-born artists who settled in the United States during the thirties. Both were great teachers as well as important painters, and their respective aesthetic theories informed several generations of American artists. In the art school he opened on Eighth Street in 1934, Hofmann continued the educational program he had taught in Munich. His method was based on his celebrated "push-pull" opposition. According to Hofmann, the essence of painting was the balancing out of certain types of pictorial tensions caused by spatial pushing and pulling at the plane of the canvas, created by color and form relationship. Downgrading the purely intellectual and theoretical in favor of the intuitive and sensuous, Hofmann stressed the instinctual and the spontaneous–qualities that puritanical American painting had seldom been able to embrace. Hofmann's notion about the nature of pictorial space was far more complex than that of either a geometric painter like Davis or a realist like Hopper. He permitted an illusion of three-dimensional depth to be created, provided that an opposing force pulling the eye back to the surface plane could be created. If this balance between the assertion of the flatness of the surface plane and the illusion of depth could be sustained, then a complex and new kind of space that was neither like the bas-relief space of Cubism or the full relief of older art could be created.

Many artists who were not actually students of Hofmann's attended his lectures, where according to Clement Greenberg "you could learn more about Matisse's color ... than from Matisse himself." But none saw a painting of Hofmann's until his exhibition in 1944 when he showed intensely colored painterly abstractions. Since then, the work he did in the thirties has been seen; as one might have expected, Hofmann married Cubist forms to Fauve color in a series of still lifes. Another artist who mixed elements of Cubism and Fauvism in an original manner was Arthur B. Carles, whose rhythmic compositions seemed to anticipate the loose painterliness of Abstract Expressionism.

Although somewhat older than the Abstract Expressionists, Hofmann kept pace with their work, and often set that pace himself. In the fifties he showed billowing baroque abstractions or freely improvised gestural "action" paintings like his young colleagues. Beginning in the late fifties, however, Hofmann's painting flowered, and he painted in several manners at once. In one style, he freely improvised, creating gay linear motifs and bursts of paint which danced across loaded surfaces, illustrating his belief that a painting had to have movement above all if it was to live. In his alternate severely architectonic style, he covered the surface with thickly painted rectangles of pure color. Sometimes these flat areas were floated on an illusionistic ground; at other times they were locked together as in *Cathedral*, one of Hofmann's late masterpieces, to form an impassive opaque façade which stressed surface more than depth.

Although Josef Albers was a more methodical and less romantic painter than Hofmann, whose uninhibited style immediately found favor with the expressionists of the New York School, his influence was enormous as well. Albers, like the painter and designer Moholy-Nagy, and the architects Walter Gropius and Mies van der Rohe, fled Germany when the Bauhaus was closed. The first of the Bauhaus faculty to arrive in New York, Albers came to America in 1933, where he was determined to continue the radical program of art education propounded at the Bauhaus, which had sought to replace worn-out academic training with schooling that would not crush the free spirit of modernism. Toward this end, he founded the now famed Black Mountain College in the hills of Asheville, North Carolina, the same year that he arrived in America.

Black Mountain College was at the same time the most radical experiment in education undertaken in the United States until the present, as well as the most important art school, in terms of what developed out of the contacts that took place there, in the history of American art. Freer than the Bauhaus, Black Mountain had no structured curriculum, although Albers taught a "trial and error"

Hans Hofmann (1880-1966). Cathedral, 1959. (74 × 48″)
Private Collection, Shaker Heights, Ohio.

Josef Albers (1888-1976). Homage to the Square: Ritardando, 1958. (40 × 40″)
Collection Roy R. Neuberger, New York.

method derived from the Bauhaus basic course which stressed color and design as abstract principles, to be organized by the artist in terms of their spatial and emotive relationships. Among the distinguished alumni of Black Mountain were Robert Rauschenberg and Kenneth Noland, two of the principal artists of the sixties, as well as the sculptor John Chamberlain. Other artists like Helen Frankenthaler often drove down from New York to visit. The Black Mountain faculty in the forties and early fifties had such distinguished members and visiting lecturers as Robert Motherwell, Willem de Kooning, Clement Greenberg, Merce Cunningham, John Cage and Buckminster Fuller. In fact it might not be going too far to maintain that virtually every creative idea that later emerged in American art of the sixties had its origin at Black Mountain.

The main thrust of Albers' teaching was that head, heart and hand had to be organized into a single unity. He wished to give his students a firm understanding of technique without destroying their creativity and spontaneity, however. He held that "knowledge does not destroy spontaneous work, rather it creates a solid base for it." It may in fact have been Albers' emphasis on knowledge, logic and thoroughness that allowed Rauschenberg and Noland to become the first of the younger or "second generation" New York School painters to react against the ambiguity and contradictions in Abstract Expressionism which could only be resolved by changing the formal basis of painting. Albers maintained he wished "first to teach the student to see in the widest sense, to open his eyes to the phenomena about him, and most important of all, to open his own living, being and doing." His wife, Anni Albers, taught the materials classes in which problems, mainly derived from Johannes Itten's original basic design course at the Bauhaus, were given to students involving the combination of natural and synthetic materials. The purpose of these exercises was to see how "the material sets up its own limits for the task of the imagination." Rauschenberg's use of raw materials in his first audacious constructions as well as Noland's focus on the interaction of adjacent colors can perhaps both be traced back to approaches they learned as Black Mountain students.

After Albers left Black Mountain in 1950 to become the chairman of the Yale art department, the school soon closed, not only because Albers was no longer there to direct activities, but because New York had become too exciting, and artists did not want to live elsewhere.

Although in certain respects their teaching was related in its stress on form, color and materials, Hofmann and Albers differed in terms of their attitude toward discipline and fundamentals. Hofmann, who had never been at the Bauhaus, felt that the Bauhaus approach was too rigid and theoretical. He taught freedom of expression, speed of execution, and assertive paint application with an emphasis on surface, both as plane and as matter. His way won out for the fifties, but Albers' more methodical and logical approach finally triumphed in the sixties, after the gestural manner of Abstract Expressionism had played itself out. Obviously neither Hofmann nor Albers, as Europeans, was concerned with creating an "American" style; their schools were the very antithesis of the Art Students League, and their teaching a much needed corrective to that of John Sloan and Thomas Hart Benton, who were far better known in the thirties, however. This is not to say that Sloan and Benton were not important teachers; Sloan had an open mind and an understanding of Cézanne which he preached even if he himself did not quite practice it. And if only for what Jackson Pollock learned from him about the Old Masters, Benton was an important figure.

Thus one of the most important things that happened in America during the thirties was that a generation of American artists were being educated, both formally and informally, to understand a tradition they had as yet never possessed, except perhaps in the instances of isolated individuals like Eakins and Ryder. By the time World War II broke out, and scores of European artists arrived in New York, Americans had learned their lessons well and were willing and able to assimilate what further lessons the Surrealists, Cubists and Constructivists could teach them. Although many were still struggling with technique, color and the elements of design, others had begun to master their craft, and to raise it to a level few if any had achieved in America. Besides learning painting culture and achieving an understanding of the aesthetic basis of modernism, American artists were becoming more self-conscious about turning their limitations into assets. If American art had been crude, then they would cultivate directness; if it had been raw, then they would deliberately seek spontaneity and

the ''unfinished''; if it had been idiosyncratic, then they would insist even more forcibly on their own individualism. Although they might paint, like the early American modernists, a private inner vision, no longer would they be modest and humble in ambition like the Precisionists. For another crucial change that came about in the thirties was that not only was the level of painting upgraded, but the level of ambition ascended to heights it had never scaled in the history of American art. Rejecting American Scene painting as too narrow, provincial and particular, they were determined to create an art that could hold its own with the art of the museums as well as with that of the modern masters they admired and began by imitating. American artists faced the new challenge they had set before themselves with both trepidation and excitement. Before they could achieve their goal, however, they had to, as Barnett Newman put it, find a subject worth painting. Usually, that subject was their own sense of self, their own intensely personal conception of the world and nature and their own feelings and responses to that world.

Arshile Gorky (1904-1948). The Betrothal, II, 1947. (50³/₄ × 38″)
Collection Whitney Museum of American Art, New York.

THE NEW YORK SCHOOL

Although there is no specific hour one can point to as that of the nascence of the New York School, as the group of American painters who revolutionized world art came to be known, the opening of Peggy Guggenheim's Art of This Century gallery in 1942 constitutes one of the most important dates in its early history. When the war broke out in Europe, Miss Guggenheim, niece of the celebrated Kandinsky collector, Solomon R. Guggenheim, and later the wife of Surrealist Max Ernst, was forced to flee. She had already begun to collect in London many Cubist, Futurist, Constructivist and Surrealist paintings and sculptures toward the end of opening a museum of modern art. In Paris on the eve of the German invasion, she bought a work of art a day aided by Howard Putzel, an art dealer with a respected eye who later worked for her finding new talent in New York.

With the Germans literally on her heels, Miss Guggenheim transported across France her cache of works by artists such as Braque, Léger, Picasso, Severini, Delaunay, Brancusi, Arp, Miró and Schwitters—in short the leaders of every non-realist art movement of the twentieth century—which she had acquired for a modest $40,000. If she had done nothing but support Jackson Pollock for five years after the Federal Art Project folded, Peggy Guggenheim would have been one of the leading heroines of American art. But she accomplished far more than saving America's greatest innovator from poverty; her gallery, Art of This Century, was once again, like the Armory Show and Stieglitz' 291, a place where American and European modernists exhibited together. Only by this time, Americans who exhibited there, like Rothko, Still, Pollock, Motherwell, Baziotes, Hofmann and Gottlieb had absorbed a sufficient amount of European painting culture to compete with the modern masters on their own terms.

The opening of the gallery, held for the benefit of Red Cross war relief in October 1942, was, like the Armory Show, a sensation. Decor was by the eccentric avant-garde architect Frederick Kiesler, who created a startling environmental setting for paintings by the leading European modernists, which were suspended, unframed, in mid-air by means of rods. Kiesler, one of the original members of de Stijl, had also known Schwitters in Germany, and was an important and continuing link between early experiments in environmental art begun in Europe and those realized in New York in the fifties.

Her eye educated by Duchamp and Ernst, Miss Guggenheim was able to recognize the genius of the most radical young New York painters at a time when few, if any, had the slightest inkling of the meaning of the new art developing in the abandoned manufacturing lofts below Fourteenth Street.

Of the European works exhibited at Art of This Century, perhaps the most influential, in terms of their impact on the young Americans who also showed there, were the works of Kandinsky, Miró, Klee, Arp and Masson. During the thirties, abstract painters in America had been heavily indebted to the strict geometric abstraction of the purists and constructivists and to the hard-edged angular shapes of synthetic Cubism, especially as it was practiced by their hero, Picasso. But these generally "classical" styles, in their formality, restraint, closed forms and precisely delimited shallow relief space, did not satisfy the American appetite for a flamboyant all-out expression, a sense of physical presence and motion, and, probably most important of all, an intense romantic imagery. The freely improvised drawing and more ambiguously open space of Klee, Kandinsky and Miró provided the Americans with examples of liberated styles, which appealed to their instinct for individual self-expression and romantic gesture; on the other hand, their dislike of anything that seemed based on a preconceived and predictable formula drew them to Masson's early use of automatism to create spontaneously generated images drawn in paint. The final important ingredient in the initial phase of Abstract Expressionism was the vocabulary of bulbous organic forms based on nature known as biomorphic shapes originally developed by Arp.

This so-called "biomorphic" or surrealizing phase of Abstract Expressionism which took place during the forties encompasses the mature works of Gorky, Gottlieb's mysterious pictographs, Rothko's and Baziotes' viscous marine imagery, and Still's menacing personages. Most importantly of all, it includes Jackson Pollock's first mature works, the totemic paintings based on archetypal or mythic themes. Typical of these thickly painted and brightly colored works is *Pasiphae*, a densely painted work in which intense emotion, expressed through vehement paint application, is structured by rhythmically patterned linear elements. Although the title of this painting refers us to the legend of the abduction of the wife of King Minos by the mythical man-bull the Minotaur, it would be taking Pollock too literally to think that one could recognize the famous event in the mysterious calligraphy, suggestive of occult symbols, or the disembodied anatomical fragments emerging from the churning sea of paint in which they swim. In fact, it has been suggested that Pollock was so far from referring to a specific theme that this painting was originally entitled *Moby Dick*, after Melville's giant whale. Rather than illustrating any literary text, whether Greek or American, Pollock was intent on giving a general feeling about the immense power of the forces of nature which had previously been symbolized by such mythic beasts as the Minotaur and Moby Dick. It is, of course, interesting to speculate why Pollock, who had rejected American Scene painting in favor of modernism with its French sources, should have changed the title from an evocation of a great American symbol to the image, favored by the Surrealists and used extensively by Picasso, of the Minotaur, the name in fact of a review devoted to the art of the School of Paris widely read among avant-garde American painters as well.

Although Pollock's themes in the totemic paintings are closely related to those of the Surrealists, his linear passages recall Kandinsky's free drawing as well as Masson's calligraphy. The forms of Arshile Gorky, on the other hand, another American artist deeply indebted to Surrealism, were biomorphic shapes reminiscent of Miró and Arp. Gorky, who had already flattened bulging organic shapes in his synthetic Cubist works of the late thirties, was a complex artist whose imagery was alternately both florid and tortured.

Although his life was beset by tragedy and disappointment, Gorky was fortunate in having a number of good friends and influential supporters. He was spiritually adopted by the leader of the Surrealists-in-exile, the poet and redoubtable culture hero, André Breton. In Gorky's rich and ambiguous imagery, Breton saw analogies to the many-layered meanings of Surrealist poetry. Gorky had other important connections to the Surrealists, who accepted him as one of their group, as well. The art dealer Julian Levy, for example, who showed the Surrealists in his New York gallery, was introduced to Gorky's work by the ubiquitous John Graham, who had also arranged for the first public exhibition of Pollock's paintings in 1941 at the MacMillan gallery.

Reminiscing about Gorky's wartime activity as a camouflage painter, Julian Levy described Gorky's strange and colorful appearance: "From poverty, or of a piece with his camouflage, for he

was a very camouflaged man, Arshile Gorky as long as I knew him wore a patched coat." From Levy's description, one gets a very vivid impression of Gorky's tattered appearance, while photographs and self-portraits reveal the intensity of the gaze of this ardent poet-painter, who once corrected a woman who mistook him for Jesus Christ by announcing, "Madam, I am Arshile Gorky."

Although the art of the New York School was identified early by the critic Robert Coates as "Abstract Expressionism," Gorky's and Pollock's interest in Kandinsky and Hofmann's free technique, loaded surfaces and brilliant color constituted the only points of contact between so-called "Abstract Expressionism" (a term first used by Alfred Barr to describe Kandinsky in the thirties) and German Expressionism. In fact, most of the artists to whom the name was applied considered it a misnomer. They preferred anything from "abstract impressionism," which would have acknowledged an obvious debt to the late Monet, to "intrasubjectivism," which would have made clear the emphasis on psychological content, as opposed to the emotional and empathic content of Expressionism. Many would have been happy with "abstract Surrealism"–by far a more accurate description of American art in the forties than "Abstract Expressionism," the title that stuck.

But any attempt to construct a group identity for a movement that never consciously existed as a movement was bound to fall short of correctness. For Abstract Expressionism, although it had certain common stylistic characteristics uniting its leaders, was never a homogeneous style; on the contrary, the so-called "first generation" New York School painters went so far in the direction of creating highly individualized personal styles that the result was a series of parallel styles, each of which was imitated by a host of younger painters.

Arshile Gorky was, of course, the first to arrive at such a mature manner. By the early forties, he was already painting works in a style so loose and fluid that it outstripped in sheer painterliness anything that had gone before. Having schooled himself first with the Old Masters and then with Cézanne and Picasso, Gorky was inspired by contact with Kandinsky and Miró, and to an extent with the Surrealist Matta, from whom he appears to have learned to embed sharply attenuated linear passages in an atmospheric space of undefined but shallow depth. A sensualist whose desires appear to have been repeatedly frustrated by experience, Gorky combined in his charged imagery the pleasure-loving and the possessed.

The first paintings by Gorky in which traces of the other modern masters have been so thoroughly assimilated that they have become merely aspects of Gorky's own style were done in 1942, the same year that Peggy Guggenheim opened her gallery. Beginning with the series based on his father's garden in Sochi, his works became progressively freer and full of random drips and transparent washes. Based on childhood memories, the Sochi theme focused Gorky's imagination on landscape. Probably inspired by Kandinsky's example of drawing on memories of past places and feelings with which the artist had many associations, Gorky began painting magically populated landscapes refulgent with personal meaning. Many of these, like Kandinsky's landscapes of the Russian countryside, were associated with specific images Gorky recalled from his childhood in Armenia.

Explaining the meaning of the paintings based on the *Garden of Sochi*, the subject of several works bearing the same title, Gorky wrote: "The garden was identified as the Garden of Wish Fulfillment and often I had seen my mother and other village women opening their bosoms and taking their soft and dependable breasts in their hands to rub them on the rock. Above all this stood an enormous tree all bleached under the sun the rain the cold and deprived of leaves. This was the Holy Tree. I myself do not know why this tree was holy but I had witnessed many people whoever did pass by that would tear voluntarily a strip of their clothes and attach this to the tree." In the painting, as in later paintings with explicitly sexual themes such as *The Betrothal*, swelling organic forms created by fine hairbreadth lines bring to mind associations with sexual organs and breasts. And the tree is present, too; even if it is barely recognizable, we can still make out the fluttering forms standing ambiguously for the strips of clothing or for vaguely anatomical appendages.

The interest in landscape first evidenced in the Sochi paintings, which were based on memories of the past, was reinforced in the present by summer vacations in the country, where Gorky began

to make many drawings based not on literal nature but on a variety of ambiguous organic forms. These drawings in turn became the basis for future paintings; for Gorky worked as academic artists had in the past, transferring his large-scale cartoons to canvas by drawing on a prepared grid. In these drawings, knife-sharp lines are threaded in and out of space with a nimble grace and an astonishing variety of inflated convex and subsiding concave contour. These "hybrid" forms, as André Breton called them, that Gorky created with his swift line were full of details allusive at one moment to human or animal anatomy, at others to plant or landscape forms. The paintings that ultimately resulted from these many studies were thinly painted, with frequently improvised passages of smudged or dripped paint suggestive of the soft billowing of clouds, the fluid movement of water, or the curving contours of a hillside. In their emphasis on flow and movement, these paintings offered an image as ephemeral as natural phenomena themselves.

Gorky's tragic suicide in 1948 coincided with the departure of Peggy Guggenheim and her entourage a year earlier to bring to an end the direct influence of Surrealism on American art. Of course the Surrealist legacy, in the form of automatism both as a process of formal invention and a technique for generating images continued to have importance.

Despite the degree to which Abstract Expressionism depended on earlier modern art movements such as Surrealism and Cubism, it would be inaccurate to imply that the new American painting developing in the shadow of World War II was merely an eclectic synthesis of these sources. Although its greatness lay in the fact that it did represent an extraordinary and seemingly impossible merger of diverse aspects of various modern movements that preceded it from post-Impressionism to Surrealism, the art of the New York School was above all else a highly original style. This originality was both personal and national. The artists who created the style, painters like Pollock, Gorky, de Kooning, Still and Motherwell, were extreme individualists, men whose lives and imagery testify to what they suffered in the sense of alienation and isolation that allowed their art to take on such a highly personal character.

Not only the isolation—both psychological as well as often geographical—of the individuals who created Abstract Expressionism, but also the many years American art was isolated as a provincial school divorced or cut off from the mainstream contributed to the originality of the New York School when it finally emerged in the forties. Like Spanish painting of the seventeenth century, which had served a protracted apprenticeship to Flemish and Italian mainstream styles, American painting, when it finally crystallized as an independent international force, burst forth with a highly particularized and identifiable character. Although it clearly developed from European models, American art was soon bigger, bolder, more literal and direct, more powerful in impact, and more devoted to speed and rawness of execution than European art had ever been. In fact, it happened that certain aspects of American provincialism, which had originally inhibited the development of a high style, were turned into positive factors. This was particularly true of those native-born painters of the first generation of Abstract Expressionists, who had assimilated the European tradition, not because it belonged to them by birth right, but only through a concentrated act of will.

Thus the crudeness of Still's and Pollock's early works and the awkwardness of Motherwell's forms speak of the enormous distance, both actually and figuratively, these non-East Coast painters had to travel to form a connection with the tradition of European painting. Earlier American artists from backwater areas, bogged down in a misunderstanding of the gradual evolution of modern art from older styles, had never succeeded as these men did in coming to grips with the high art tradition; instead like Benton, they had created travesties of the old masters that were not only provincial and naive, but confused with popular illustration and academic attempts to revive the past *in toto*. By the time Franz Kline abandoned Ashcan School subjects in favor of abstractions of urban structures, however, all this had changed; and Kline was capable of expressing the crude American vigor of the Ashcan School without being condemned to express this energy in terms of second-hand or outdated pictorial conventions.

The success of American art has in some respects obscured the desperation of its origins. If a sense of struggle, both actual and metaphoric, was deliberately cultivated to expose both the dif-

ficulty of living as well as the difficulty of creating, then this pictured conflict was also to serve as an analogue of the struggle to create a tradition in which to paint. American artists of the thirties had labored to locate such a tradition within the various styles and cultures, American and European, of the past. But American artists of the forties were more realistic; they finally faced it that they would have to turn their attention from the past to the present, inventing their own myths and tradition wholecloth out of that present. In a journal entry, for example, Jack Tworkov described their dilemma: "The old world, the world of aristocratic dreaming has been shaken to bits... Nothing archaic can help us or set us an example. Everything in the world is new–like ourselves."

The need to create a style consistent with that newness spurred many New York artists to set off a series of innovational moves that exploded like a chain reaction during the extraordinarily creative decade of the forties. Fortunately, certain characteristically American ways of behaving and dealing with the world helped them in their determination to find new approaches to painting. For example, the pragmatic attitude helped sweep away notions of decorum and academic formulas, allowing anything to be used, providing it was available and served the purpose. Pragmatically, artists appropriated tools and materials that had never been utilized to make fine art: de Kooning used a fine sign painter's liner to create his rapidly executed arabesques and taught Gorky to do the same; Kline found house-painter's brushes practical in creating his wide swaths of paint, and later inspired Stella to paint his stripes with them, too; Gottlieb used a household sponge mop to apply large areas of color impersonally, which may have suggested to Noland the technique of rolling paint on evenly with

Jackson Pollock (1912-1956). Pasiphae, 1943. (56$^1/_8 \times$ 96'')
Courtesy Marlborough-Gerson Gallery, New York. Collection Lee Krasner Pollock.

wall-painting rollers. Pollock, of course, took the pragmatic attitude to its greatest extreme and devised a technique of spilling and pouring that eliminated the conventional tools of art altogether. Many others, too, used commercial house paints straight out of the can, discarding the notion of premixing on the palette as academic. Others bought the cheapest grade of enamel called Sapolin, which dried unevenly, producing novel surface effects alternating the glossy and the matte. The result of all this pragmatic improvisation was that at last the lack of a proper academic tradition had become an asset instead of a liability, permitting opportunities for experimentation, originality and innovation unlimited by conventional attitudes and norms.

During the thirties, Americans had put their greatest effort into locating a painting tradition in which to work; in the forties that tradition was at last solidly and firmly established. By the end of the

Burgoyne Diller (1906-1965). First Theme, 1939-1940. (34 × 34″)
Property of Mrs. Burgoyne Diller.

fifties, it would harden into an academy in its own right. But for the time being, the presence of some of Europe's greatest artists living in the United States as refugees gave Americans heretofore undreamed-of possibilities for enlarging their vision. First Hofmann, Albers and the members of the Bauhaus faculty, then Peggy Guggenheim and the Surrealists, and finally Piet Mondrian, the leading geometric painter and theoretician of abstract art settled in the United States. Mondrian's influence, however, was at first confined mainly to his small circle of friends and admirers, which included Harry Holtzman, Charmion von Wiegand, Michael Loewe, Ilya Bolotowsky, and most importantly, Fritz Glarner and Burgoyne Diller.

Although there is little or nothing to distinguish Glarner's ''relational paintings,'' as he called them, or Diller's classically architectonic arrangements of bands and bars of color suspended on a flat ground from contemporary paintings produced in Paris or London, both painters created formal arrangements of a quality that American abstraction had seldom if ever achieved earlier. Believing that art should express not the feelings or moods of the artist, but some impersonal and timeless absolute, the artists close to Mondrian painted pure non-objective Cubist works whose static immobility was the very antithesis of the romantic Expressionist manner being developed by their colleagues.

Glarner, for example, subtly modifying the tricolor harmony of the primaries developed by neo-Plasticism, also altered the shape of his planes so that they were no longer regular rectangles, but irregular and slightly angled. His modifications of geometry were entirely typical of the American attitude toward geometric forms, which were seen as being as open to a personal and idiosyncratic interpretation as the vocabulary of organic forms inherited from Surrealism. Diller, on the other hand, was a much stricter classicist; he worked with increasing asceticism toward a reduced format which, by the time he died in the mid sixties, resembled the minimal paintings of far younger artists. Often using black as a dramatic foil and background for brilliant red and blue or yellow bars, Diller, who was also a sculptor of the first order in his later years, created stark frontal arrangements of great dignity and monumentality.

Ad Reinhardt (1913-1967). Blue Painting, 1953. (75 × 28'')
The Museum of Art, Carnegie Institute, Pittsburgh, Pennsylvania.

But the geometric discipline of Mondrian and the constructivists in which such artists worked was precisely the tradition other painters like Gorky, de Kooning and Pollock were rejecting because they found it too conventional, constraining and unemotional. Although the geometric tradition re-emerged in the sixties with renewed vitality—in a form of course vastly altered because of its emphasis on color—during the forties and fifties it was a decidedly minor strain, for the Surrealists rather than the geometric painters captured the imagination of the most radical young Americans during the formative years of the New York School. The single exception was Ad Reinhardt, the only first generation "Abstract Expressionist" to begin and end his career as an abstract painter. Reinhardt's reductive format and color, however, are more appropriately discussed in relation to "minimal" art which he in large measure inspired. In this context, it should be remembered that with the exception of Reinhardt, Abstract Expressionism was only nominally an abstract style; in actuality landscape and figure elements stand behind all the work to a greater and lesser degree. And even in Reinhardt's case, the determination to create a Vitruvian image, as tall as a man and as wide as a man's outstretched arms, provides an implicit allusion to the figure, which might be inscribed within one of Reinhardt's blank cruciforms. Thus even for a maverick among the Abstract Expressionists like Reinhardt, man was always the measure.

Given the general distaste for the geometric tradition, it was altogether natural that the Surrealist conception of painting as a form of visual poetry had a great appeal for Americans with their Whitmanesque vision. Much more exciting to the young American avant-garde than the regular shapes, predictably if not inexorably echoing the framing edge of the various constructionist styles, were the more ambiguous and open, both literally and figuratively, space and forms of the Surrealists.

Paradoxically, American art had come full circle: Americans, who once held fast to the easily understood, the positive, the material and the literal, had acquired a taste for complexity and metaphor. The forms of the Surrealists, charged as they were with a variety of only vaguely definable associations, provided an example of an art of "content" as opposed to the merely decorative or formal art of late Cubism. Since American artists were rebelling against the purely formal in their determination to make a universally meaningful statement that would not only decorate but inform—if not ideally uplift—they felt they had a lot to learn from the Surrealists.

In Abstract Expressionism, then, American artists were at last able to realize their long maturing ambition for an art both of formal grandeur as well as spiritual significance. The literalism that limited American art for centuries was but a small portion of Abstract Expressionism; it was largely confined to making literal the flatness of the painting, and asserting the real qualities of the medium (i.e. that paint was fluid and surface was palpable). In all other respects, Abstract Expressionism was an art dedicated, above all, to transcending the mundane, the banal and the material through the use of metaphor and symbol.

As it had been for the Surrealist, the Unconscious became the field of most fertile exploration in terms of imagery for many Abstract Expressionists such as Gorky, Pollock, Motherwell, Baziotes, and the early Rothko and Gottlieb. Freud's stress on the sexual component of unconscious fantasies appears to have been a more important influence on Motherwell and Gorky, whereas the others were more drawn to Jung's theory of the collective archetypes. Pollock especially, who had executed many drawings for study with his Jungian analyst, was involved in excavating the buried content of the unconscious that linked modern man to his most ancient ancestors.

In opposition to the Jungian bias of the majority of New York painters, Robert Motherwell gave a decidedly Freudian orientation to his images. Motherwell, who came into contact with the Surrealists through Kurt Seligmann, a Surrealist painter who wrote a book on magic widely read during the period, found his great theme of the forties and fifties in Freud's opposition of the life force and the death instinct. The numerous elegies to the Spanish Republic Motherwell began painting in 1949 are imagined as huge phallic configurations whose monumentality commemorates both man's courage and his impulse to self-destruction. Love and death alternate as the two dominant subjects of Motherwell's work. In the *Je t'aime* and *Chi amo crede* series, the life force triumphs; in the elegies and later paintings like *Africa* and the paintings commemorating Kennedy's assassination, the dark brooding

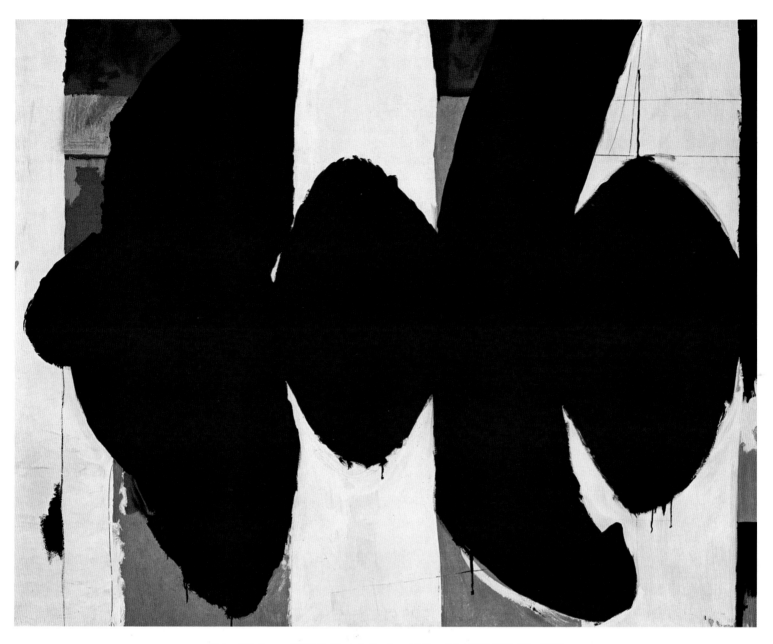

Robert Motherwell (1915). Elegy to the Spanish Republic, 1953-1954. (80 × 100″)
Albright-Knox Art Gallery, Buffalo, New York. Gift of Seymour H. Knox.

forces of destruction crowd out the light. For Motherwell, automatism was the great principle of form creation, enabling him to create Rorschach-like configurations without inhibition. In his elaboration of the ''paranoiac-critical'' method of reading images, Salvador Dalí in a sense had predicted the manner in which Abstract Expressionists would present their ambiguous forms, with their loosely defined, perhaps even subliminal, multivalent associations.

It was true not only of Motherwell's and Gorky's sexually charged imagery, but of that of virtually all the first generation Abstract Expressionists, that their images evoked a whole string of associations, of which the viewer might or might not be fully conscious. Thus Pollock's image might be thought reminiscent of the maelstrom or the primordial matter from which all life issued. Or Still's canyons and ravines might call to mind an Ice Age landscape as the bizarre mythic beasts of his early

paintings conjured images of extinct creatures who inhabited the earth before man. More down to earth but not less romantic were the allusions to the contemporary industrial environment in the paintings of de Kooning and Franz Kline.

In the forties, Kline, who supported himself in this bleak period by drawing caricatures in Greenwich Village, painted small oils inspired by the same urban scenes depicted by his friend the American Scene painter, Reginald Marsh. A mural executed by Kline during this period still exists on the wall of a Greenwich Village tavern. Painted in the awkward illustrational style of provincial realism, it reveals that Kline's roots are within the tradition of the Ashcan School. However, many of the subway and elevated stations painted by Kline before his conversion to abstraction have real quality. Kline's gentle, delicate sense of touch, for example, reveals a refinement far beyond the crudities of Ashcan School realism.

For Kline to realize himself, however, it was necessary that he change his scale from that of a modest genre painter to one more expressive of the reality of the New York scene. Inspired by Pollock's and de Kooning's success in creating a broad gestural style, Kline began to experiment with improvising form in a series of calligraphic brush drawings on newsprint, or sometimes on the pages of the telephone book. According to legend, he was inspired to blow these drawings up to full scale paintings by seeing them through a stereopticon.

The year 1950 was decisive for Kline, as it was for many other New York painters. In that year he enlarged his scale, renounced color for black and white, and gave up painting Ashcan School subjects for bold abstractions which nevertheless continued to recall the great bridges and elevated railroads of his early works. Even their color–the dirty black and peeling white of the manufacturing loft area where Kline and his fellow artists lived and worked–evoked the urban landscape. And Kline was not adverse to the associations his paintings called up. "There are forms that are figurative to me, and if they develop into a figurative image it's all right," he said. "I don't have the feeling that something has to be completely non-associative... I think that if you use long lines, they become–what could they be? The only thing they could be is either highways or architecture or bridges."

Quite the opposite was true of the attitude toward form of painters like Rothko and Gottlieb, whose early ties were to Avery's nature image. Although Gottlieb's compartmentalized pictographs and Rothko's graceful biomorphic paintings of the forties emphasized color relationships, they were relatively undeveloped with regard to the sophistication both achieved after renouncing biomorphism and becoming fully abstract. Rothko's imposing image of rectangles floating in an atmospheric field and Gottlieb's explosive sunbursts have, like Kline's paintings, implicit landscape analogies. But their link is to the world of nature, not to the urban landscape that attracted Kline. The frontality and simplicity of their few large forms was as impressive as the originality of their color relationships. Having arrived at an image or format they merely varied but hardly changed after a point, in the fifties both Rothko and Gottlieb began to concentrate the burden of expression in their paintings on color. Each developed a highly individual palette, characteristic of their respective sensibilities and totally unlike the color range of any other painter. Rothko chose in the main to concentrate on deep resonant harmonies–red, blue or green color chords as sonorous as organ harmonies. Gottlieb on the other hand often contrasted intense blues and fiery reds with sputtering masses of shadowy black. At other times, he created unlikely combinations of pastel tints with dark shades, particularly those of the brown scale, to which he seemed especially attracted. Both Rothko and Gottlieb paid great attention to facture and surface. The many variations and modulations within their large rectangles and disks of color create subtle inflections that maintain the liveliness of their works.

Explaining that he painted large not to create a public art but to make a more intimate statement, Rothko insisted, "To paint a small picture is to place yourself outside your experience, to look upon an experience as a stereopticon view or with a reducing glass. However you paint the larger picture, you are in it. It isn't something you command." Thus to create an image so large it would take up the viewer's entire field of vision and hence occupy his entire consciousness for the moment he was looking at it, became a general goal for the artists of Rothko's generation, who wished to make of art an experience as total, as engaging and as real as life itself.

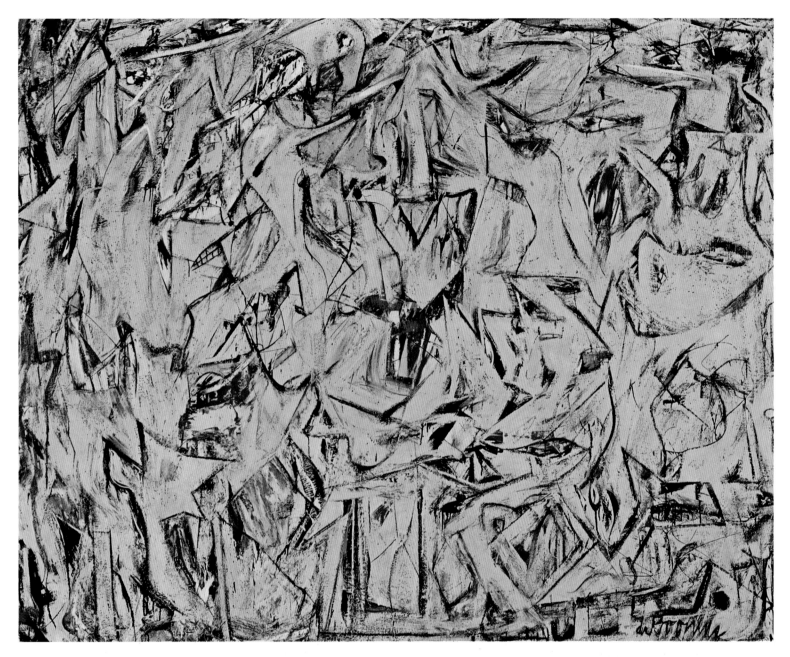

Willem de Kooning (1904). Excavation, 1950. ($80^1/_2 \times 100^1/_8$")
Courtesy of The Art Institute of Chicago, Chicago, Illinois.

The interest among the Abstract Expressionists in the unconscious must be seen as part of their determination to create a statement so broad and general that it would be universally meaningful. Partly the intensity of their determination to create such a universal statement must be seen as a reaction to, indeed a profound disgust at, the narrowness and parochialism of earlier American art. Beyond this, their stress on the elemental themes basic to human existence reflected a desire to regain for modern art some of the depth, dimension and fullness of expression of the great art of the past, for the Abstract Expressionists, however wild their art might have seemed at first, had no desire to break with tradition. Rather they wished to keep that tradition alive and moving; but to do so they were forced to alter its course.

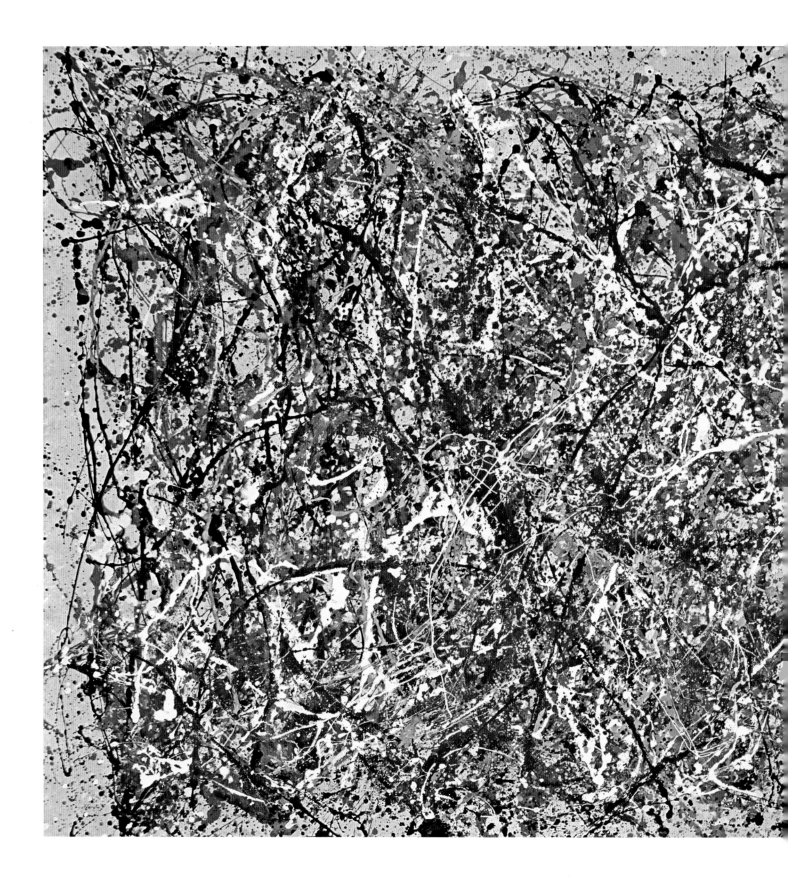

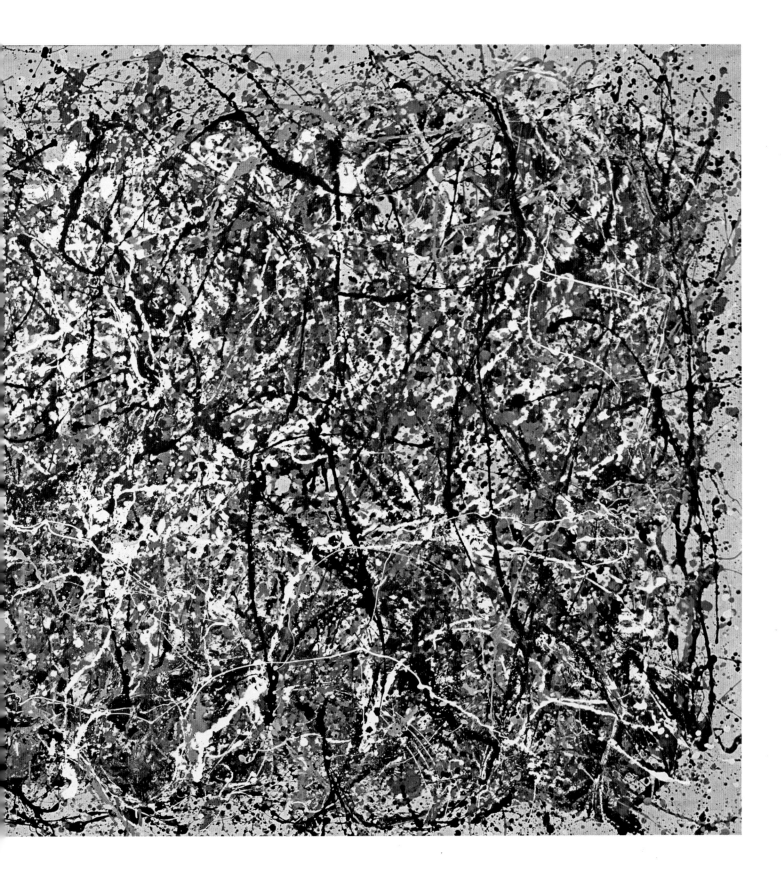

Jackson Pollock (1912-1956). One (Number 31, 1950). (8 ft. 10 in. × 17 ft. 5⁵/₈ in.)
Collection, The Museum of Modern Art, New York. Gift of Sidney Janis.

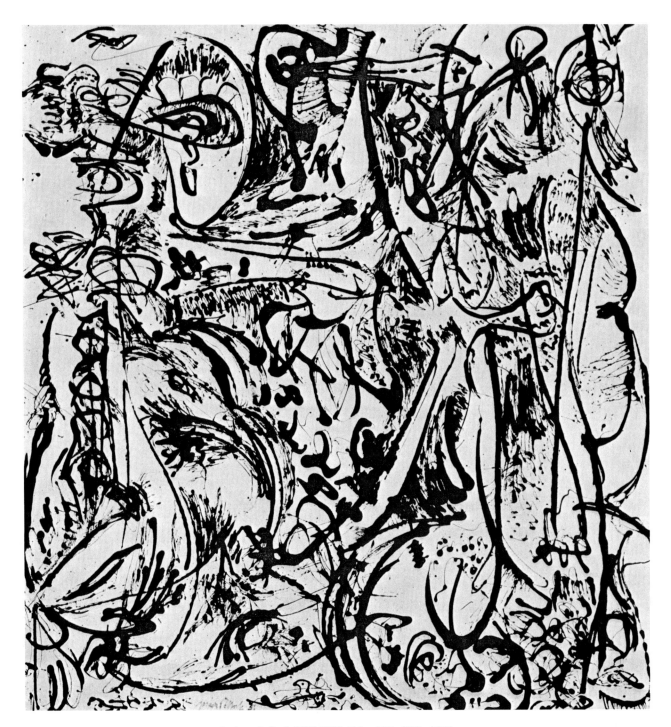

Jackson Pollock (1912-1956). Echo, 1951. (91$^7/_8 \times$ 86'')
Collection, The Museum of Modern Art, New York.
Acquired through the Lillie P. Bliss Bequest and the Mr. and Mrs. David Rockefeller Fund.

This was hardly evident to the general public, however, nor even for that matter to critics or museums. Critics referred to their art as ''Schmeerkunst''; Pollock was sufficiently notorious to attract attention as ''Jack the Dripper'' in the mass magazines; and the museums, by and large, retained their double standard–abstract for European art and ''realistic'' for American. The situation became so desperate in fact that in 1951 a group of artists including Pollock, Kline, Motherwell, de Kooning, Tworkov, and Marca-Relli were forced, like the Eight nearly half a century before them, to organize

their own exhibition, which they called the "Ninth Street show" because it was held in one of the store-front galleries on East Ninth Street.

If the first phase of Abstract Expressionism was its psychological, mythic and biomorphic phase, with its roots in the Surrealist interest in the unconscious as the locus for the most profound and universal content, then this phase may be seen as terminating in Gorky's last paintings and in de Kooning's brilliant series of black and white paintings (which set the fashion for the many dramatic black and white paintings of the period) done in the late forties. The ultimate and perhaps finest statement of the biomorphic exists in de Kooning's astonishingly complex and sophisticated master-piece of 1950, *Excavation*, a painting whose title seems to refer to the constant process of tearing down and rebuilding that characterizes Manhattan's distressed urban landscape.

In *Excavation*, de Kooning uses line to create a series of interlocking organic shapes, which often interpenetrate as well to share a common contour. By this time, rapidity of execution was an important part of de Kooning's style and expression; his whiplash-like line, now thick, now thin, now blotted, now erased altogether, weaves in and out, appearing and disappearing with mischievous agility. Spatial ambiguity as well as ambiguity of content is heightened to its utmost. Not only are we confused by the double image of a flesh-colored field of hills and valleys, referring equally to figure and landscape, but also the darting and skipping line does not create any entirely legible or closed contours either. Consequently, the loosely biomorphic shapes collide and flow into one another, creating a spatial organization that establishes neither a continuous nor precisely a discontinuous surface. This ambiguity of course was much desired and cultivated by de Kooning, who suggested that he wished to create a pictorial space that, in its slipping planes, lack of fixedness or recognizable referents, would be an analogy for the rootlessness and sense of disorientation of what he termed the contemporary "no environment." A deracinated immigrant, like a number of the other Abstract Expressionists who were born in Europe, living in a city in a constant state of crisis during and after a war which had overturned any semblance of world order, de Kooning was especially responsive to this sense of disorientation shared by many in mid-century America as well as elsewhere in the modern world.

In de Kooning's ultimate paintings in the biomorphic manner, fragments of the human anatomy –an eye, a mouth, or forms that suggest anatomical parts generally–are sandwiched into the densely packed shallow space he creates by means of line and value modulations. These detached anatomical fragments, the mark of a figure art totally out of context in a landscape image, are to be found in a similarly telescoped fashion in Pollock's, Gorky's, Rothko's and Gottlieb's paintings of the forties. Not only a Surrealist compression of metaphor, but the ending of a long development in painting brought about this strange superimposition of two genres that were formally distinct separate specialities in themselves. In a sense the projection of these fragments of the human figure into landscape contexts, which occurs also in Motherwell's elegies, might be seen as evidence of a telescoping process coming at the end of a great tradition of painting when the drive toward reduction and purification creates at the same time an unavoidable compression.

That tradition, of course, is the tradition of painterly painting initiated by the Venetians in the sixteenth century. The ensuing split between the linear and the painterly, outlined by Heinrich Wölfflin in *The Principles of Art History*, which began with the polarization of artists into partisans of Poussin (the linear classicist) and Rubens (the master of baroque painterliness), divided the art world again in the Ingres vs. Delacroix controversy that raged for most of the nineteenth century. The relationship of drawing to painting, or line to color, is one of the crucial questions that painters attempted to resolve in a number of radical ways in the forties in New York. Gorky's solution was virtually to disengage line from color, using the latter as autonomous patching and shading. To an extent de Kooning followed his example. And even those painters who did not use line as shape-defining coutour, like Baziotes and Gottlieb, for example, created flat forms whose contours produced a legible edge, which could in some respects be considered "drawing."

Eventually, however, Pollock arrived at a way of absolutely marrying the linear to the painterly by drawing in paint. Moreover, this painterly drawing–prepared for by the hundreds if not thousands

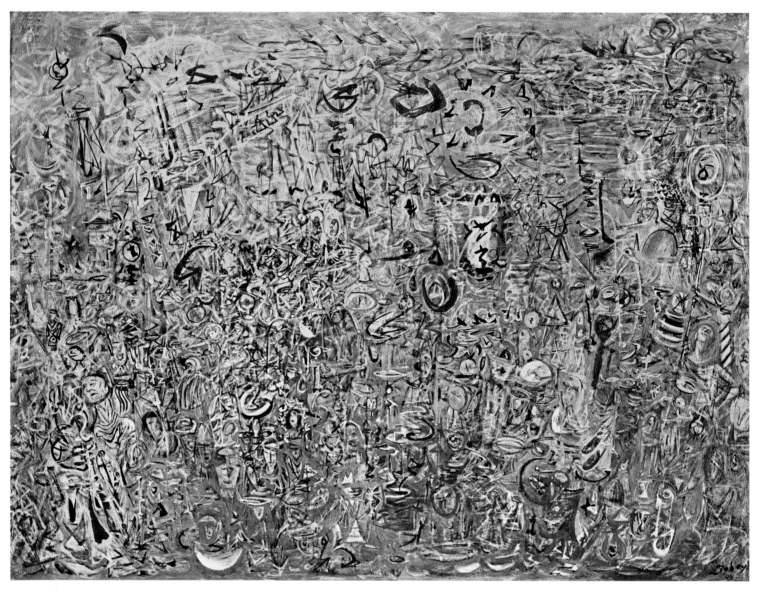

Mark Tobey (1890-1976). Pacific Transition, 1943. $(23^1/_4 \times 31^1/_4'')$
Courtesy of City Art Museum, St. Louis, Missouri. Gift of Joseph Pulitzer, Jr.

of pen and ink sketches he created throughout the late thirties and early forties–was executed in an automatic technique which allowed an even greater freedom of gesture than the freest painters in Western art had ever achieved. Others beside Pollock, including Gorky and Hofmann, probably under the influence of the "automatic" Surrealists, had allowed paint to run and drip in their paintings of the early forties. But beginning in small works done late in 1946, Pollock systematically used dripping from a stick or brush as an exclusively automatic technique throughout the work. In the paintings of 1947-1951, among which are Pollock's greatest masterpieces, the exclusive use of the drip technique creates a homogeneous surface, a fabric of densely woven and interwoven irregularly rising and falling loops and nets of paint. Because painting and drawing are compressed into a single technique by means of the overtly painterly quality of the dripped line, there is no discontinuity between the two, as there is in all painting, to a greater or lesser extent, before Pollock's. The resolution of the opposition between painting and drawing, like the compression and telescoping of landscape and figure into a single genre, is again indicative of a climactic moment in the history of

Western painting. This was the moment in which painting attempted to reduce itself to essentials, to distill its own essence—a process initiated by the early modernists such as Kandinsky and Mondrian and still being carried on by painters working today.

By marrying painting and drawing in an automatic technique that did not record the small intimate maneuvers of the hand, but the big physical gestures of the wrist and arm, Pollock "broke the ice" for his colleagues, as de Kooning put it. If the biomorphic phase based largely on Surrealist precedents had been the first chapter in Abstract Expressionism, then Pollock's drip paintings of the late forties inaugurated a second phase, which Harold Rosenberg christened "action painting" because of its emphasis on gesture and its record as the principal expression and emotion bearing element in painting.

Behind Rosenberg's formulation of the aesthetic of "action painting," which was apparently pieced together from talk at the Cedar Bar, the artists' meeting place, are notions drawn from currently fashionable existentialist thought as well as certain Dada notions concerning the relation of art and life. Such vaguely formulated existentialist metaphors did indeed influence many American painters after the war as the ideas of Camus and Sartre filtered into New York. At the Artist's Club on East Eighth Street, organized as a forum for aesthetic discussions late in 1949, painters spoke of deliberately leaving their works looking unfinished, so that the painting would appear in a transient state of "becoming," rather than in a final fixed state of absolute definition, which to them meant sterility and deadness.

Many New York painters felt that Pollock's drip paintings, with their automatic "handwriting" permitting rapid execution and their emphasis on physical gesture, their fluid space, lack of closed shapes or exclusively linear elements of conventional drawing, represented a way of transcending and superseding the restricting canons of Cubist space and structure. Especially important was

Bradley Walker Tomlin (1899-1953). Number 9: In Praise of Gertrude Stein, 1950. (49 × 102¹/₄'')
Collection, The Museum of Modern Art, New York. Gift of Mrs. John D. Rockefeller, 3rd.

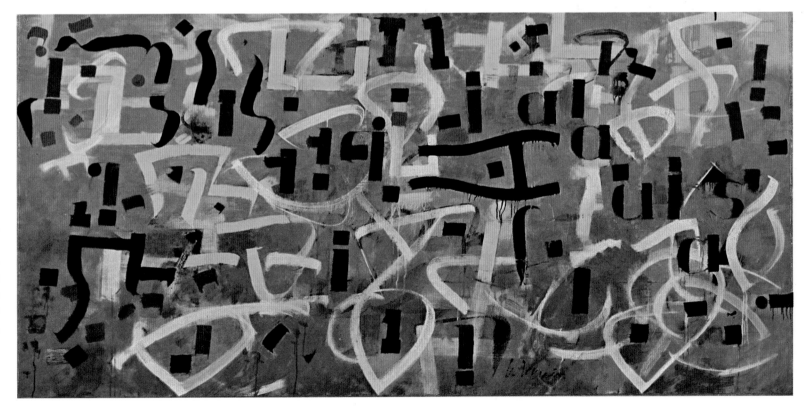

Pollock's new manner of composing, which became known as the "all-over" style. Before Pollock created his drip paintings, the Pacific Northwest painter Mark Tobey, like Morris Graves a devotee of Eastern mysticism, had created a densely meshed all-over image. But the smallness of scale of Tobey's "white writing" paintings, the purely graphic quality of his line, and the presence of anecdotal details meant that Tobey's paintings, although they might represent a moving personal statement, could never revolutionize art history as Pollock's drip paintings would.

Misunderstanding the concept of all-overness, many artists and critics saw Pollock's compositions as nothing more than "apocalyptic wallpaper," a phrase used by Rosenberg in his historic essay on action painting. In actual fact, although Pollock's "all-over" style had certain things in common with purely decorative art such as Islamic tile work, which repeats the same pattern *ad infinitum* and without variation, his drip paintings are great precisely because of their fantastic degree of variation–of form, of contour, of rhythm and pressure. They are "all-over" only in that Pollock creates a homogeneous surface, without a single climax, every part of the canvas receiving equal emphasis. Pollock's intention in creating an all-over style was to diffuse any notion of focus or pictorial climax, forcing the eye to constantly travel and retravel labyrinthine paths of his intertwining nets and skeins of paint. In creating an all-over style, Pollock had two precedents: the openness and opticality of Matisse's paintings like the *Blue Window*, and the atomized post-Impressionism and large mural scale of Monet's late paintings of waterlilies. Fortunately, he could see these works in the Museum of Modern Art, where the superb collection assembled by Alfred Barr served as an inspiration to the generations of New York painters who went there to study and to learn what they could not acquire from their own native tradition.

Thus Pollock united in perhaps the most complex–in the sense of the number of diverse elements it assimilated and reconciled–style of the century, the cohesiveness and denseness of pictorial incident of analytic Cubism with the openness and visual opulence of post-Impressionism. Others had explored one or the other of these elements; for example, Richard Pousette-Dart, in a series of paintings of enlarged pointillist dots assertively applied with heavy impasto, drew heavily on Monet, as did Milton Resnick later. By the same token, de Kooning's fragmented paintings done around 1950, such as *Excavation*, recapitulate the space and structuring of analytic Cubism in a larger format and a more painterly technique. That Pollock was able to unite these two great modernist traditions, marrying the structural integrity of Cubism with the purely "optical" and painterly art of post-Impressionism, testifies to his genius not only as an innovator, but as a synthesizer

Pollock's drip paintings were significant in other respects, too. They established a new scale for American painting which was closer to the mural scale of older decorative art than to the more intimate scale of easel painting. Pollock's first large-scale work was a nearly 20-foot long mural commissioned by Peggy Guggenheim for her gallery entrance (it is now at the University of Iowa) which was painted in 1943. By 1950, Clyfford Still, Barnett Newman and Mark Rothko had all produced very large paintings. The size of these paintings in itself would not be exceptional; but in their work, as opposed to big paintings in earlier art, large size was coupled with a single image that could be read at a glance, and hence seemed to dominate the viewer with its imposing simplicity and wholeness. For this reason these large paintings by Pollock, Still, Rothko and Newman did not provoke the anecdotal "reading" required by the big paintings like the historical "machines" of the past; rather their immediate effect was like the overwhelming impact of Romanesque frescoes, which also dominated the viewer with their impressive grandeur and spiritual force. Although Motherwell and Kline, too, painted large pictures in the fifties, many Abstract Expressionists such as de Kooning and Guston stayed well within the bounds of easel painting. In the sixties, a size both physically larger and a scale that proclaimed itself, because of the lack of internal relationships within the painting, as grander than that of Abstract Expressionism even was adopted by color painters such as Noland, Stella and Olitski. These painters followed Pollock's example of creating a pictorial field larger than the field of vision; other artists, such as Allan Kaprow and pop sculptor George Segal saw Pollock's paintings as constituting visual environments, as if they physically surrounded the viewer, and began creating literal environments.

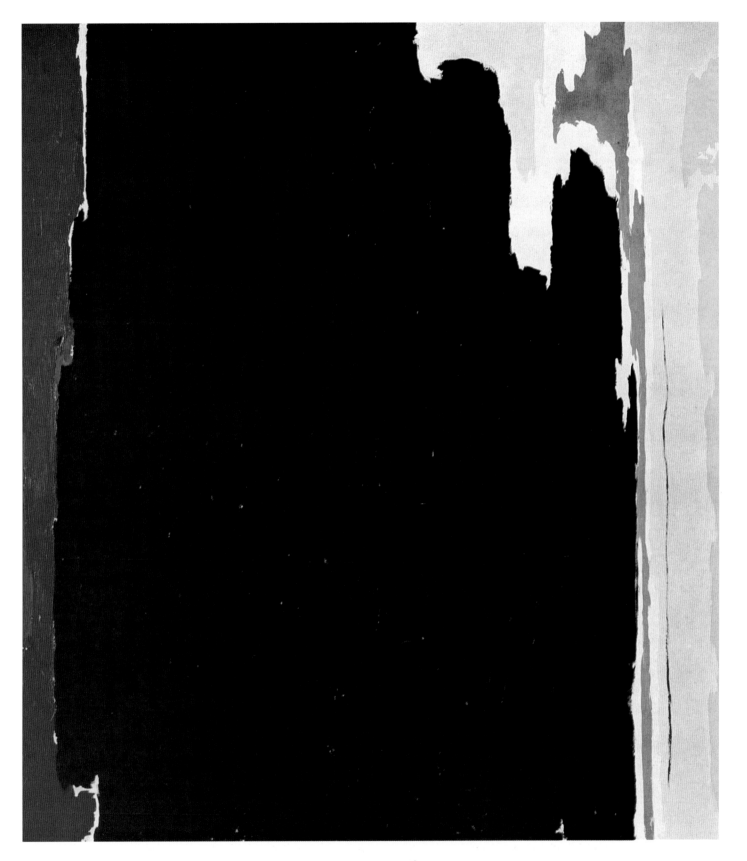

Clyfford Still (1904). Painting, 1951. ($93^1/_4 \times 75^3/_4$")
From the Collection of The Detroit Institute of Art, Detroit, Michigan.

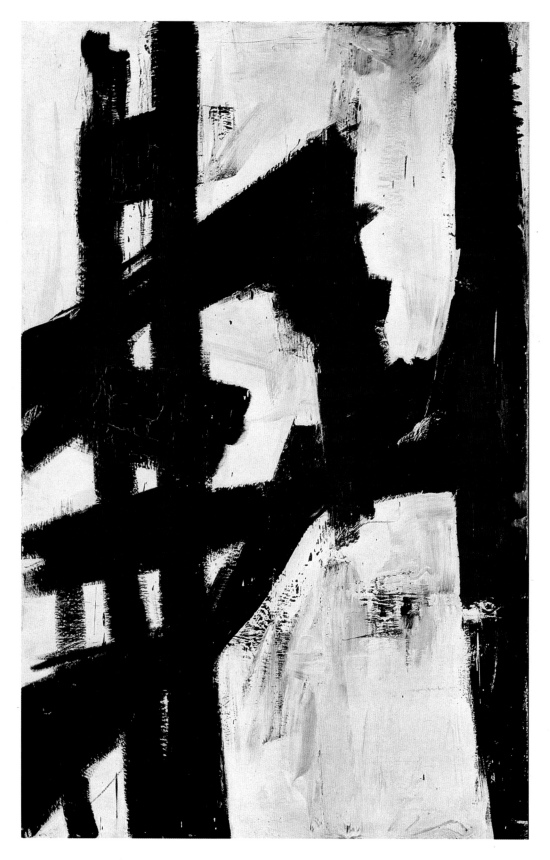

Franz Kline (1910-1962). New York, 1953. (79 × 50$\frac{1}{2}$'')
Albright-Knox Art Gallery, Buffalo, New York. Gift of Seymour H. Knox.

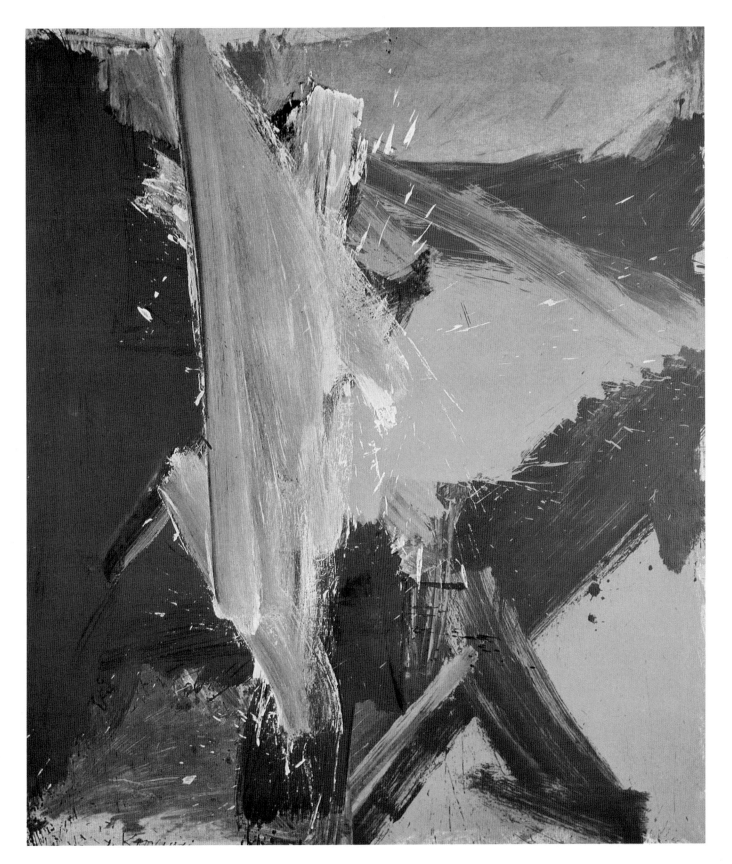

Willem de Kooning (1904). Merritt Parkway, 1959. (89³/₄ × 80³/₈″)
Collection of Mr. and Mrs. Ira Haupt, New Jersey.

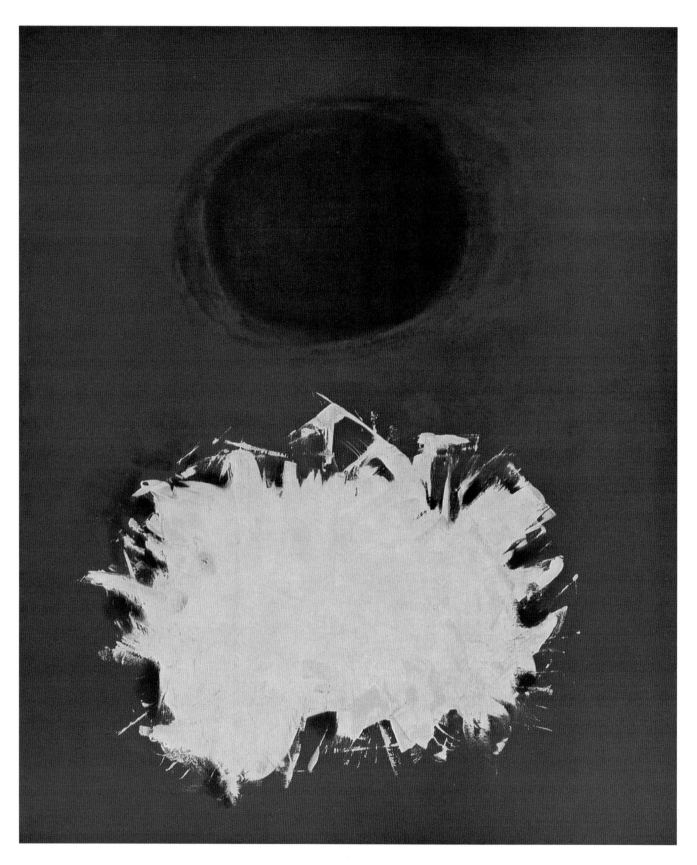

Adolph Gottlieb (1903-1974). Pink Smash, 1959. (108 × 90″)
Estate of the Artist.

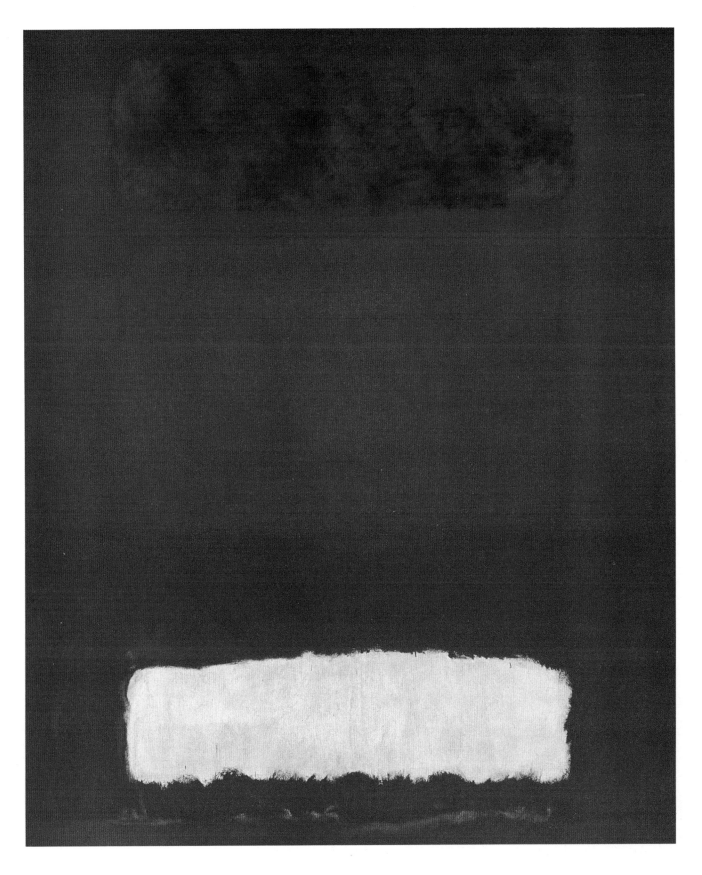

Mark Rothko (1903-1970). Red, White and Brown, 1957. (99$^1/_2$ × 81$^3/_4$'')
Öffentliche Kunstsammlung, Basel, Switzerland.

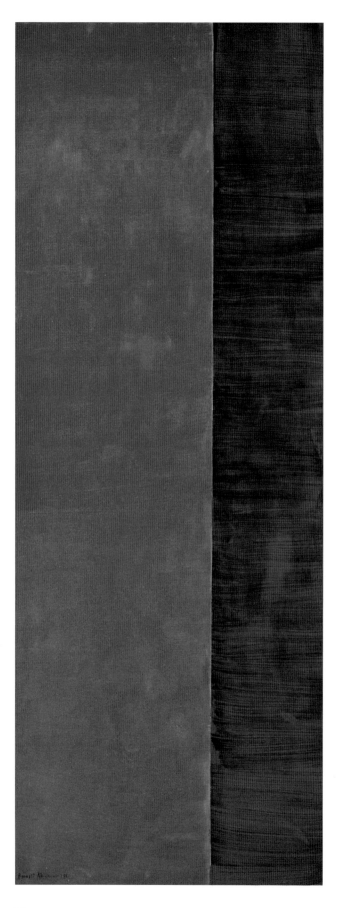

The other painter who came almost as close as Pollock to effacing any remaining disjunction between the linear and the painterly was Clyfford Still. Like Pollock, Still was an idiosyncratic if not actually eccentric individualist from America's heartland who mastered the technical aspects of painting with difficulty. Like Pollock, too, Still was able to turn this awkwardness into a positive factor, and to create an image of extreme intensity and originality. During the forties, Still lathered on thick passages of pigment, probably with a palette knife, which created a richly encrusted surface, as flat and opaque as a wall. Still's shapes, with their irregular flame-like edges biting into the adjoining ground, because they did not appear as shapes *against* a background, but as a continuous surface, from which figure could not be separated from ground, affirmed the flat two-dimensionality of the canvas in a particularly convincing manner. That it was important for painting to affirm its actual identity, as opposed to attempting to create a sculptural illusionism, no matter how great the degree of optical illusionism it might set up, became one of the central tenets of American painting of the sixties.

But to discuss merely the formal implications of Still's contribution is to overlook the most obviously compelling aspect of his work: the sheer torrential power of his primordial landscape imagery, with its cruel aggressive forms hacked and clawed from their surroundings. Indeed, the harsh execution of Still's work represents a kind of conquest of spirit over matter through the intense struggle to create form from chaos.

Although they are the very opposite of Still's seething, violent images, Rothko's aloof, tranquil rectangles share one characteristic with Still's work; they, too, refuse to set up conventional figure-ground relationships, their hazy, indistinct and soft contours bleeding and melting into their atmospheric environment, seeming to float contiguously with their surroundings rather than be isolated against a background behind them.

By 1950, when Bradley Walker Tomlin, Franz Kline and Philip Guston abandoned representation to join the swelling ranks of abstract artists, certain principles were established for advanced art: these were large scale, a single image, open form, and ''all-over'' composition. Once the all-over had been established as

Barnett Newman (1905-1970). Ulysses, 1952. (132 × 50'')
Collection Jaime del Amo, Los Angeles, California.

canonical, it was but one step to altogether eliminate internal relationship within the painting, the primary formal element in Cubist composition, which Mondrian maintained was the heart of painting. This was accomplished by Barnett Newman around 1950.

Newman's "non-relational" composition, in which a single image was oriented with regard not to other shapes but to the framing edge, may be seen as inaugurating the third and final phase of Abstract Expressionism. This phase overlapped with "action painting," but survived it in the sixties when gestural abstraction had been abandoned by every major painter except de Kooning. This final development of Abstract Expressionism has been termed color-field painting or chromatic abstraction to differentiate its emphasis on color from action painting's emphasis on surface and gesture. Turning its back on Surrealism, color-field painting made an uneasy truce with the geometric tradition.

Newman's "non-relational" composition in which a field was divided rather than having forms silhouetted on it or against it was radical in several respects. Although there were no internal relationships in Pollock's drip paintings, Pollock's web was constructed like the grid of analytic Cubism, so that pictorial incident was concentrated at the center and faded out at the edges. Newman, on the other hand, following the precedent of Monet, Matisse and Miró, carried color evenly throughout the painting, creating a field of color coextensive with the whole of the pictorial field.

The relationship of chromatic abstraction to action painting or gestural abstraction is complex. Where de Kooning, Kline and the other gestural abstractionists were still closely allied to Cubism in their reliance on value contrasts and internal relationships, Rothko, Newman and Reinhardt dealt solely with contrasts of hue, and were principally interested, not in a dynamic image evocative of speed, movement and flux, but in a static monumental icon inducive of contemplation. Gottlieb's main interest, on the other hand, was in creating unusual color relationships and a high style of pictorial decoration. Because theirs was a highly disciplined art, Gottlieb's, Rothko's, and Newman's color relationships were highly structured. Gottlieb's image was distilled from his earlier pictographs. Instead of the multiple symbols caged in compartments, Gottlieb chose two of his most charged symbols–a solar disk and a whirling burst of undifferentiated matter that might stand for the earth. Gradually, these forms were simplified still further until their symbolic value became subservient to their purely formal role.

Praising the value of a few large simple shapes, Rothko began to confine himself solely to rectangles, which, like Newman's bands, echoed the framing edge with relentless logic. Yet a romantic lyricism, not cold logic, is the basis of Rothko's statement. The halations caused by the subtle vibration of his edges where adjacent colors touch give the appearance of actually radiating light. And indeed, Rothko's is a literally radiant image.

The lack of internal relationships resulting from a single image being related, not to other analogous shapes on a field in the manner of Cubist "rhyming," but exclusively to the framing edge is a feature of chromatic abstraction carried over into the best painting of the sixties. As a structural principle, it is first noticeable in the pared-down banded paintings Barnett Newman exhibited at the Betty Parsons gallery in 1950. In the same manner, Newman's show at French & Co. in 1959 was a revelation for many young painters, like Larry Poons, who were forcibly impressed with the sheer optical brilliance of his vaporous fields of luxuriant color.

By the time of Newman's exhibition at French & Co., where the influential critic Clement Greenberg as director also organized shows of works of Gottlieb, Dzubas, Olitski, Noland and Louis, there was already revolt germinating among younger painters against the excesses of action painting, which they felt was pictorially as well as emotively exhausted. Although downtown in the cramped store-front galleries on East Tenth Street, second-generation Abstract Expressionists imitated de Kooning's impastoed surfaces and broad gestures, there were significant signs of a change in taste. The 1959-1960 French & Co. exhibitions organized by Greenberg, who had praised de Kooning in the early fifties only to damn his Tenth Street imitators later, and the Museum of Modern Art's "Sixteen Americans" held in 1959, which included Rauschenberg, Johns and Stella, raised the curtain on a new chapter of American art, just as Tenth Street closed an episode that was fast becoming history.

Roy Lichtenstein (1923). Okay, Hot Shot, Okay, 1963. (80 × 68″)
Collection R. Morone, Turin, Italy.

THE SIXTIES

On first appearance, Abstract Expressionism, like any genuinely innovative style, appeared to break with the past in a radical manner. Soon, however, it was clear that as art it was firmly rooted within a tradition. Yet that tradition was largely European. Consequently, the assimilation by its practitioners of the aesthetic of modernism–of the entire body of theory, forms and technique developed primarily by the French avant-garde from Manet to Picasso and Matisse–meant the suppression of a great deal that was central to the American tradition.

Unlike the European tradition, American art had no classical roots, for the Greeks and Romans had never been to America. In the main American art had been neither monumental nor decorative, but fundamentally popular and realistic, in keeping with the demands of democratic taste. Despite the primary debt of the Abstract Expressionists to European art, however, they managed to preserve, if not the naive forms of earlier American art, at least many of its unique and compelling qualities of expression. These included boldness of imagery, directness of technique, stress on the material physicality of medium and surface, and candor of statement.

Nonetheless, certain elements in American taste were necessarily submerged for the two decades during which Abstract Expressionism dominated American painting. These were the puritanical asceticism that had produced a strict inhibited style like Precisionism, the love of the bizarre and the fantastic that had created the topsy-turvy world of Magic Realism, as well as the delight in storytelling detail and democratic genre that brought American Scene painting and a photographic realist like Andrew Wyeth to the pinnacles of popularity. Such native tastes and preferences, not to say deep-rooted national needs, were to receive fresh expression in pop art (and its San Francisco offshoot "funk") and in minimal art.

Pop and minimal were two of the most important of the multiple styles of American art of the sixties. The third, in the eyes of many critics by far the most significant style to develop after Abstract Expressionism, was color abstraction. Baptized "post-painterly abstraction" by its foremost defender, Clement Greenberg, color painting has carried on the long tradition of "optical" or retinal art that has its roots in the bright-hued palette of neo-Impressionism, Fauvism, and orphic Cubism.

A continuation of the European tradition of a color-light art, itself descended from Venetian colorism, post-painterly abstraction (so called by Greenberg to distinguish it from the painterliness of Abstract Expressionism) was not, however, like the vogue for "op" art that gained publicity in the

early sixties, merely an extension of Bauhaus theories of color and design. It is true that the work of Noland, Stella, and Kelly, to name three of the most important American abstract artists in the sixties, had certain obvious links to the earlier tradition of geometric formalism. Their work, however, was decisively post-Cubist in its rejection of internal relationships of shapes depicted against a background, which was the basis of Cubist design.

A comparison of Noland's circles and Stella's tondos with Delaunay's disks quickly reveals two significant and crucial changes: the palette of Noland and Stella is extended far beyond the limits of the conventional palette of Delaunay, and their shapes are related, not internally to one another, but only as a central image is related to the frame. This *gestalt* or wholistic feature of their work, a central element in American painting in the sixties, makes it more precise to speak of pictorial structure, based on an indivisible wholeness, rather than of composition in the traditional sense. A similar comparison of Kelly's painting with neo-Plastic color and design would reveal that he deviates from his sources in exactly the same manner that Noland and Stella reject Cubism. Indeed, Noland's highly personal, intuitive use of color, Stella's arbitrary, irrational geometry, and Kelly's insistence on reality as a point of departure for his forms, which until recently were always abstracted from real objects or nature, reveal that any notion of classicism one might be tempted to associate with their work is contradicted by their subjective and individual uses of geometry, which have romantic, expressionist, or realist overtones. In addition, the development in the sixties of new types of pigments including transparent water soluble plastic-base paints of great brilliance, "dayglo" colors with fluorescent properties and metallic pigments that reflect light, widely used by artists like Noland, Stella and Kelly, clearly differentiates American abstract works of the sixties from earlier geometric styles as much as their large scale, a legacy of Abstract Expressionism.

Thus the re-emergence of geometric abstraction in America in the sixties occurred in a form decisively altered by certain technical developments and above all, by the experience of Abstract Expressionism, with its emphasis on the intuitive and the subjective. This was prophesied by Barnett Newman in his painting ironically titled *The Death of Euclid*, in which he symbolically killed off the father of geometry. Because Newman, Rothko, Motherwell, and Still were able to create highly structured works independent of geometry, American painters of succeeding generations were afforded many new options not open to earlier abstract artists.

In several respects the decade of the sixties was unlike any previous period in American art. First of all, many of the most decisive innovations were made by very young artists. Helen Frankenthaler, Jasper Johns and Frank Stella were all in their early twenties when they created some of their most inspired and radical works. This was possible because they did not have to spend a lifetime learning how to paint. They could look around them in New York and learn from the achievement of their elders. The new level of technical competence of American painting in the sixties resulted in the production of many more tasteful, well-made, intelligent works than were ever previously produced in America, or perhaps anywhere else in the world. But real originality was as rare, if not rarer, than it had ever been, although the ranks of painters and art lovers began to swell at an alarming rate.

During the sixties, the New York art world expanded to spill over into the universities and the mass media. President Johnson invited artists to the White House—an unprecedented honor for an American artist, whom John Sloan had likened to the unwanted cockroach in the frontier kitchen. Dealers, curators, critics, writers and collectors engaged in a frantic round of activity, while bewildered artists tried to adjust to the new situation in which Americans had at last begun to identify culture with salvation.

This millenium so eagerly awaited by Henri and Stieglitz, as they pursued their lonely missions early in the century, unfortunately did not produce the spiritual conversion they desired; it did, however, touch off a wave of speculation that continues to keep the American art world spinning at a dizzying rate. Some artists have reacted to society's embrace with hostility and withdrawal; others keep upping the ante, making larger and larger works, harder and harder to accommodate in existing architectural contexts. These decorative monumental paintings appear to demand the possibility for a genuinely mural expression heretofore unavailable to the modern artist, who has never

before contemplated the rapprochement between art and society that now seems open to contemporary American artists. Still others, like Andy Warhol, the self-styled sacred prostitute of the art world, have passively accepted the attention of the public and the media, allowing themselves to be consumed by it if need be.

Unlike the forties and fifties, when a style with more or less uniform aesthetic premises–despite the degree of individual interpretation it might receive–was the single repository of all avant-garde impulses, the sixties saw warring factions compete. Sometimes the competition was not so polite for the banner of vanguardism, already slightly bedraggled by the struggle of artists to create an art sufficiently extreme so as not to be immediately assimilable by the shock-proof middle class and the sensation hungry mass media. Acceptance by the media of the best (as well as the worst) of contemporary art rang down the curtain on the century-long opposition of the avant-garde to the established values of the Academy and bourgeois society. One hundred years after Courbet successfully flaunted Academy authority by opening his own Pavillon du Réalisme, Jackson Pollock's death in a violent auto accident established a world market for avant-garde art that today is being collected and consumed as fast as it is being created.

Whether the enormous influx of money, often in the form of investment speculation tied to the vicissitudes of the American economy, has had the desired effect predicted earlier in the century by Dana of producing an American Renaissance is the source of considerable debate. One thing, however, is certain: the history of world art in the second half of the twentieth century bears an unmistakably American stamp. The force, impact and power of contemporary art, its search for increasingly direct and candid means of expression, its pragmatic attitudes and techniques, its emphasis on immediacy and its frequent commerce with violence, either of imagery or content, reflect the dominance of values familiar to students of American history and culture.

In the sixties, American art, so long the plain provincial country cousin of world art, has become its glamorous and sought-after Cinderella. Sophisticated, colorful, ambitious, secure in its recognition and achievements, American painting today has taken its place as one of the outstanding creations of modern civilization.

Although the activity of younger American painters like Frank Stella, Roy Lichtenstein, Larry Zox, Darby Bannard, Larry Poons, Edward Avedesian was at first seen only as a rejection of Abstract Expressionism, it is clear now that the continued quality of American art in the sixties depends first and foremost on a reformulation and extension of the premises of Abstract Expressionism, rather than on the total reversal that their stringent reductiveness or blatant pop and hard-edged imagery originally seemed.

Yet there is no doubt that, around 1960, there was a widespread revolution in taste, not to say aesthetic standards in New York. One of the first indications that such a reversal of taste was taking place was that the reputations of followers of de Kooning and Kline, the so-called second-generation action painters, were beginning to decline, while the severe "minimal" art of Ad Reinhardt, the "black monk" and *advocatus diaboli* of Abstract Expressionism, was winning new respect among young artists, who agreed with Reinhardt that the more apocalyptic pronouncements of the "heroic" generation and its literary apologists were a lot of hot air. Refusing to espouse what Reinhardt had mockingly described as "divine madness among third generation Abstract Expressionists," many young artists found Reinhardt's clarity a refreshing antidote to the muddled romanticism of late Abstract Expressionism, especially in its anti-intellectual Tenth Street phase.

Many features in Reinhardt's work link him, despite his role in all of the history-making events of the Abstract Expressionists, to the art of the sixties, rather than to that of his own generation. He was always a conceptual rather than an improvisational painter, and the only member of the New York School to begin and end his career as an abstract artist. The youngest member of the American Abstract Artists in the thirties, Reinhardt began his career as an admirer of Stuart Davis. In the forties he gave up his jagged geometric planes for atmospheric paintings filled with delicate calligraphic elements, reminiscent of misty Chinese landscapes. Tracery-like particles suspended in a shallow space were in turn renounced in the early fifties for a more structural method of composing, in which

rectangles were locked together in a compact architectonic unity. These early compositions of meshed rectangles were painted in closely-keyed harmonies of first the red and then the blue scale.

Ultimately, Reinhardt rejected color itself as a purely decorative element. In the view of a moralist like Reinhardt, who insisted above all on the ethical content of art–like the original puritans who rejected the purely visual as merely hedonistic display–decorative painting was just another form of self-indulgence, too easy to like to be good. With this attitude, Reinhardt began in 1953 to paint black paintings that were virtually monochromatic. Matte-surfaced and recessed behind a black frame, these quiet works, with their light absorbing as opposed to light reflecting surfaces, seemed literally to retire in the presence of the viewer, requiring some special effort to make out their faintly discernible cruciform image at all.

Like the recent pearlescent disks of the California abstractionist Robert Irwin, and the diaphanous curtains of melting color of Jules Olitski, Reinhardt's black paintings appear to change as the viewer perceives them, their central image emerging from darkness only gradually, as the images of an Irwin and an Olitski also take time to bring fully into focus. The main emphasis of these three artists who in the sixties have made of the monochrome or near monochrome painting an experience of extreme subtlety, has been on the nuance of perceptual differentiation as opposed to the sharp contrasts and instantaneous impact of geometric art. In opposition to older art, their works look relatively devoid of pictorial incident, as does much of American abstraction in the sixties, since composition has become subservient to a color and light experience.

Reinhardt's reductive form and color anticipated minimal art, while his practice of working in series, a feature of Albers' attitude toward form also, became standard procedure in the sixties, as abstract art became increasingly self-conscious and concerned with articulating and solving a given set of formal problems. Other aspects of Reinhardt's work, however, are clearly related to Abstract Expressionism. Its barely disguised romanticism, its explicitly human scale and adherence to easel painting conventions make it clear that Reinhardt's painting is linked to that of his contemporaries. On the other hand, a crucial similarity with the art of the sixties that could be singled out is Reinhardt's creation of an image that is *literally* as opposed to illusionistically located behind the frame.

Reinhardt's reputation as a minimalist *avant la lettre* rose at the same time that pop art exploded, that is, around 1960. The first of the new styles to emerge, pop had been brewing longer and became public more rapidly and easily than any abstract style because it was immediately appealing to a mass public which found Abstract Expressionism unintelligible. Brash, audacious, jazzy, and best of all, familiar, pop brought art to a large public mystified by the aloofness and hermeticism of abstract painting. What the general public did not realize, however, was that pop art had the same sources and many of the same formal premises as abstract painting. For example, Lichtenstein's stylized comic strip and advertising images, their enlarged Ben Day dots looking like a Seurat under a microscope, barely masked the relationship of his work to Léger's machine forms and flat, hard-edged style.

Similarly, Rosenquist's past as a billboard painter was not as important for his art as Magritte's strange juxtapositions of images and creamy paint surfaces, or the space and composition of Cubist collage, which he imitates in the maquettes for such large and iconographically complex works as *Horse Blinders*. When these sketches, actually collages of magazine illustrations pasted together to create maximum space and scale discontinuities, are blown up as paintings, such discontinuities appear all the more bizarre and disquieting. By the same token, Warhol's career as a commercial illustrator was not nearly as decisive for his all-over images of soup cans and brightly colored flowers as Pollock's all-over style, which Warhol mistakenly or perhaps in deliberate irony interpreted as being literally all-over. Nor was commercial art as much a precedent for his colors and shapes as Gottlieb's cosmetic tinted bursts. Although their imagery overtly referred to popular culture, the works of the pop painters were as much art made out of art as the most self-conscious purely formal arrangement. Nevertheless, in the context of the lofty moral tone of Abstract Expressionism, the return of pop artists to representation was shocking, if not horrifying, to many artists and critics of the older generation. Instead of attempting to redeem the entire Greco-Roman, Judeo-Christian heritage, which the Abstract Expressionists often seemed to be attempting, the pop artists were

Robert Rauschenberg (1925). Charlene, 1954. ($88^1/_2 \times 126''$)
Stedelijk Museum, Amsterdam, Holland.

painting Coke bottles, movie stars and soup cans, the icons of an entirely secular and materialistic culture. The irony of this mirror-image of the nightmare that the American Dream had become, in an age of rampant commercial exploitation and affluence, escaped most of the nouveau-riche collectors who rejoiced in owning the art that mocked them. But then, neither did Charles IV and his court realize what Goya was doing to their likenesses. Certainly Warhol's grotesque portraits of his patrons, playing up every feature of their vacuous narcissism, his grotesquely made-up Marilyn Monroe and tearful Jackie Kennedy will stand as an indictment of American society in the sixties as scathing as Goya's merciless portraits of the Spanish court.

Although pop art had its greatest success in America, originally it was an English phenomenon named and promoted by the critic Lawrence Alloway, who had been associated with the pop culture oriented Independent Group in London in the fifties. Perhaps because they had never suffered from the cultural inferiority complex that plagued Americans, English artists and critics embraced American pop culture long before it was fashionable in the States to consider film as art or to discourse at length on the meaning of ''camp.''

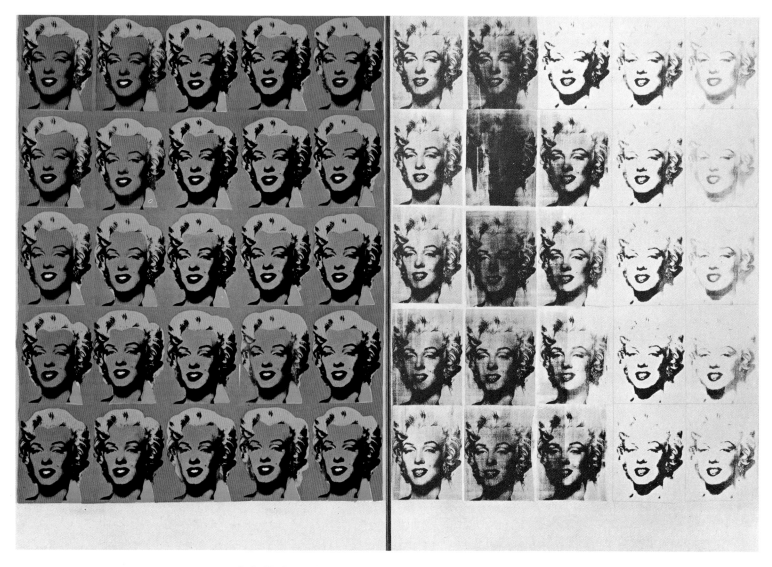

Andy Warhol (1925). Marilyn Monroe, 1962. (Two panels, 82 × 114")
Collection of Mr. and Mrs. Burton Tremaine, Meriden, Connecticut.

Of course the painting of common objects had a long history in America, too. In the late nineteenth century, the *trompe-l'œil* still-life painters Peto and Harnett made strict formal arrangements of banal items. In the twenties, Stuart Davis copied the labels from commercial products like "Odol," and Gerald Murphy made simplified, stylized still lifes as clear and matter of fact as poster images. In the fifties, de Kooning had cut the "T-Zone" out of a Camel cigarette ad and pasted it on a grimacing, leering woman who seemed to epitomize the awful vulgarity and sexual travesty of the pin-up. And de Kooning, not Andy Warhol, first painted Marilyn Monroe.

In the fifties both Larry Rivers and Robert Rauschenberg had used images from popular culture, Rauschenberg clipping news items that recorded daily life and Rivers plumbing American history for themes like "Washington Crossing the Delaware." But the single painting that set off the greatest response, among artists and public alike, was Jasper Johns' American flag, painted in 1955 and first exhibited in 1958. Although Johns had also painted the comic strip Alley Oop in the late fifties, the sudden explosion of comic strip imagery in the work of Lichtenstein, Warhol and others seems independent of the Johns work, which was not shown publicly. What all had in common, however, was

the turn to discredited sources for imagery, yet another repetition of the search for freshness in "low" art and genre, when high art lapses into mannerism.

Although Clement Greenberg quickly relegated it to the never-never land of the "history of taste," pop art has already had a number of important consequences. It breathed new life into American art in the form of lively images at a period when Abstract Expressionism had lost its driving force. Pop brought closer the rapprochement between art and society, ending the split between the two embodied in avant-garde alienation, at least in a social and economic sense. Those who feel that art cannot retain its critical stance or purity without this alienation from society find this development appalling; others welcome the return of patronage and critical and institutional approval it has brought.

Perhaps the greatest boon of pop art was to critics, who had something to talk about again, and to art historians, happy to return to tracing familiar motifs after the vagaries of Abstract Expressionism, which to most academics, with the exception of Meyer Schapiro, one of its early defenders, was both formless and meaningless. It was Schapiro also who had first pointed out that Courbet and other important nineteenth century artists had drawn on popular sources for new subjects and as models for their simplifications of form. Acquaintance with this precedent in the early history of modernism quickly revealed that pop was only recapitulating the manner in which the first modernists had found popular imagery a fresh antidote to the staleness of academicism. This is not to say that Abstract Expressionism was dead in quite the way neo-classicism had died in the middle of the last century, but merely that it had become too familiar, and for one group of artists at least, simply too remote from life and the concerns of most people.

James Rosenquist (1933). Horse Blinders (fragment), 1968-1969. (Height, 120")
Ludwig Museum, Cologne, West Germany.

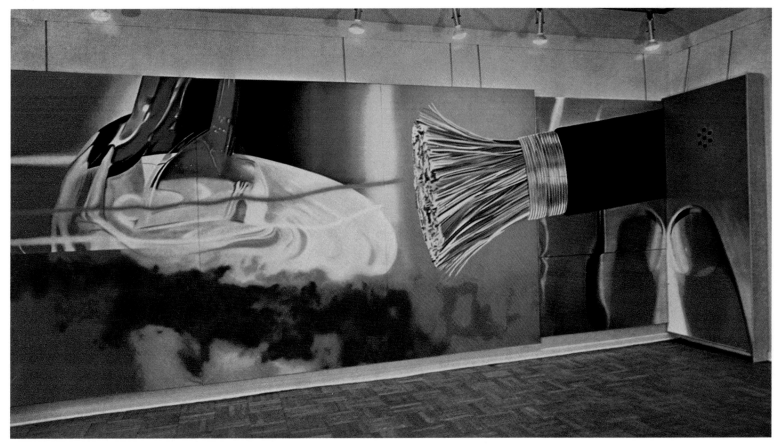

That their work can never have a large audience was taken for granted by the majority of modernists, and is still taken for granted by even the most popular abstract artists today, who deliberately work for an elite public of informed critics and connoisseurs, as Poussin, for example, worked in the seventeenth century. But like the seventeenth, the twentieth century is complex and oriented toward rapid change in the light of constant explosions of new knowledge and discoveries. As taste and patronage in the seventeenth century were broad enough to encompass Caravaggio's low-life genre and blunt populism along with Poussin's noble, lofty formalism, so today a multiplicity of styles co-exist, each with its own audience and apologists.

Pop art, however, was only one of the signs of revolt against the established canon that Abstract Expressionism was fast becoming, as it was increasingly accepted by critics, collectors, museums and art schools. This revolt ironically coincided with the very heyday of Tenth Street. While second-generation imitators of de Kooning and Kline were winning publicity and admirers, popular imagery, as we have seen, was being introduced by Rauschenberg and Johns. At the same time, Helen Frankenthaler, along with Morris Louis and Kenneth Noland, who were working in Washington, D.C. in virtual obscurity, began to see qualities in Pollock's art visible to few of their contemporaries.

In their view, the de Kooning style contained many vestiges of academic painting, especially in its reliance on drawing and value contrasts, as well as on Cubist space and composition. It was, in fact, toward the end of expunging the last vestiges of academic conventions that the most ambitious art of the sixties addressed itself. Eventually the scale of easel painting would be rejected in favor of the scale traditionally associated with mural painting and the grand manner, and its shallow relief space would be replaced by a new kind of pictorial space defined solely by contrasts in hue as opposed to traditional modeling and chiaroscuro.

Toward this end, also, representational elements, which had survived in the many semi-abstract compromise styles developed during the forties and fifties by artists like Larry Rivers were entirely rejected by the abstractionists of the sixties. Ambiguity of any kind, with regard to the location of an image in space, the loosely defined boundaries of an image, or the relationship of figure to ground became anathema in the sixties. Logic and clarity would replace ambiguity as the central value of sixties painting. In the sixties, artists drawn to representation began to make an explicitly figurative art, while those embracing abstraction purged their art of any concerns not vital to the purest, most rigorously consistent statement possible. The "crisis content"–that favorite reservoir of ambiguity for the Abstract Expressionists–was either forgotten or denied. No metaphorical allusion was hidden beneath the self-evident surface: painting was revealed in all its nakedness as an object in the world, as opposed to an allusion to any absolute. If an Abstract Expressionist like Barnett Newman had claimed in the forties that painting should embody nothing less than the "idea-complex that makes contact with mystery–of life, of men, of nature, of the hard, black chaos that is death, or the grayer softer chaos that is tragedy," an artist of the sixties like Frank Stella would flatly maintain that "what you see is what you see."

Signs of unrest in the late fifties became an issue of such importance that *Art News* offered a symposium on the subject "Is There a New Academy?" By this time, the art world was clearly divided into two polemical camps, one devoted to de Kooning and "action" painting, led by Harold Rosenberg, and the other, smaller and less noisy group who saw Pollock as the saviour of painting, revolving around Clement Greenberg. That both Greenberg and Rosenberg had originally been political writers did not lessen the vehemence of the polemic.

One of the contributors to the *Art News* symposium was Friedel Dzubas, a member of the small circle of painters including Sam Francis and Helen Frankenthaler who saw Pollock's automatism and all-over style as the basis for a post-Cubist abstraction. Echoing the feelings of this group, Dzubas pointedly asked, "Why is it that after an evening of openings on Tenth Street, I come away feeling exhausted from the spectacle of boredom and the seemingly endless repetition of safe sameness?... There is an atmosphere of complacent kaffee-klatsch, one can find all the tricks of the current trade–the dragging of the brush, the minor accidents (within reason), the seeming carelessness and violence ever so cautiously worked up."

The possibility that the "crisis content" Harold Rosenberg had attempted to establish as a metaphysical criterion–to replace the purely formal values by which art had traditionally been judged–could be staged or simulated was bothering some others, too. Rauschenberg, for example, in his twin action paintings *Factum I* and *Factum II* duplicated every "spontaneous" splash and drip. Statements in *It Is*, the magazine published briefly by sculptor Philip Pavia, also hinted at a certain dissatisfaction with the official mystique. In 1959, Paul Brach, another of the group of second generation Abstract Expressionists who began to rebel against the excesses of the Tenth Street style, wrote of the necessity "to abolish choice and chance–to forbid autobiography and confession, to reject action and find precision." Other artists like Raymond Parker, Robert Goodnough and Al Held were also beginning to tighten their contours to produce legible shapes, once again considering discipline and control more important than broadness of gesture. Al Held, for example, observed that "the rigid logic of a two-dimensional esthetic binds us to the canvas surface making it an end in itself, not a means to an end." Like many American painters working around 1960, Held wanted to do more than simply bring the image up flush with the picture plane, he wanted to develop a spatial sense "not by going inwards toward the old horizon, but outward toward the spectator." Eventually, Held developed a kind of free expressionist geometry of boldly outlined forms with a sculptural ponderousness but no three-dimensional modeling. Asserting surface by building up a heavily impastoed crust, he attempted to create an illusion of forms not receding behind the frame, but being thrust aggressively forward.

In a certain sense, this illusion that the image was being projected in front of the picture surface–that, in other words, the entire canvas field is positive foreground as opposed to negative background on which positive forms are depicted–is also at work in Larry Poons' early paintings of brilliantly colored dots on dyed canvas fields. These dots, in their sharp contrast with the color and texture of the field obviously behind them, often appear to project forward, to hang suspended in the space between the canvas and the viewer. If Manet began the effect of pushing the background plane forward, telescoping depth into a new shallowness by squeezing illusionistic space out of painting through a variety of means, then this tendency received its most extreme formulation in American painting of the sixties, when a number of artists began treating the surface plane not as the foreground plane behind which space was illusionistically depicted, but the background from which an image either literally (in Rauschenberg's case) or illusionistically (in Held's and Poons' case) appeared to project.

This tendency to view the picture plane as background was marked in the sixties. It may be seen as part of the general drive to bring the image closer to the viewer–presumably toward the end of creating greater immediacy and impact–that it is one of the recognizable characteristics of the style of artists who apparently interpreted Pollock's web as appearing to spill forward into the spectator's space. Actually Pollock himself backed off from building up his image on top of the surface in the black and white paintings that immediately succeeded the classic drip works. And it was, as we shall see, these paintings done in Duco enamel on raw canvas, with their images clearly embedded within the surface, that were the point of departure for stained color paintings.

In addition to Held, other artists who created an original interpretation of geometry in the sixties included Agnes Martin, Alfred Jensen, Miriam Schapiro, and Alexander Liberman. The outstanding painter of the minimalist persuasion, Agnes Martin superimposed a grid of small, regular intervals over muted white and grey and shining gold backgrounds. Her works have a quiet strength and an intensity seemingly out of proportion to their restrained and economical means. Jensen, too, breaks up his loaded surfaces into small regular units, which resemble the pieces of a mosaic in their colorful scintillation and emphasis on *matière*. Miriam Schapiro rotates simple geometric forms in space in order to create a complex illusionism, often stressing a tough enamel or metallic surface. In the early fifties, Liberman painted a series of precise black, red and white enamels of flat disks on a field which attracted considerable attention when they were first exhibited in 1960. Although he was one of the first to experiment with a freer painterly style in the late sixties, Liberman is best known for his series of elegant assured geometric abstractions executed earlier such as *Omega VI*.

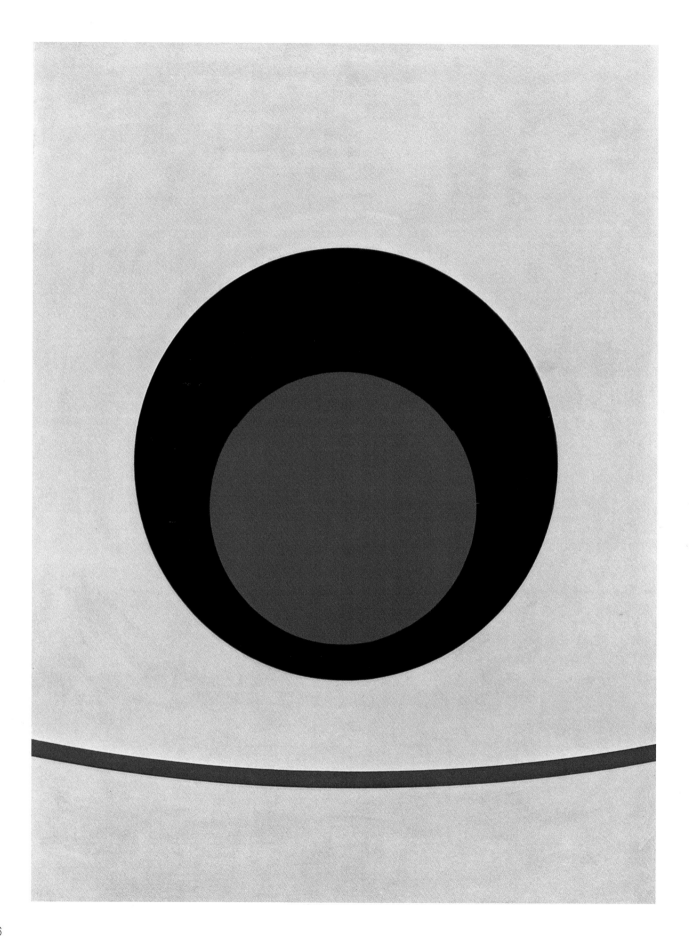

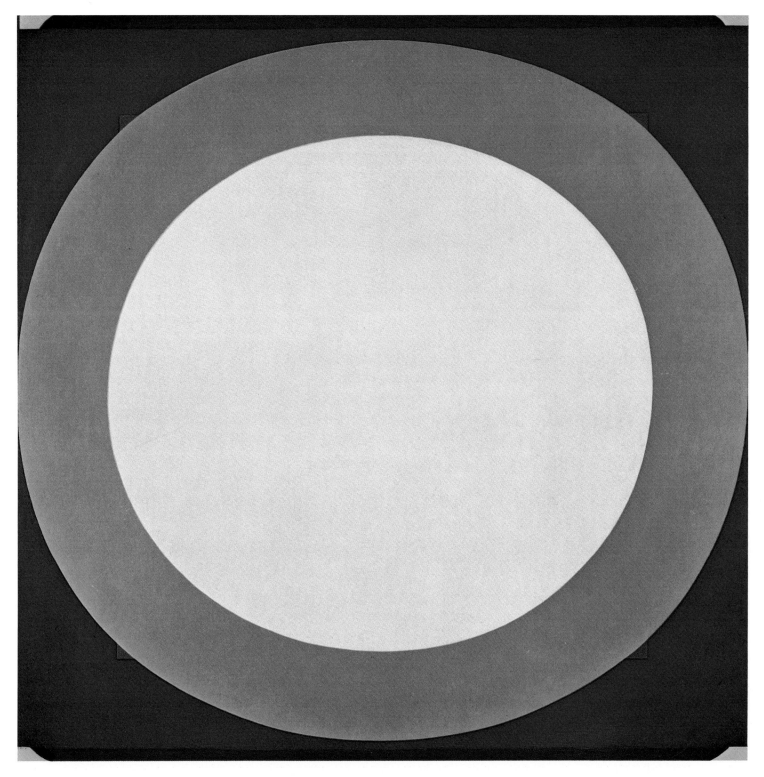

Al Held (1928). Mao, 1967. ($9^1/_2 \times 9^1/_2$ ft.)
Courtesy André Emmerich Gallery, New York.

◁ Alexander Liberman (1912). Omega VI. ($79^3/_4 \times 60''$)
The Art Museum, Princeton University, Princeton, New Jersey.

Around 1960, it was clear from the emotionalism of the dialogue that it was difficult, if not impossible, for a young American painter not to take a stand in favor either of de Kooning's expressionist painterliness, which lacked a single characteristic image–unless one can call the obsessive motif of the "woman" such–or Pollock's all-over style, which offered a technique without an image that could be imitated without producing what could only look like a forged Pollock. So many artists were drawn to the flamboyance of the de Kooning manner that this circle, which included artists such as Joan Mitchell, Grace Hartigan, Alfred Leslie, and Michael Goldberg, virtually amounted to a school.

Paradoxically, de Kooning's example was more seductive because it did offer an adaptable manner, whereas Pollock, in the drip paintings, created an image so distinctly his own that to imitate it was to duplicate it. If Pollock had something to offer, therefore, it was not a surface look, but a way of working, an attitude that was, in its rejection of the conventions of easel painting, anti-academic and radical. Thus artists who imitated the rough, brushy unfinished look of a de Kooning ended up making paintings that resembled de Kooning's, but those who looked to Pollock's drip paintings were able to develop original images that were fundamentally dissimilar from drip paintings. Sam Francis, for example, created a rippling sheet of transparent islands of painting, which flowed across the entire canvas field with a gentle fluid movement. In his later work, large expanses of white canvas create a sense of spaciousness and light highly prized by color abstractionists in general. In Noland's paintings, simplicity of image contrasts with the complexity of color relationships.

Perhaps the first painter to grasp the full import of Pollock's message, however, was Helen Frankenthaler. Visiting Pollock in 1951 at his home in Springs, Long Island, she saw his works in progress. Apparently she understood immediately how important it was that Pollock worked, not on the wall, but on the ground, spreading his unprimed, unstretched canvas on the floor, standing over it, walking around it and elaborating it equally from all four sides. Late in 1952, she began staining diluted oil paint into raw duck, adapting Pollock's mechanical technique for applying paint without the use of the brush.

Frankenthaler's adoption of Pollock's method was crucial not only to the further development of her own art, but to color abstraction in general. As early as 1937, John Graham, in his prophetic book on aesthetics mentioned earlier, pointed out that a change in technique necessarily predicated a change in form. Consequently when Frankenthaler, following Pollock, gave up painting with the conventional brush and stopped applying the undercoating of priming that kept the canvas from absorbing pigment directly, it was inevitable that she would be in a position to create a fresh formal statement. Indeed, the originality of her flowing, expanding, unfolding and flowering images was the result of this approach.

Soaking and staining paint directly into the canvas fabric combined with working on the floor from all sides, as opposed to composing in advance, had many immediate repercussions. The effacement of the movements of the hand in favor of an automatic, mechanical and impersonal technique first accomplished by Pollock in his drip paintings was eventually carried to its logical limits in the mechanically stained veils of Louis, the unmodulated circles, bands and chevrons of Noland, and the automatic spray paintings of Olitski. The look that resulted from such techniques was of uncontrived naturalness, of an image that had, so to speak, spontaneously created itself. This look, coupled with the sense of unity and immediacy of impact it afforded (because it made it impossible for the eye to focus on details), was desired if not demanded by the taste of the sixties.

The method of working on the floor, arriving at the framing edge last instead of first, gave Noland, for example, the habit of walking in circles around the periphery of his painting, which led him to begin making central images of concentric circles in the late fifties. In their symmetry, formal rigor and in the purity of their color, these paintings seem virtually burned into the canvas, their intensity and biting clarity utterly at odds with the records of successive "action painting" gestures that caused the muddy dullness of late Abstract Expressionism.

Working on the floor also affected Frankenthaler's painting decisively. By cropping her images, Frankenthaler gained both the freedom to reconsider a composition and to revise in the process of creation, without resorting to the compositional juggling at the heart of Cubist painting. But the most

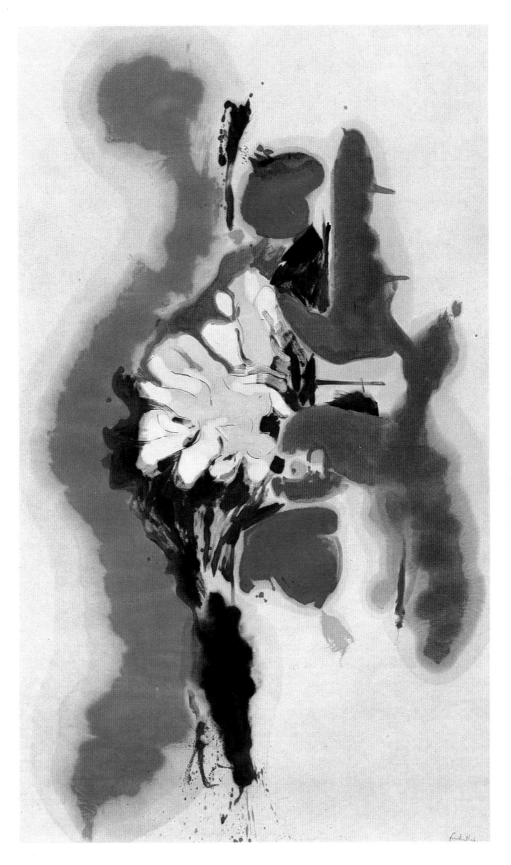

Helen Frankenthaler (1928). Blue Caterpillar, 1961. ($117^1/_8 \times 68^1/_2$'')
Collection of the Artist.

important advantage gained by using this new technique was the resolution–or at least the staving off–of the double-edged crisis which ultimately compromised the works of so many lesser artists in the sixties unable to achieve a similar solution.

The nature of this crisis was so deep and pervasive, moreover, that Pollock himself was unable to create an entirely satisfactory new synthesis once he abandoned the drip technique in 1951. This dual crisis involved: (1) the rejection of the tactile, sculptural space of painting from the Renaissance until Cubism in favor of the creation of a purely optical space that did not so much as hint at the illusion of a third dimension; and (2) the avoidance, if not ideally the banishment of figure-ground or positive shape against negative background or for that matter any kind of silhouetted arrangements. Before Pollock, the artist who had come closest to getting rid of sculptural illusionism and depicted shape was Mondrian. But Mondrian had accomplished this in the context of the small scale of easel painting, and at the price of any kind of openness or spontaneity. In developing the drip technique, Pollock allowed himself far greater breadth and openness than Mondrian could ever achieve. And it is precisely in its insistence on breadth and openness that the art of Noland and Stella diverges from geometric abstraction.

As we have seen, the drip technique allowed Pollock to reconcile flatness with a purely optical illusionism by freeing line from its traditional function as a shape creating contour. In later works, Pollock further questioned the nature of figure-ground relationships by actually cutting holes out of his webs. In his paintings on glass, he went to the extreme of attempting to render the background neutral by literally suspending the image against a transparent ground.

This is something that the stain technique, as Frankenthaler developed it, was able to do. Essentially the great advantage of staining lay in its ability to render the background neutral by obviously sinking the image directly into it, identifying figure with ground, as Clement Greenberg has pointed out. Frankenthaler's early appreciation that the revolutionary aspect of Pollock's art was his *technique* and not his *image* gave her an enormous edge in overcoming the dual obstacles–sculptural illusionism and figure-ground opposition–impeding the development of a post-Cubist abstraction, based not on delimited shallowness and figure-ground exchanges, but on opticality and openness. Obviously, the seeds of such a style existed in Impressionism and the various post-Impressionist movements, especially in Matisse's art, which impressed many American artists in the sixties with its boldness and simplicity. Following Matisse's example, artists like Ellsworth Kelly, Jack Youngerman and Raymond Parker realized that a few simple large forms generously filling the canvas could have a greater impact than any number of fragmentary shapes. Like Louis, Noland, Olitski and Stella, these artists related the single wholistic image to the frame, rather than relating shapes depicted on the field to each other.

If one seeks to find a single common denominator in the heterogeneous styles of the sixties, that common denominator is probably a debt to the work of Jackson Pollock. Although other artists of the forties and fifties like de Kooning, Motherwell, Kline, Still, Newman, Rothko and Reinhardt made important innovations, Pollock's revision of the traditional approaches to technique, pictorial space, composition and form was the most radical and decisive. It was, in fact, as radical and decisive as the reformulation of Old Master form and techniques undertaken by Manet nearly a century earlier, which became the basis for Cubism. Manet rejected Renaissance modeling and perspective as academic; Pollock in turn was able to lay the basis for an art that went beyond Cubism in rejecting Cubist space and modeling. Paradoxically that art turned out to be primarily a color art, since the area in which Pollock's work was least developed was precisely that of color. Fortunately, color relationships had been explored by Hofmann, Albers, and the color-field painters Newman, Rothko and Gottlieb, so that examples of paintings in which the burden of expression was on color and its luminous qualities were plentiful when the urge to develop a color art became dominant.

Frankenthaler's major contribution was not, as it has been widely held, that she invented the stain technique, but that she was able to turn Pollock's technique toward the end of creating an art of pure and vibrant light and color. If one compares Frankenthaler's paintings with de Kooning school works of the early fifties, one is immediately struck by how different they look. Because pigment is thinned

down to watercolor consistency, the whiteness of the canvas ground is fully utilized for its light-reflecting potential, in much the same manner that the page reflects light beneath the transparency of a watercolor wash.

This was especially important for the last great American artist to die without achieving material success or fame, Morris Louis, whose death in 1962 cut short a brilliant and at that time virtually unknown career. Louis maintained that Frankenthaler was a bridge "between Pollock and what was possible." The historic occasion early in 1953 when he and Kenneth Noland were taken to Frankenthaler's studio by Clement Greenberg to see her recently completed *Mountains and Sea* changed the course of American painting in the sixties. In many respects, Louis's greatest paintings, his *Veils* of 1954 and 1958, are unthinkable without Frankenthaler.

A comparison between Frankenthaler and Louis is instructive as to the opposition in their intention, however. Whereas Louis superimposes successive transparent planes, creating misty, foggy, rainbow or otherwise weather-related atmospheric effects, Frankenthaler paints a landscape image, and tends to modulate a form from within, contrasting not only hue, but saturation and intensity. Frankenthaler's emphasis on *liquidity* of pigment is part of Louis's drive as well, although his perhaps more masculine interest in rigorous structure and symmetry is another obvious divergence. Before Louis and Frankenthaler used such diluted pigments, Marin had attempted to translate a watercolor technique into oil. He was hampered from fully achieving his goal, however, because he continued to prime the canvas, with the result that he was painting on a hard rather than an absorbent ground

Morris Louis (1912-1962). Blue Veil, 1958-1959. (100$^1/_2$ × 149'')
Courtesy of the Fogg Art Museum, Harvard University, Cambridge, Massachusetts. Gift of Mrs. Culver Orswell.

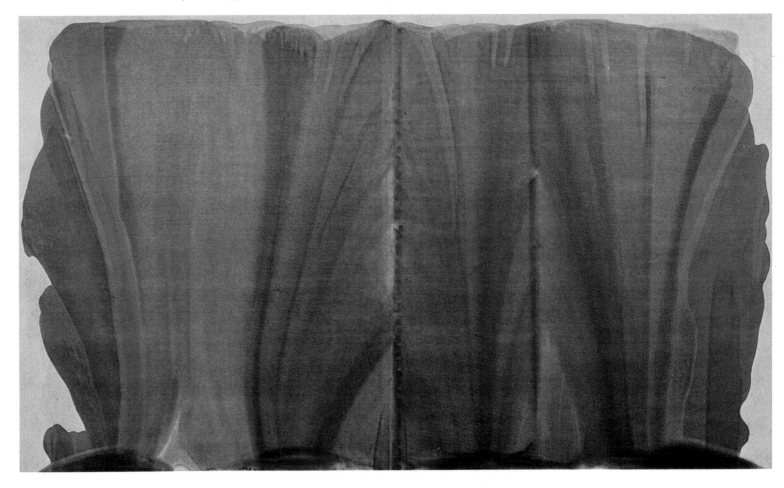

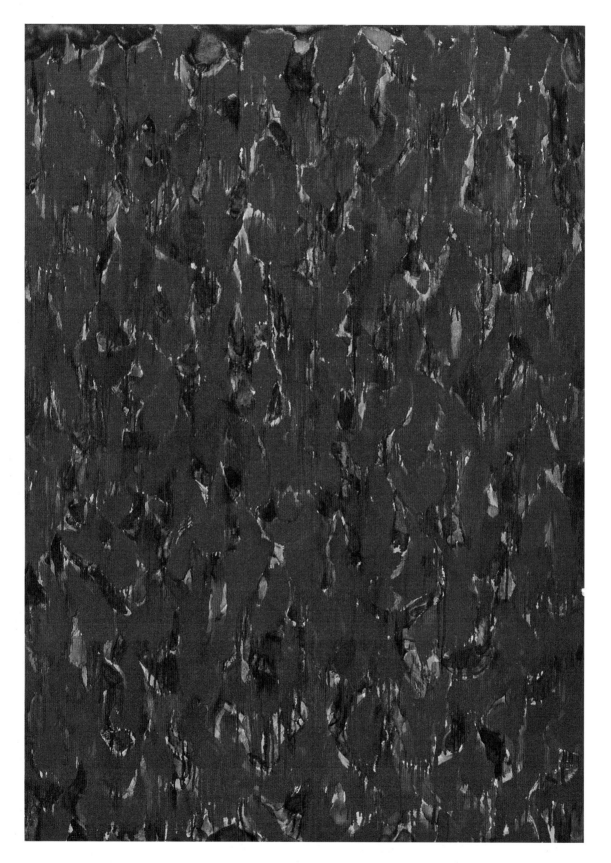

Sam Francis (1923). Red No. 1, 1953. ($64^1/_8 \times 45^1/_8$")
Collection of Mr. and Mrs. Guy Weill, Scarsdale, New York.

in his oils. This was not true in the watercolors themselves, of course, since the paper absorbed pigment directly–probably the reason Marin's watercolors usually remain superior to his oils. In staining, however, Frankenthaler, Louis, Noland and Olitski in his pre-spray paintings, allowed the raw ground to soak up color directly, as the page absorbed watercolor. This enabled them to achieve in oil and plastic-base paints both a freshness and a luminosity previously available only in water-color, an intimist medium inimical to a monumental statement.

In this connection it is interesting to note that some of the highest moments in American art had occurred in the landscape watercolors of Homer, O'Keeffe and Marin, while many of Demuth's finest works are also watercolors. In her more explicit use of landscape image, Frankenthaler shows a stronger link to an established native tradition than the majority of color painters. Frankenthaler's historic role has only begun to be acknowledged. She was the first to appreciate the manner in which Pollock's work reconciled the linear with the painterly. For the other artists who followed Pollock rather than de Kooning, painting and drawing were equally identified. And this is altogether natural, since Wölfflin's categories were based on the premises of old master painting, which were rejected one by one by the modernists, until Pollock accomplished their final demolition.

Frankenthaler often used bare canvas dramatically; and Louis and Noland were equally able to use unpainted areas as an expressive element. In his "unfurl" paintings, Louis apparently draped raw canvas over a trough, spilling rivulets of paint in diagonally spreading streams, leaving the center of the canvas dramatically bared. Because the naked, literally undressed, quality of the canvas as yielding fabric rather than hard ground is stressed, the viewer often has the acute physical sensa-tion of being hurtled headlong through a space both mysteriously infinite and explicitly and con-cretely finite.

A similar spatial drama and tension is created in many of Kenneth Noland's "bull's-eye" paint-ings with circular motifs. It is also an important element in the series of monumental chevron paintings executed by Noland in 1964. In these, the interaction of adjacent warm and cool colors such as clear bold yellows, reds and blues creates, through the properties of colors to advance or recede, a sense of space in its purely optical quality entirely opposed to the tactile sculptural space of Cubism. Thus even if Pollock's momentous union of the linear and the painterly voids Wölfflin's classical distinction between these two pictorial polarities, there continues to be a split between an illusionism based on traditional value contrasts–the last vestiges of the modeling of form of representational art–and a purely optical or visual illusionism resulting exclusively from contrasts in hue.

For this type of purely optical illusionism, Hofmann's celebrated "push-pull" dynamic and Albers' experiments in color contrasts were vital precedents. Their method of balancing out spatial tensions through color advancement and recession is in many ways still the basis of the illusionism of the painting in the sixties. Indeed, the central feature of current American painting might be seen as the investigation of the nature of illusionism, and its relationship to the flatness demanded by modernism. For in the sixties, literalism–the demand for an end to illusionism or any kind of fiction whatsoever–led a number of pop and minimal artists who began as painters, such as Claes Olden-burg, Robert Morris, George Segal, Donald Judd, Larry Bell, Craig Kauffman and Sylvia Stone, to abandon painting altogether for the creation of literal three-dimensional objects existing in real space. Their work is so close to the painting of the sixties that it really should be seen for what it is, an extension of painting rather than a purely sculptural expression.

On the other hand, the final identification, not of *flatness*, but of an inescapable illusionism as the irreducible essence of painting led to a renaissance of illusionism in the paintings of many former minimalist painters in the late sixties. It was almost, in fact, as if an artist had to choose between renouncing painting for real three-dimensional objects, or reformulating illusionism to be consistent with flatness. The group mentioned above took the first course, while painters like Noland, Olitski, Stella, Darby Bannard and Ronald Davis took the latter, creating a kind of self-cancelling illusionism that consistently contradicted itself through a variety of devices.

Opposed to this redemption of illusionism through a space developed largely through color relationships was the literalism of the object makers, which had earlier been felt by Rauschenberg,

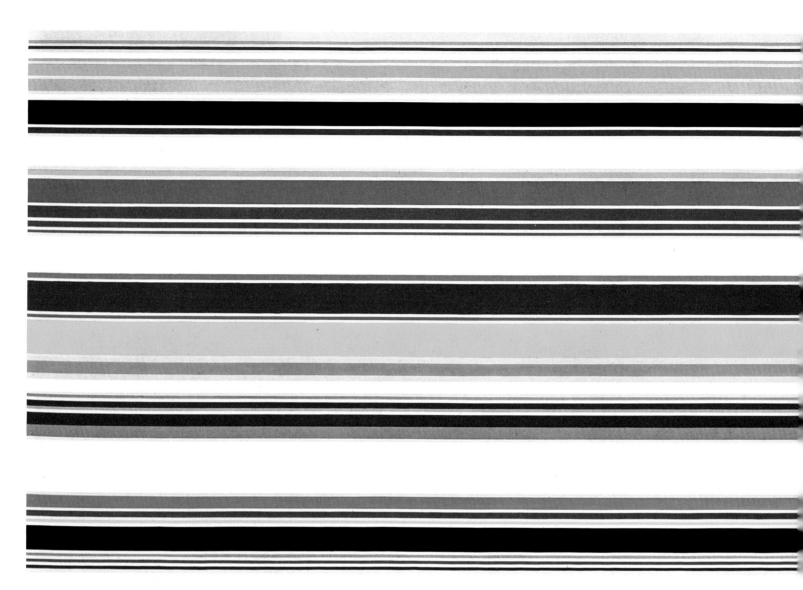

Kenneth Noland (1924). Via Blues, 1967. (7 ft. 6^1/$_8$ in. × 22 ft.)

pop artists like Lichtenstein and Jim Dine (at least in his early works), and hard-edge painters like Al Held and Nicholas Krushenick. Rauschenberg had anticipated the drive toward literalism by refusing to create space behind the picture plane. Instead he regarded it as a background on which to affix objects literally spilled forward into the spectator's space. In his combine paintings of the early fifties, such as *Charlene*, magazine and newspaper photos, pieces of fabric and clothing were patched together in a tightly structured formal arrangement enlivened by intermediary passages of painterly brushwork. This was a combination that essentially blew up Schwitters' Merz collages to American scale and married its Cubist composition to de Kooning's wide-open gesture. Soon Rauschenberg was piling common objects and detritus from the environment on paintings in which space and form were entirely literal, as opposed to illusionistic, and reproduced images, treated in an equally literal manner, were actually incorporated into the work as opposed to being depicted by the artists.

The drive toward literalism of image and space Rauschenberg prophetically felt in the late fifties was perhaps the single dominant development in American art in the sixties. The other significant development was, of course, the renewal of interest in color as a vehicle for expression. The distaste for illusion and metaphor, which took a variety of forms, must be seen as an essential aspect of the

The Collection of Mr. and Mrs. Robert A. Rowan, Pasadena, California.

rejection of the ambiguity of Abstract Expressionism and the inevitable consequence of the resurgence of native tastes and modes of feeling and thinking after the European current had played itself out. It is this literalism in fact that makes pop a false or pseudo-representational art. Not only is pop painting flat, like the decorative styles, it deals almost exclusively in second-hand images–pictures of pictures. Lichtenstein, Warhol and Rosenquist always make it explicit that their images are derived from reproduced sources; since their billboard or magazine page or film origin is known, it is known also that these images are to begin with flat. Not the three-dimensional images of the natural world, but the flat images of the world of prints is drawn on by pop artists.

What is the source of the literalism endemic to American art of the sixties? When we consider the literalism implicit in Pragmatism, the only system of philosophic inquiry developed exclusively by Americans, we begin to understand that literalism may be the defining characteristic of the American mind. As Pragmatism identified moral and ethical truth with the bare facts as experienced, so large numbers of American artists began to find *any* contradiction between illusion and reality intolerable. For them, experience has to tally precisely with reality. If a painting was created on a two-dimensional surface, then that flatness had to be stated as boldly and plainly as possible. If a form was to look three-dimensional, then it had to be created in three dimensions, not two. Thinking this way, many

Jules Olitski (1922). High A Yellow, 1967. ($92^1/_2 \times 150''$)
Collection Whitney Museum of American Art, New York.

concluded that shapes could no longer be drawn or pictured; they had to be actual. Ellsworth Kelly, for example, stopped depicting shapes against a background to create geometric canvases that were literally shaped. Earlier, Claes Oldenburg and George Segal, who began as expressionist figure painters, renounced painting for the creation of three-dimensional objects and figures, which often look as if they had rolled directly out of their paintings to stand on the floor. No longer content to remain behind a canvas screen, they demand actual confrontation by the viewer in his own space.

To an extent this drive toward literalism meshed with certain of the fundamental assumptions of modernism carried farthest by Mondrian. The Dutch master's theory of neo-Plasticism, well known and discussed among Americans, challenged the very basis of representation, Plato's concept of *mimesis*, according to which objects were considered merely imitations of abstract absolutes. Mondrian, by contrast, claimed that the art object was not an imitation of anything but an autonomous reality. The manner of insuring the reality of art was to cease creating a fictive, three-dimensional world on a surface that was literally two-dimensional, and to acknowledge that two-dimensionality as fully as possible.

Mondrian, of course, had no idea how far his doctrines would be carried in his adopted country. Although Mondrian lived and worked in New York during the War, his immediate influence was restricted to a small circle of admirers who imitated the geometric forms of neo-Plasticism with a fidelity that could not lead to the creation of very original art. Of the group, only Burgoyne Diller,

apparently through sheer intensity of spirit, created paintings of great distinction. However, Mondrian's own late painting, *Broadway Boogie Woogie*, with its tiny rectangles of color creating a brilliant optical dazzle, remained one of the shrines of pilgrimage for several generations of American artists in their frequent visits to the Museum of Modern Art, the only real art school many ever attended. (The most obvious reference to Mondrian, of course, is in Larry Poons' dot paintings with their optical flicker.)

Because the most complex ideas are also the most difficult to assimilate, it is not surprising that Mondrian's ideas were not understood any faster than Pollock's. Neither made any fundamental impact on the art of the fifties. In the sixties, however, their influence was decisive. Together with the flat shapes and high color of Matisse, whose exhibition of *collages découpés* at the Museum of Modern Art in 1960 rocked the New York art world, Mondrian and Pollock staked out between them virtually the entire territory explored by innovative artists in the sixties.

Larry Poons (1937). Rosewood, 1966. (120 × 160″)
William Rubin Collection, New York.

If one wished to adumbrate most succinctly the history of recent American art, one might hold that its course was set by three painters, a critic, and a composer-aesthetician. The painters of course were Jackson Pollock, Piet Mondrian, and Henri Matisse; the critic was Clement Greenberg, whose power was enhanced by the appearance of strong artists such as Louis and Noland whom he could once again champion as he had championed Pollock; and the composer-aesthetician was the guru of pop and mixed-media, John Cage, whose mixture of Dada and Zen was compatible with certain aspects of Harold Rosenberg's Dada-derived conception of action painting. With Cage's benediction, the arena of art was permitted to merge with the arena of life, as actual gestures in Happenings, the theater of action, replaced the metaphorical gestures of action painting.

Greenberg and Cage, although not painters, decisively affected painting, not only because of the strength and originality of their ideas, and the clarity and insistence with which they articulated them, but because the time was ripe for Greenberg's classic taste for the grand manner as well as for Cage's anti-classicism and preference for anarchic self-expression and restless experimentation over any set of norms of aesthetic decorum.

In 1961 both Greenberg's collected essays, *Art and Culture*, and Cage's lectures, *Silence*, were published. They became the bibles of the sixties. No artist or critic working in the period failed to be affected by one or the other or both. By the end of the sixties the New York art world was once again clearly polarized, this time around the aesthetic positions articulated by Greenberg and Cage, which were seen as diametrically opposed world views having unavoidable social, political and moral consequences as well.

Greenberg's insistence on the timeless authority of the classical systems of aesthetics, particularly in their modern reformulation by Kant and Lessing, defined the limits of art for color painters as stopping short of literalism and theater, the anathema respectively of transcendence and purity. Cage's affirmation of contemporary life blended elements of John Dewey with aspects of Duchamp's ironic stance, encouraging art to encroach upon the environment until the boundaries between art and life were effaced. His advice to artists to draw inspiration from the everyday environment in fact had been the original stimulus for the development of pop imagery. In the late sixties, artists disaffected with the commercialism of the art world took Cage's permissiveness as a signal to abandon creating objects entirely in favor of ephemeral theatrical gestures that could not be bought or sold or owned as private property. Cage's own definition of art as a kind of revolutionary behavior, as opposed to any specific conservative order of forms, was particularly attractive to the radical younger generation, many of whom interpreted Greenberg's insistence on quality as an attempt to impose an official authoritarian canon in the form of a rigorous definition of the limits, which quickly seemed the rules, of art.

The development of painting in the sixties from reductive minimalism to a complex illusionism can be observed in the works of a number of painters including Larry Zox, Darby Bannard, Larry Poons and Ronald Davis. But it is most clearly traced in the work of Frank Stella, whose monochrome shaped paintings, in their impassive, object-like literalness, became the touchstone of minimal art, to the extent that his conversion to the sophisticated illusionism of color abstraction in 1965 deprived the minimal sensibility of much of its energy and impetus. Like Noland, Louis, and most of the younger painters whose careers began in the late fifties, Stella painted loosely brushed Abstract Expressionist works early in his precocious career. The exhibition of a group of his first "stripe" paintings in 1959 at the Museum of Modern Art had an effect similar to Jasper Johns' first exhibition largely because, like Johns' targets and flags, Stella's black stripe paintings were a bold challenge to existing criteria of taste as well as images of an extreme if not arrogant originality. Like Johns' paintings of common objects–lowbrow themes in relation to the heroic ambition and rhetoric of Abstract Expressionism–Stella's black paintings were considered an insulting affront to the fine art of painting, not least because they were, like Johns' original flag, the work of a painter in his early twenties who achieved instant fame and recognition. This was virtually unprecedented in America, where artists usually waited until well into middle age before they sold a painting or showed in a museum, which made Stella's entry into the art world that much more dramatic.

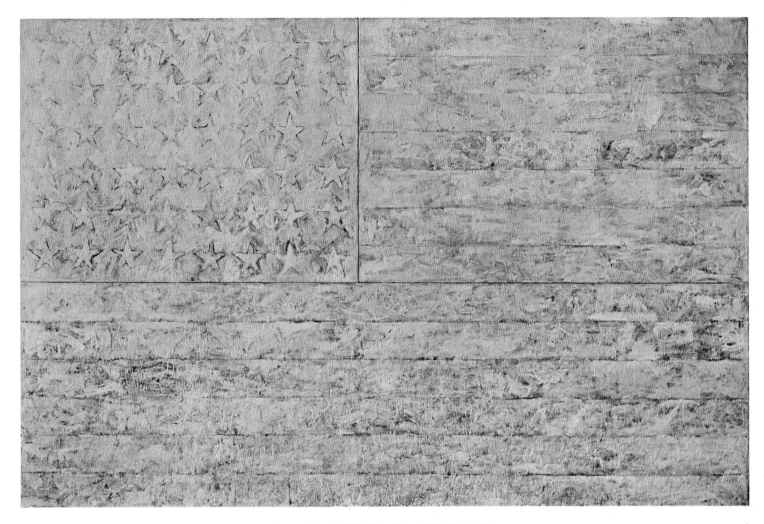

Jasper Johns (1930). White Flag, 1955. (72 × 144″)
Collection of the Artist.

The connection between Stella's and Johns' work was hardly fortuitous. As Frankenthaler was the first to grasp the radicality of Pollock's technique, Stella was the first to understand the implications of Johns' attitudes toward space and shape, as opposed to the sensational aspects of his blatantly American imagery. Stella understood that Johns' importance as a formal innovator was far greater than his interest as merely a source of pop imagery. He saw first of all that Johns had resolved the contradiction implicit in the ambiguity of Abstract Expressionist space. Proclaiming the flatness of his surface by choosing images one knew in advance to be flat–e.g. flags and targets–Johns underscored that self-proclaimed flatness by identifying the image, in the case of the flag, with the shape and dimension of the entire pictorial field.

That Johns' attitude toward space and especially toward *shape* was radical has tended to become obscured because virtually everything else about his work, including its intimate scale, encaustic medium, and Cézannesque paint handling, was reactionary. The issue of the formal importance of Johns' paintings has been complicated, moreover, by the direction his work has taken in the sixties. Because his later paintings are looser and less clearly structured than the iconic flags and targets, the radicality of the early works is perhaps not as clear as it should be. Johns' flags and targets, however, represented an important turning point. Like Reinhardt's crosses, they were entirely preconceived images painted in a context of the improvisational excesses of late Abstract Expressionism.

Johns' choice of a form that could neither be revised, such as a standardized or stereotyped image like a flag, nor seen as a series of related details was crucial for the development of the conceptual art of the sixties.

The repetition of modular units repeating the horizontal axis of the frame in rhythmic progression in addition to the identification of image with the pictorial field, resulting in the elimination of positive shape vs. negative background arrangements, clearly link Johns' flags with Stella's early stripe paintings. Johns' assertion of surface, too, as hard and resistant as opposed to yielding and absorbent, with its echo of Still's sensuous impasto, is related to Stella's adoption of metallic pigments in the 1960 aluminum paintings, although Pollock's use of aluminum paint was probably foremost in Stella's mind. As opposed to the literal reflectiveness of Stella's metallic silver, bronze and purple shaped paintings, however, Johns' use of encaustic acted like the glazes in old master paintings to create a surface that was paradoxically hard but transparent. The use of the encaustic technique in which Johns' finest paintings are executed allowed him to maintain freshness while still using fine handwork and subsequent layers of overpainting.

Stella's decision in 1960 to cut out the corners of an aluminum painting such as *Marquis de Portago* because they appeared to him "left over"–that is they functioned as background with relation to a shape–had the effect of shifting the emphasis definitively from internal relations between shapes depicted on a field to an eccentric perimeter that was insistently if not obsessively reiterated by bands of equal width separated by channels of raw canvas.

Immediately such paintings set off a vogue for the shaped canvas which produced many works that appear obvious and contrived in retrospect. Besides Stella, however, Noland, in his elongated diamonds, Kelly in his intensely saturated geometric paintings, and most recently Ronald Davis in his highly illusionistic plastic paintings, have made important works in which shape is literal, identical with the limits of the pictorial field, instead of depicted as in older art.

Davis's work is especially interesting because of his development of a new technique. Painting directly with liquid plastic, he creates a hard surface, which is glossy and reflective, literally filtering and transmitting light from behind. In opposition to traditional art, which built up an image on top of the ground with layers of paint and glazes, Davis locates his image *literally* behind the surface. This entirely changes the nature of the illusionism he employs and makes it something quite different from traditional illusionism. Whereas traditional painting attempted to trick the eye into believing that a three-dimensional cavity existed behind the surface of the painting, Davis constantly reveals the artificiality of his illusionism by creating a hard reflective surface. Instead of the logical world of Uccello (who certainly influenced Davis), which confronted the viewer with an image that faces him frontally, one is confronted with a hallucinatory world of images which, as Davis presents them, are only visible if the viewer is flying in the air above them. Hence the sensation that one is looking down at an image.

It was Malevich, of course, who first suggested that painters in the modern world should imitate views as seen from airplanes; the frequency of such aerial views in recent American art like Davis's, however, is astonishingly prevalent.

The range of artistic activity in America at the end of the sixties is extremely broad. Its spectrum extends from the late works of Newman, Rothko and Motherwell, which grow increasingly grave, austere and monumental, much in the spirit of the late masterpieces of the greatest painterly painters, Titian, Caravaggio, and Velazquez. Action painting has re-emerged as pure theater in a performance oriented anti-formal art. Many young painters are rejecting the public image and role sought after by the most ambitious painters of the sixties in favor of a casual intimate art like the unstretched pieces of canvas of Richard Tuttle. Others continue to explore ways of extending color relationships and illusionism; many like Larry Poons and Dan Christensen, inspired by Olitski's success, are returning to the painterliness they previously had rejected, once again attracted to freedom of execution. A number of second-generation Abstract Expressionists, such as Alfred Leslie, having recognized the confusion in action painting attitudes regarding space and shape have returned to the figure, joining realists like Philip Pearlstein and Jack Beal in creating a hard-edged explicitly sculptural realism,

Frank Stella (1936). Marquis de Portago, 1960. (93^1/$_4$ × 71^1/$_2$″)
Carter Burden Collection, New York.

Jack Youngerman (1926). Black, Yellow, Red, 1964. (96 × 73″)
Collection The Finch College Museum of Art, New York. Gift of the Artist.

whose calculated coldness stands in stark opposition to earlier sentimental expressionist "returns to the figure."

Having survived the crisis of the late fifties, many Abstract Expressionists such as John Ferren, Adja Yunkers, Raymond Parker, and Jack Youngerman are creating large, simple shapes related to Matisse's late works, to which Adolph Gottlieb's recent decorative abstractions are also related. Color abstraction generally dominates the scene, although its split into two camps seems fairly obvious: one group of abstractionists creates an exclusively hard-edged industrial urban art and the other devotes itself to a more lyrical allusive abstraction tied to landscape. This, essentially, is the expressive difference between Stella's muscular arcs and interlaces and Noland's horizontal banded works, with their implicit reference to the horizon line of landscape painting. Nature metaphors are beginning to be increasingly prevalent in the work of many younger artists. The switch from a cold artificial style to a more open style with distinct landscape allusions is especially noticeable in a painter like Darby Bannard. But the clearest example of the presence of landscape allusions is probably Olitski's atmospheric abstractions, with their *repoussoir* framing elements and contrast of vast open expanses with small, scale-giving elements, both familiar devices in traditional landscape compositions. Once again, American painting has begun to reiterate the traditional opposition of nature to the city, of the urban landscape to industrial forms, that split not only American painting, but all of modern art down the center.

Ellsworth Kelly (1923). Two Panels. Yellow and Black, 1968. (92 × 116")
Courtesy Sidney Janis Gallery, New York.

Although Bannard and a number of younger artists have reduced the size of their paintings, large scale continues to be an important characteristic of new American art, which seeks now for complexity on every level, as it once sought for simplicity. Yet because of the sophistication of the artistic and critical audience, this complexity is being sought after for the most part with the greatest precision, clarity and logic. Although many young artists feel that the signals from the Renaissance are getting weaker, considering Pollock's abandonment of the traditional forms and techniques as the end of painting, others view Pollock today as a new beginning, and continue to be inspired by the level of ambition and achievement of American painting in the sixties.

These radicals dream of an art finally free of those last vestiges of Renaissance space and drawing that lingered on in Cubism. Indeed, if on the basis of recent American painting one were to decide the outcome of the debate raging for centuries between those who argued for the supremacy of color or design, one would have to conclude that Rubens and Delacroix have found their ultimate justification in a far-away country, never before noted for its love of pleasure and sensuality. Alive today, they might have an equally difficult time believing that the center of world art is no longer Rome or Paris, but New York.

Ronald Davis (1937). Disk, 1968. (55 × 136″)
From the Collection of Mr. and Mrs. Joseph A. Helman, St. Louis, Missouri.

THE SEVENTIES:
AMERICAN ART COMES OF AGE

Embarking on its third century, American painting at the end of the nineteen seventies has emerged, independent at last of foreign models, as the leading force in world art: a fully mature tradition, heir to both the legacy of European modernism as well as to indigenous American modes of thought and expression. An informed synthesis of these two sources, undertaken on a new level of conceptual and technical sophistication, is the major achievement of American art in the seventies.

During the sixties, American painters consolidated the stylistic and formal revolutions of the Abstract Expressionists, the first painters successfully to challenge classical Cubist principles of strict geometric design. Both the spontaneous, subjective "painterly" style of action painters like Pollock and de Kooning, as well as the more formal structural art of the "color-field" or chromatic abstractionists like Newman and Rothko, were radical extensions of the parameters of painting. Inventors of a post-Cubist style, the Abstract Expressionists were at last totally original American painters; their works were the first paintings made in America to carry sufficient authority to hang beside the masterpieces of the past.

In a more traditional culture, one can imagine that such an accomplishment would have ushered in a period of increasingly refined, well-executed academic art. To some extent, it is true that the seventies, in comparison with the dramatic "breakthrough" years of postwar American art, have been a relatively academic period, characterized by the professionalization of art, the growth of art schools, and the gradual assimilation of art into a social context. Americans, however, have particular difficulty accommodating the idea of an end to progress in any area, including the arts. A country that prizes novelty and invention above tradition and stability–at least until the present moment–America has generally demonstrated little respect for or interest in historical precedent. In the seventies, however, American artists developed a surprising and unexpected sense of history. In the past, Americans considered novelty and innovation as ends in themselves; in the seventies, American artists returned to conventional materials and techniques and found inspiration in reconsidering the art of the old and modern masters.

Constantly mobile, volatile and changing, America is a geographically large country that continues to breed individual psychological isolation despite the continued growth of the transportation and communication industries. As we might expect, this isolation is reflected in its art. Because of the fundamentally egalitarian, democratic ideology of the United States, popular taste has always

rejected the "mainstream" of modern art, descended from the alien School of Paris. We have seen how, by the middle of the nineteen fifties, proto pop artists like Robert Rauschenberg and Larry Rivers began challenging the "high art" elitist principles of Abstract Expressionism, a hermetic symbolic style accessible only to a cultured minority. Although there was a relative diversity of styles in the sixties, essentially only three styles–pop, minimal and color-field abstraction–dominated American art during that explosive decade. At the same time, however, strong regional schools developed in Washington, D.C., Chicago, Los Angeles and San Francisco, although these local expressions continued to be tied to the dominant New York styles. In San Francisco and Chicago, for example, representational art, both surreal and realistic, flourished throughout the sixties and seventies. In Chicago, Peter Saul and Jim Nutt developed fantasy styles with a more biting edge of social criticism than pop art; figurative painting first received an enthusiastic reception in Chicago as well. Washington, D.C., where Louis and Noland began painting stained canvases in the fifties, remains today an active center of color-field painting. Veteran color-field painters like Tom Downing, Gene Davis, Howard Mehring and Alma Thomas have been joined by younger artists like Sam Gilliam, whose stained canvases extend the premises of Louis' and Noland's abstraction further into the area of the literalist sensibility. In early paintings, Gilliam draped unstretched pieces of stained and dyed canvas against the wall or in environments, emphasizing that a painting is literally nothing more than a colored surface, a mere piece of cloth. Recently Gilliam has begun collaging areas of dappled color on to stretched paintings; the collage is a device for structuring color without resorting to conventional drawing or illusionism used earlier by Lee Krasner and Howard Mehring.

Ironically, the shift toward conservatism characteristic of the seventies manifested itself early in Los Angeles, the center of the most extreme anti-traditional art in the sixties. So total was the rejection of the past by Los Angeles artists in the sixties that Robert Irwin and Larry Bell abandoned painting entirely to pioneer a highly evocative art of minimal environments. Billy Al Bengston sprayed glittering automobile lacquer on to metal surfaces, and Ron Davis, Craig Kauffman and John McCracken experimented with glossy plastic surfaces. In the seventies, however, the best known painters of the Los Angeles School–Ron Davis, Billy Al Bengston, Ed Moses and Craig Kauffman–began working once again with oil paint on canvas. Moreover, a second generation of gifted Southern California abstract painters, whose works stress shimmering light effects inspired by the brilliant California skies, have also rejected the plastic pigments and other new media, so attractive to the sixties' taste for the ephemeral and the impermanent, in favor of conventional materials and techniques.

If the "cool" sixties reacted against the romantic expressionism of the New York School, the seventies in turn have rejected the slick surfaces, alienated objectivity, gigantism, and serial imagery reminiscent of the factory assembly line, as well as the mechanical hard edges and simplified graphic images of the sixties. For the art of the seventies is not only more heterogeneous, diverse and pluralistic than that of the sixties, it is also frequently more intimate, poetic and personal. Once again, painting has become, not a mass-produced product, but a unique, personal communication. This is reflected not only in the choice of politically or psychologically loaded imagery, but also in the return to painterly hand painting and to the reduced scale of easel painting, as opposed to the environmental scale of mural painting characteristic of the art of the sixties.

In the seventies, the impulse toward a public art has finally been afforded freedom to express itself in state commissions for large-scale works awarded to abstract painters like Al Held, Ellsworth Kelly, Helen Frankenthaler and Frank Stella; at the same time, the alternative of an intimate art has become more viable as a possibility for younger painters eager to work on a human rather than an architectural scale. We have seen how, in the sixties, native American attitudes and tastes, particularly the characteristically American love of genre and American Scene subjects, suppressed during the rise of Abstract Expressionism, began to surface once again. This tendency toward the assertion of American themes became even more pronounced in the seventies, as the memory of European art receded in the face of a new consciousness of the roots of a distinctively American culture. Intensified by the 1976 celebrations marking the Bicentennial of the American Revolution, the search for American roots triggered a wave of popular sentiment that continues to gain ground,

unleashing a general reaction against abstract art among middle-class patrons, paradoxically at precisely the moment that government and institutional patronage has begun to take up the cause of abstraction as monumental public art.

The idea that modernist abstraction is un-American is of course not new. We may recall that the initial American response to the introduction of modern European art early in the century was that this new art was the product of an "Ellis Island" alien mentality. Each time there is a surge of populist, regionalist sentiment in America, the reaction against modern styles manifests itself again. Thus in the thirties, popular taste applauded mediocre regional art and American Scene genre, while both museums and the public ignored the art of the American abstract artists who laid the groundwork for Abstract Expressionism. Although the W.P.A. federal art patronage program, inaugurated during the Depression years as a means of providing work for artists, may not literally have encouraged what Arshile Gorky termed "poor art for poor people," the program did emphasize regional and popular genre subjects. As a result of the establishment of the National Endowment for the Arts, an agency of federal art patronage founded in the sixties, popular taste is once again a critical factor, and realistic genre art is being encouraged, as is a greater participation by a greater number in the arts. Federal art patronage in democratic America supports pluralism, the widest possible spectrum of artistic activity, rather than exclusively patronizing "high art" or elitist modern styles. Indeed in the populist decade of the seventies, the very term "modernism" has become suspect because of its elitist connotations.

Current anti-modernism in America has other sources as well. The breakdown of authority in all areas of American life, resulting from the nightmare of a corrupt government, also affected American art. Challenges to authority in all spheres made it no longer possible for an authoritarian critic like Clement Greenberg to proclaim that valid important art could be made only in the area designated as the "mainstream" of modernism because of its direct descent from Cubism. Pop art was not, in its academic references to the art of the past and its ironic commentary on a cultural context of reproduced images, a genuinely popular style as much as it was a critical examination of the expansion of popular culture; but pop opened the doors to a revival of representational painting intentionally and aggressively directed at the common man.

Fifty years ago, Marsden Hartley pessimistically predicted that art could not take root in America until ninety million people had become aware of it. Hartley would probably have been astonished to find that through the blatant familiar imagery of pop art, such a goal was, for the first time in history, a real possibility. Suddenly, in America, an educated or semi-educated mass public, previously ignorant of the existence of the visual arts, began taking an interest in painting and sculpture, along with good wines, gourmet cooking and other appurtenances of the good life. By and large their taste was for an art that was understandable, accessible and direct in its address. Their biggest reception has been, not surprisingly, for Photo Realism, a leading seventies' style of *trompe-l'œil* illusionism that vies with photography itself in duplicating and documenting the external world. The heir apparent of pop art, Photo Realism (or Hyper-Realism or Super-Realism as it is sometimes called) bears the same relationship to photography that pop art did to graphic design, advertising and print-making. Pop artists flattened and stylized the images derived from mass media, forcing them to conform with the pictorial principles of modernism, but the Photo Realists, whose labored academic style recalled Pre-Raphaelite precedents, feel no such necessity. Thus the slick, glossy surfaces of the paintings of Richard Estes, Robert Bechtle, Ralph Goings, Robert Cottingham et al. gleam with highlights that delight the viewer who has no previous knowledge of art and is gratified to recognize the familiar streets of city and suburbs. In its obsession with Americana, Photo Realism is but the latest incarnation of American Scene painting, a latter-day version of the Ashcan School, often replete with requisite ashcans and other industrial eyesores. A devotion to the unpleasant detail that reveals the vacuity of the consumer culture shows that Photo Realism has the same muckraking impetus that formed the spirit of the original Ashcan School. In both cases, a journalistic, story-telling element is expressed in a nominally objective style. However, the Photo Realist selection of scenes that are particularly tawdry and tasteless, the choice of showing empty streets devoid of human life, is not

Jasper Johns (1930). Untitled, 1972. (72 × 192"

neutral but loaded with negative social comment regarding the deterioration of the American Scene into an urban and suburban wasteland of mass culture artifacts, careless litter and traffic jams–in short, the neon wilderness. The social commentary of a Photo Realist like Audrey Flack, who specializes in mechanically executed still lifes of vulgar objects of the lowest level of mass culture and plastic *kitsch*, is presented as documentary reportage, which is quite different from the ironic *double-entendres* of pop art. At the same time that the Photo Realists are specializing in dead-pan documentary, pop artists like Roy Lichtenstein, who has repainted the masterpieces of Cézanne, Picasso, Matisse, Mondrian, Léger and other modern giants in a cartoon style, or Andy Warhol, whose latest series of paintings of American Indians and hammers and sickles marked ''Made in U.S.A.'' poke fun at politi-

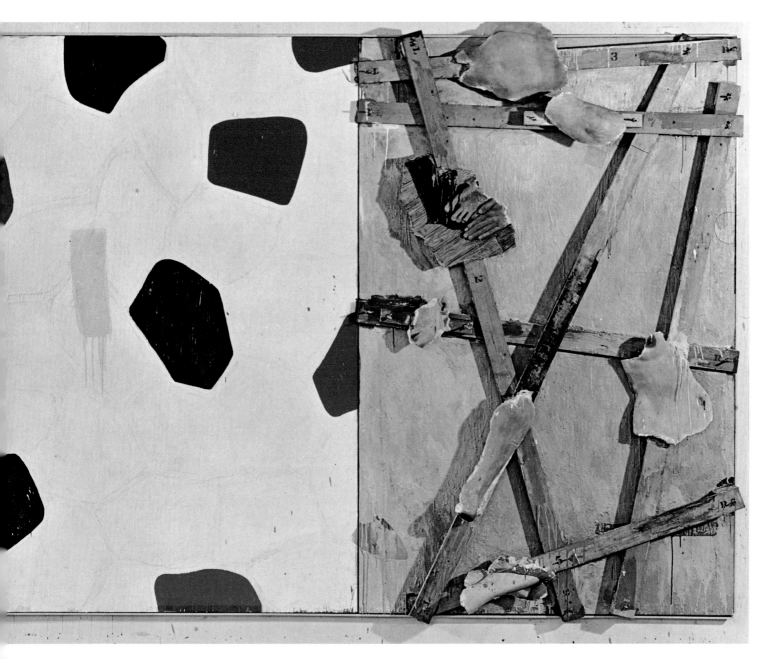

udwig Museum, Cologne, West Germany.

cally volatile subjects, continue to engage in a clever dialogue with high culture, which emphasizes the irony of mass culture reproductions of the formerly high culture aristocratic objects of the past.

Because it so flagrantly embraced traditional academic modes of illusionism, rehabilitating the entire panoply of *trompe-l'œil* devices against which modernism originally rebelled, Photo Realism attracted immediate attention when it first began to be widely exhibited around 1970, about the time that photography itself was beginning to gain recognition as a fine art in America. We must remember, however, that *trompe-l'œil* painting has been popular in the past in America. The recent rediscovery of the *trompe-l'œil* still lifes painted by Peto, Harnett and Haberle in the late nineteenth century, as well as the photography craze, also helped stimulate the emergence of Photo Realism as

a major style of the seventies. In any case, the popularity of Photo Realism, coupled with the renaissance of photography itself, has revived the possibility of representational art as a serious threat to the hegemony of abstraction in American art. However, no Photo Realist challenged the fundamental assumptions of both abstraction as well as representation in so incisive a manner as Jasper Johns, who has emerged as a figure perhaps even more critical for American art of the seventies than he was for the sixties.

Johns originally won fame with his paintings of American flags, early pop icons which he began painting in 1955. His later paintings, however, such as the enigmatic polyptych *Untitled*, 1972, are disquieting, disorienting, puzzling works which cause problems of interpretation and even of recognition. Provoking much critical controversy, Johns' later works have been appreciated by a small group of artists, critics and *amateurs*–the traditional public for avant-garde art from Caravaggio to Duchamp, Johns' chosen mentor in his intellectual pursuits. Although their hermeticism is mitigated to some extent by the inclusion of some recognizable images, such as the parts of the human body, beginning with his first large polyptych *According to What* in 1964, Johns' paintings are based on an intricate, highly personal iconography as esoteric as that of any sixteenth-century Mannerist artist.

Like Mannerist painters who adhered to the doctrine of *ut pictura poesis* (as in poetry, so in painting), which demanded that the work of art illustrate a specific literary text full of philosophical and poetic references, so Johns has derived his iconography from a variety of written sources, ranging from Duchamp's *The Green Box*, the notes for the preparation of Duchamp's chef-d'œuvre, the so-called *Large Glass*, to Ludwig Wittgenstein's *Philosophical Investigations*, to poems by John Ashbery and the late Frank O'Hara, to treatises on visual perception by Ernst Gombrich and others. Because it is based on complex sources, on first encounter a painting like *Untitled*, 1972 immediately raises questions of interpretation. Indeed the nature of visual perception itself is called into question. For *Untitled*, 1972, in its symmetrical division into two similar but not identical halves, splits the visual field in a manner that seems to induce optical schizophrenia because of the problems which the focusing of such an arrangement creates for binocular vision.

Made up of four panels, each six feet high by four feet wide, bolted together to form a single horizontal surface, *Untitled*, 1972 is the first in an extended and interrelated series of paintings and prints derived from paintings exploring the relationship of parts to the whole. This theme has been Johns' central subject in the seventies. *Untitled*, 1972 also marks the introduction of motifs that, for the first time in Johns' career, appear to be purely abstract. Further examination of these elements, however, reveals that, like the dismembered parts of the human body which recall Johns' initial plaster casts of body parts in the 1955 *Target with Plaster Cast*, both the curious shapes resembling flagstones in the two center panels, as well as the linear pattern of intersecting strokes resembling cross-hatching also refer back to earlier works by Johns. The "flagstone" motif is derived from *Harlem Light*, a painting of 1967 said to have been based on the raised relief of a crudely painted stone wall in Harlem. That these stones, normally used to pave American garden walks and terraces, are known colloquially as "flags" must have appealed to Johns' sense of punning irony, since a wall or a floor is as explicitly flat as the American flag. Like the flag, walls and floors present only one surface to view, reinforcing the viewer's consciousness of their flatness. In the seventies, Johns became increasingly preoccupied with epistemological issues, constantly questioning preconceived ideas concerning cognition, precognition, recognition and their relationship to visual perception. Double and "decoy" images that may signify more than one meaning are typical in the works of the late sixties and seventies. Thus the "cross-hatching" in the left hand panel of *Untitled*, 1972, subsequently taken up as a motif in graphic works, resembles an enlargement of the rapid irregular scribble Johns has used in drawings and prints, particularly of the flag; this scribble in turn often referred to the natural anarchy of patches of growth in fields.

Johns' preoccupation with "fields" in earlier paintings like *Slow Field* and *Field Painting* is with the field of vision as opposed to the color field of abstract art. Indeed his entire effort of the sixties and seventies can be seen as a conceptual reaction against the hedonism of color-field abstraction. For like Duchamp, Johns maintains that art must be intellectually as well as visually arresting–an idea at

odds with the aesthetics of pure visibility that dominated abstract color painting in the sixties. In that they provoke speculation and interpretation, Johns' works pose some difficulty for the viewer. In their steadfast commitment to an intellectual, cerebral, conceptual content, Johns' paintings redefine the idea of the difficult. Johns' involvement with philosophical questions connects his approach to the theoretical discussions of the Cubo-Futurists, the first artists to be fascinated by philosophical and conceptual problems early in the twentieth century. Bringing such theoretical preoccupations back into the artistic dialogue, Johns has changed the nature of this dialogue, demonstrating the new found willingness and ability of American artists to enter into theoretical discussions, which in the past they had avoided in favor of direct emotional expression. In the sense that restraint from impulsive ''action'' and considered analysis are marks of maturity, Johns' recent works are yet another indication of the new sober, reflective spirit of American painting in the seventies.

At a moment when hand painting, conventional media and a stress on conceptual content are primary to painting in America, Johns has re-emerged as a key artist for the present period. His fragmentation of the pictorial field as well as his fragmenting of the human body into parts, and his final reconstitution of these parts into new wholes that are both more and less than the sum of their parts, posits a philosophical conundrum that has stimulated a revival in criticism, simply by supplying substance for intelligent analysis. In Johns' recent works, there is a curious symbiosis between painting and printmaking that also characterizes the art of the seventies. Motifs from paintings are elaborated upon in prints; these motifs are then taken up once again in subsequent paintings. For example, the ''cross-hatch'' pattern that is in itself a reference to the processes of printmaking, reappears in a series of later paintings and prints by Johns. Other artists such as Frank Stella, whose recent metal reliefs resembling giant subway graffiti are etched in acid baths in a manner derived from the aquatint process, have also borrowed from graphic techniques to create innovative paintings. And both Robert Rauschenberg, in the ''Hoarfrost'' series of paintings on silk, and Andy Warhol in portraits and still lifes of the seventies continue to use techniques derived from serigraphy.

That formal innovation could be achieved most easily through technical innovation was an idea John Graham had initially promulgated as long ago as the thirties. Essentially a surrealist notion, the idea of formal invention through technical change has remained an important possibility for American artists. In the seventies, although oil and canvas have regained popularity as the principal painting materials, translations of techniques from one medium to another continue to mean freedom for artists to borrow techniques from graphic art, photography, drawing and watercolor. Indeed, the displacement of techniques originated for works on paper into the area of works on canvas such as, for example, the use of an essentially watercolor technique of staining liquified pigment into an absorbent ground characteristic in the paintings of Frankenthaler and Noland, remains an important possibility even in the conventional seventies. Similarly, in the work of artists like Nancy Graves and Cy Twombly, graphic elements are charged with a gestural energy that appears more diagrammatic than spontaneous; the canvas ground is used like a page of paper—as the neutral area on which marks are deployed. In the case of both Graves and Twombly, the archaic quality of the markings implies that drawing might be a kind of secret handwriting, which might be deciphered if the code were broken. The implication of significance in mysterious traces and marks raises questions of interpretation reminiscent of the manner in which early Abstract Expressionism evoked myth and symbol in its allusion to preconscious signs and pictographs.

A renewed interest in content, and in the works of the first generation Abstract Expressionists generally, is typical of the maturing art of the seventies. Once again, the idea of an exclusively decorative art is being questioned, in much the same probing spirit that the Abstract Expressionists had once challenged the validity of geometric Cubism. The preoccupation with significance and the denial of an art that exists purely for its own sake are both historical American prejudices against formalism, which may be traced far back to the Puritan rejection of art that did not in some way instruct, elevate or edify. The current focus on the works of Abstract Expressionists who claimed that their work had transcendental metaphysical content is an indication that another group of fundamentally American attitudes, at odds with the materialism of the American Scene, is reasserting itself.

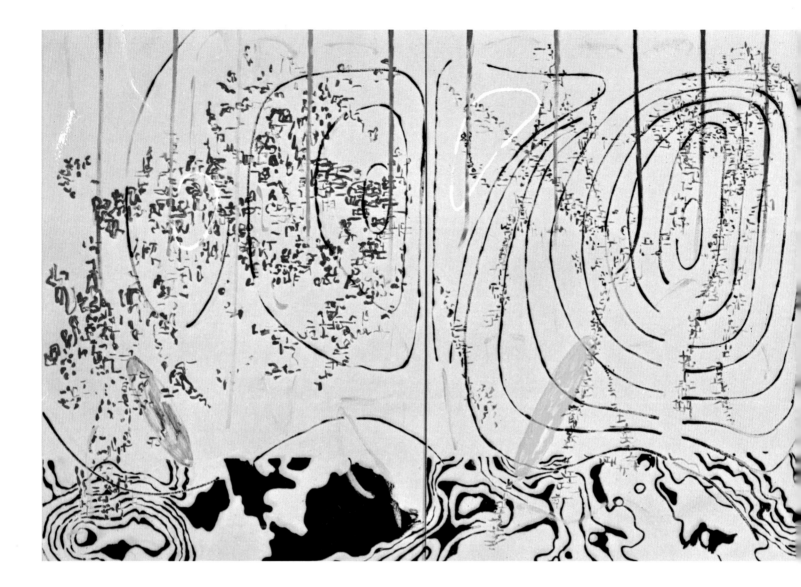

The death of Ad Reinhardt in 1967 and Barnett Newman and Mark Rothko in 1970 deprived American art of three exceptional leaders; however, in their absence, their reductive serial works were canonized, establishing more firmly a growing school of quiet, contemplative, so-called minimal paintings inspired by Newman's broad expanses of rich, luminous color light, Reinhardt's ascetic, nearly invisible paintings and Rothko's brooding, majestic late works. For all three, the goal was to create an environment for meditation rather than an object for decorative purposes. This goal was finally achieved by Rothko, who ended his own life, like a number of other American abstract artists, in a tragic suicide. At Rice University in Houston, Texas, a special chapel was erected to house an environment of Rothko's monochromatic paintings. The American equivalent of Matisse's chapel at Vence, the Rothko Chapel has become a pilgrimage site for younger artists, inspiring painters like Brice Marden and Jake Berthot to emulate Rothko's monochromatic diptych and triptych forms.

The widespread appreciation of Rothko's exquisitely sensitive surfaces and refined painterliness, which depends on the saturation of intense colors soaked into the canvas in repeated coats to create an inner glow rather than on thick impasto, is responsible for the revival of soft edge painterly painting in the late seventies. Curiously, although Rothko was an abstract artist, the example of his sensitive brushwork has had the biggest impression on representational artists like Jim Dine and Susan Rothenberg.

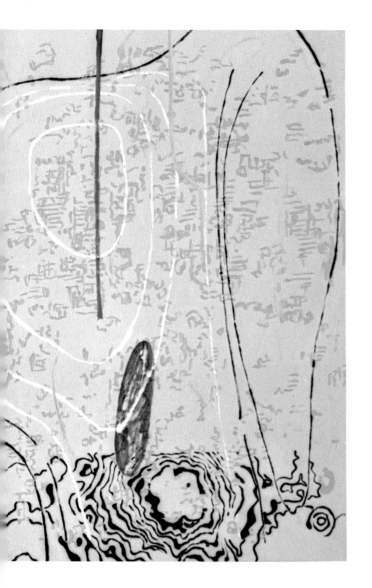

Nancy Graves (1940). A B C, 1977. (44 × 96″: each panel 44 × 32″)
Courtesy André Emmerich Gallery, New York.

Dine, who won renown as a pop artist, has become increasingly reflective and introspective in his works of the seventies. He continues to paint images such as the bathrobe motif that originated in a pop self-portrait; but he no longer affixes objects to his surfaces. Now these generalized images are no longer references to popular culture, but pretexts for the creation of patterns of color and line. In a recent painting like *Cardinal*, Dine is clearly indebted to the refined surfaces and subtle modulation of Rothko's late paintings, rather than to the images of the world of mass culture that originally inspired him. Although Dine's recent paintings allude to the human figure, and some are even figure studies, they are not as directly involved in a return to traditional figure paintings as literal as that of Alfred Leslie, who has equated figure painting with a tradition of humanism he seeks to revive in America.

"I wanted to put back into art all the painting that the Modernists took out," Leslie has stated, "by restoring the practice of pre-twentieth-century painting... I wanted an art like the art of David, Caravaggio and Rubens, meant to influence the conduct of people." Beginning in the late sixties, Leslie, originally an abstract painter, was among the first to renounce abstract art in favor of a style more available and accessible to a large public. Leslie's early attempts to resurrect the heroic dimensions and naturalistic style of Caravaggio and David, whose works had captured the imagination of a popular audience in earlier epochs, were clumsy and naive. Slowly mastering the technical facility

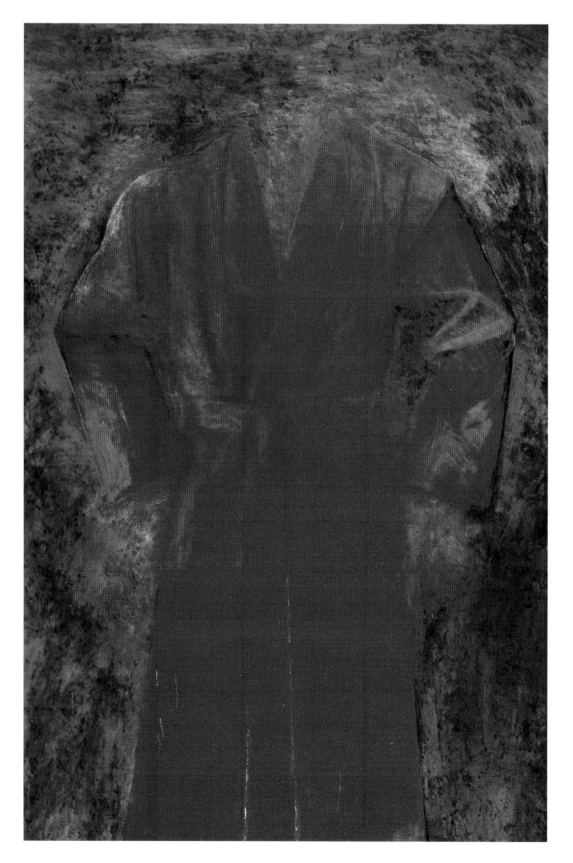

Jim Dine (1935). Cardinal, 1976. (108 × 72″)
Courtesy The Pace Gallery, New York.

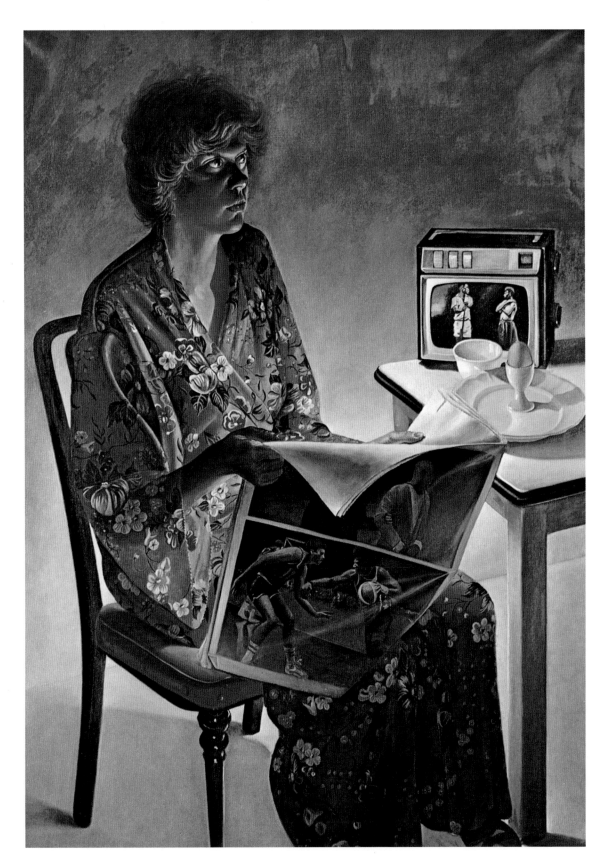

Alfred Leslie (1927). The 7 A.M. News, 1976. (84 × 60″)
Courtesy Allan Frumkin Gallery, New York.

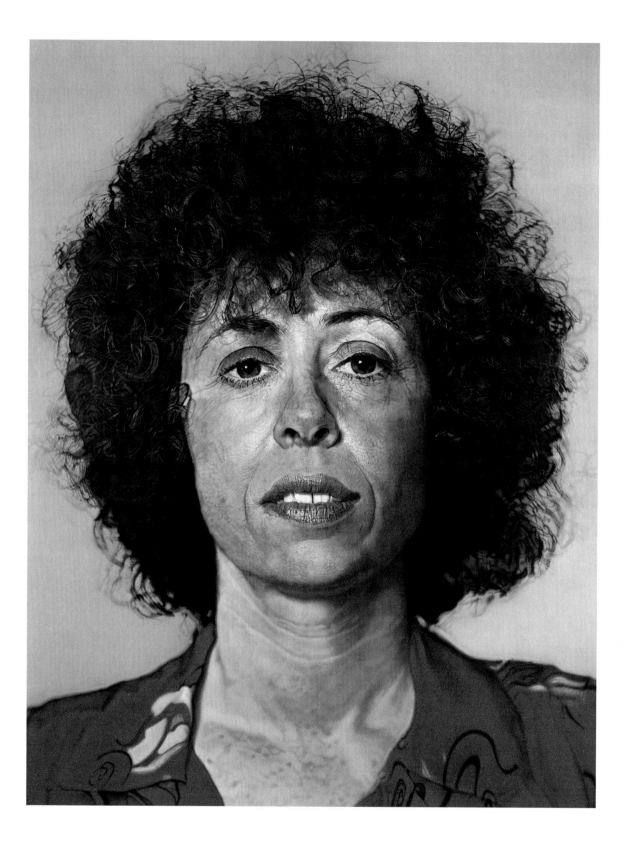

Chuck Close (1940). Linda, 1976. (108 × 84″)
Courtesy The Pace Gallery, New York.

necessary for such an ambitious effort, Leslie went to such typically American literalist extremes as having a jeep put in his studio so that he could "paint from nature" one of the props in his painting *The Death of Frank O'Hara*. In one of several versions of his homage to O'Hara, the American poet whose life was prematurely cut short by a freak auto accident, Leslie based his composition so closely on Caravaggio's *Entombment* that the painting is virtually a copy of Caravaggio in modern dress, executed however in a style that has as much to do with billboard painting as with the old masters.

Emulating Caravaggio's candlelight studies and David's sculptural realism, Leslie has invented a contemporary form of Caravaggesque realism, a monumental genre painting suitable to the democratic American experience. In *The 7 A.M. News*, a solitary woman sits reading a newspaper beside a table on which a television set flickers. Her face is illuminated by the harsh glare of the ubiquitous "tube" that has replaced both Caravaggesque candlelight and divine illumination. Her eyes, however, look away from the instruments of mass "communication" toward heaven, as if she were

Agnes Martin (1912). Untitled No. 8, 1975. (72 × 72″)
Courtesy The Pace Gallery, New York.

communicating rather with some mystical force that transcends the mundane reality of electronic technology. In her isolation, the woman reminds us of Edward Hopper's profoundly alienated figures sitting alone in cafeterias, bars and rented rooms.

Like Jim Dine, whose robes are far larger than life size, Leslie demands the viewer's attention by enlarging his images to heroic monumental scale. As large as the projections on movie screens, Leslie's figures are seen in exaggerated close-ups influenced by cinematic images. With their curiously stupefied gaze, eyes often raised toward heaven like those of religious figures in Mannerist altarpieces, Leslie's portraits, like those of Chuck Close, have the theatrical drama of sheer colossal size. Close, however, does not deal with the figure at all, confining himself exclusively to immense portrait blow-ups based on photographs rather than on nature. Although they take photographs rather than people as models, Close's portraits like *Linda* are quite distinct from Photo Realist paintings in that they are based not on naive duplication of photographic images of reality, but on an abstract system of tiny dots arranged on a grid. At close range, these dots ultimately coalesce like the spots of color in a pointillist painting, into a recognizable image. This image in turn, at any point, depending on the viewer's focus, may once again break down into a series of abstract points. Thus in Close's work, there is a conscious engagement with the issues raised by modernist abstraction. That the faces are visible as both an abstract system of marks on the canvas as well as in the form of a recognizable image of uncanny force lends a tension and conceptual content to Close's work absent in Photo Realist painting. Like Leslie's over-size figures, Close's portraits involve the viewer in an intimate psychological confrontation with their subjects. This confrontation is particularly unsettling since Close's portraits, like those of Warhol as well as Leslie, are strangely inanimate and immobile: for all three, the human face has become a kind of still life–a searing commentary on the alienation of contemporary life.

Although America has been described, both at home as well as abroad, as the most materialistic country in history, another aspect of the American character, as fundamental as the empirical, pragmatic, literalist tendency, has begun to reassert itself in the seventies. This is the spiritual dimension that informed the work of Rothko, Newman and Reinhardt. We sense allusions to this spirituality in the trance-like expressions on the faces of Alfred Leslie's figures, which signify an altered state of consciousness. When we direct our attention to the notion of an altered state of consciousness, we realize that the impulse behind Reinhardt's black paintings, which demand an otherworldly state of mind to be visualized at all, was toward inducing such meditative states. A number of painters have followed Reinhardt in making nearly invisible images, but none has done so as successfully as Agnes Martin. For Martin's virtually monochrome square canvases like *Untitled No. 8* require a degree of concentration so intense from the viewer that, like Reinhardt's black paintings, they are oases of quiet in a tumultuous, over-stimulated environment. Superimposing a graphic grid-like linear network on her pale monochrome backgrounds, Martin has simplified her image to a bare minimum. Other artists like Robert Mangold, Robert Ryman, James Bishop and Jo Baer have also worked with minimal formats encouraging quiet contemplation, which are at the opposite pole of expression to the this-worldly art of Photo Realism. The presence of two such divergent types of painting in America in the seventies–one extremely material, the other extremely immaterial–is an indication of the broadness of the spectrum of artistic activity today, which ranges from the purest abstraction to a hyper-realism.

Like Agnes Martin, Jack Tworkov superimposes a linear network on a painterly background. Tworkov, however, often implies perspective with his network of lines which sets up a dynamic element in the work that is absent from the absolute frontality of Martin and the other minimal painters. A veteran Abstract Expressionist, Tworkov is among those American artists who, after years of searching, have found a truly distinctive personal style late in life. For one of the curiosities of American art in the seventies is that, possibly for the first time, the genuine innovations, the work of lasting value, are being made not by young artists like the *wunderkinder* of the sixties, but by mature painters well into their fifties, sixties and seventies such as Robert Goodnough, Friedel Dzubas, Giorgio Cavallon, Cleve Gray, Stephen Greene and other mature artists who, like Hans Hofmann in the sixties, have found unique stylistic identities at the end of long careers.

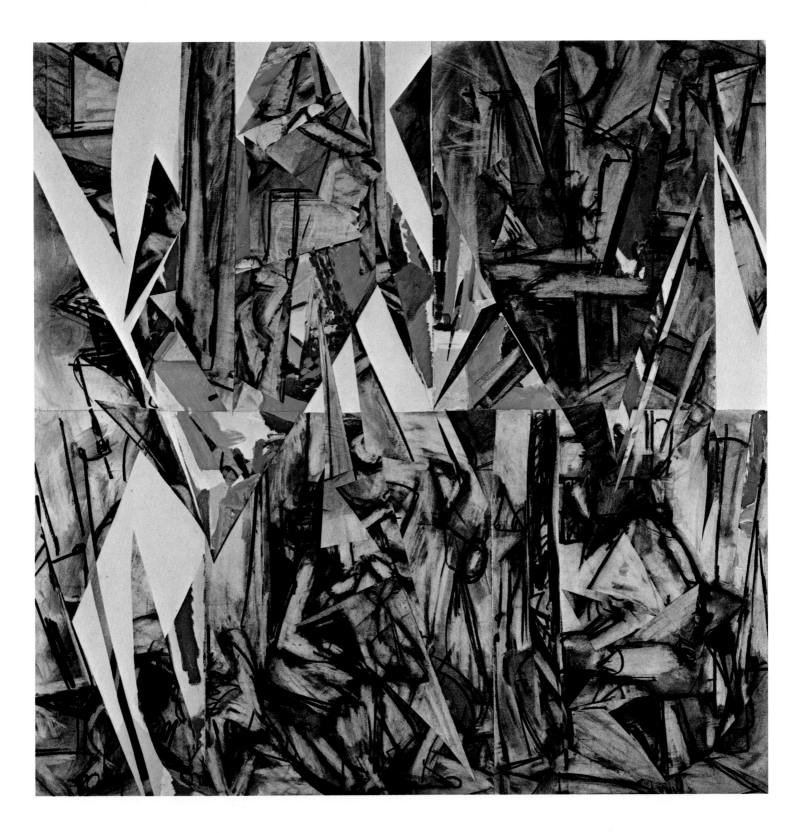

Lee Krasner (1911). Imperative, 1976. (50 × 50″)
Courtesy The Pace Gallery, New York.

Richard Diebenkorn (1922). Ocean Park No. 60, 1973. (93 × 81″)
Albright-Knox Art Gallery, Buffalo, New York.

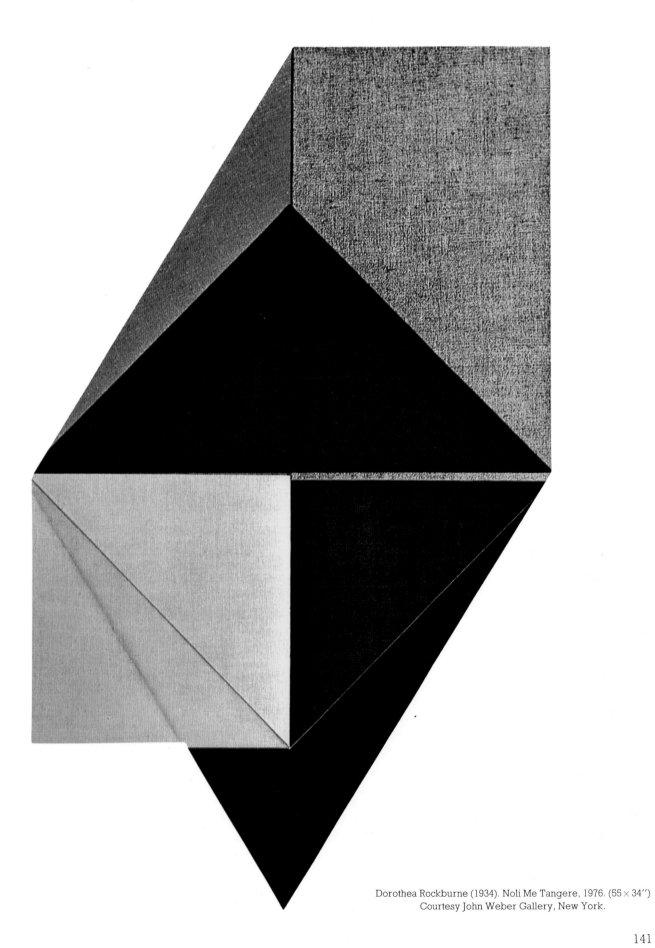

Dorothea Rockburne (1934). Noli Me Tangere, 1976. (55 × 34″)
Courtesy John Weber Gallery, New York.

One such mature artist to have emerged as an important force in the seventies is Lee Krasner, whose recent series of collage paintings such as *Imperative* incorporate fragments of Cubist drawings which she made while a student of Hans Hofmann in the thirties. Krasner kept these drawings inspired by Picasso for nearly forty years. Finally, in the seventies, she cut them up into shapes in a manner suggested by Matisse's late *découpages*. Action now has been stilled; gesture is solidified into shapes that, although they continue to be informed by Krasner's inner sense of rhythm, have taken on a stable, monumental form. Krasner's willingness to delve back into her own personal history exemplifies the direction of the best recent American art, which has finally come to view the past not as a threat, but as a source of renewal and sustenance.

Another mature artist who has emerged as a painter of the first rank in the seventies is Richard Diebenkorn, whose return to abstract art after many years as a representational artist reverses the direction of the many abstract painters like Philip Guston and Alfred Leslie who have recently turned to figurative subjects. In the fifties and early sixties, Diebenkorn was based on the Bay area around San Francisco, where he painted landscapes and figure studies. Even in his figurative work, however, Diebenkorn was concerned with pictorial structure rather than with specific detail. Impressed by Matisse early in his career, he came to a new appreciation of the Parisian master during a trip to Leningrad in 1965, which gave him the opportunity to study Matisse in greater depth. In 1966 Diebenkorn moved to Los Angeles to take a job as a professor. The following year he began his series of abstractions on the theme of ''Ocean Park'' (the name of an amusement park in the beach community of Santa Monica where Diebenkorn keeps a studio). These paintings, like *Ocean Park No. 60*, are based on Matisse's most abstract oils. They employ drawing as a structuring element to contain areas of color that appear to reflect light. Like Motherwell, de Kooning and Still, who are continuing to paint some of their finest works in the seventies, Diebenkorn has devoted a lifetime to painting; the result is a mastery of technique unavailable to earlier American artists struggling to assimilate a painting culture that was essentially foreign.

In paintings like *Ocean Park No. 60*, Diebenkorn's approach to drawn geometry is intuitive rather than dogmatic or programmatic. This intuitive attitude toward geometry is typical of American artists who use geometry as a means of containing color rather than as an end in itself. For younger artists using geometry like Dorothea Rockburne, order is arrived at through empirical search rather than taken as an *a priori* point of departure; the result is a classicism with a particularly American inflection. In paintings like *Noli Me Tangere* Rockburne has turned to the harmonies of the Sienese masters like Duccio, whose art she has closely studied. Her complex technique as well is derived from a study of Renaissance methods. Covering a linen sheet with gesso, Rockburne folds her material into the form she wishes it to assume, much as one might fold paper. When the material, which she coats with varnish on the reverse side of the gessoed surface, dries, the linen hardens to become its own support, eliminating the need for a stretcher. With economy and elegance, Rockburne identifies surface with support–a step toward the unification of the painting as objective reality beyond the identification of image with ground that inspired both the stained canvas as well as shaped paintings in the sixties.

Rockburne's synthesis of elements taken from the historical past with characteristically American empirical methods and structure typifies the work of a new generation of American artists, who are taking the lessons of history not as restrictive dogma but as liberating precedent to be incorporated within a gradually maturing native tradition. After a crisis of confidence that echoed the historical crisis of a country on the verge of a second civil war over the issues of Viet Nam and racial integration, American artists have found their way back to a conviction in the worth of paintings as a humanistic vocation and as a genuine means of communication. Within the eschatological context of recent years, the question ''Is painting dead?'' was seriously entertained. For American painters of the seventies, more and more of whom are returning to the traditional materials and concerns of their craft, and viewing innovation, not as an end in itself, but as part of a process reaching far beyond the brief span of America's short life as a civilization, the answer is a resounding NO.

Philip Guston (1913-1980). The Green Rug. Oil on canvas. (94 × 68$\frac{1}{2}$'')
Private Collection, New York.

Susan Rothenberg (1945). ▷
Red Banner, 1979. Acrylic on canvas. ($89 \times 124''$)
Museum of Fine Arts, Houston, Texas.

Neil Jenney (1945).
Angled Wood and Angled Wood, 1969.
Acrylic on canvas. ($58^1/_2 \times 76^1/_4''$)

Robert Moskowitz (1935).
Thinker, 1982. Oil on canvas. ($108 \times 63''$)
Courtesy of Blum-Helman.

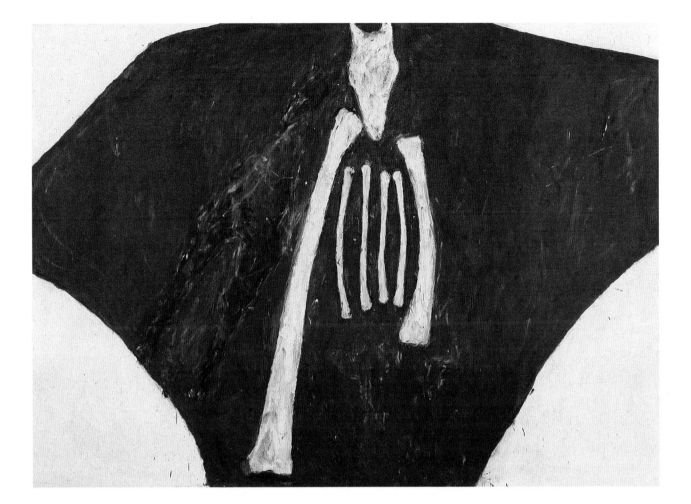

During the early years of Abstract Expressionism, the issue of expressive content and metaphoric or symbolic meaning was paramount. However, the leading members of the New York School such as Pollock, de Kooning, Rothko and Guston left behind their roots in figurative art and devoted themselves exclusively to abstraction. The idea that subject, form and content were identical, and could be subsumed in terms of form and style alone, excluded the possibility of any iconographic reading of avant-garde American art until recently. Some European critics saw the rejection of subject matter by the Abstract Expressionists as the reason that the style could be officially embraced, since it excluded any possibility of social or political criticism in favor of a lofty statement of the transcendence of a timeless art over any strictly mundane concerns. We have seen how the urge to locate art within the realm of the spiritual rather than within the confines of the mundane defines one of the polarities of American aesthetics. In the eighties, however, the pendulum swung back, at least to a certain extent, to the concerns traditionally associated with realism: recognizable imagery, the figure, genre, history painting, landscape, and even explicit and implicit social criticism.

Unquestionably, the devotion of Pop art to familiar images, which greatly enlarged an art public more interested in commonplace subject matter than in "elitist" formal concerns, left its mark. The success of Pop art persuaded a new generation of American painters that art could be a powerful mode of communication. Now, however, the "new image" painters, artists like Susan Rothenberg, Robert Moskowitz, Lois Lane, and Bill Jensen, did not derive inspiration from the standardized reproductions of comic books or advertisements. Their representations were creations of the artist's imagination, not merely recycled reproductions. The return of representation in their work did not

146

signal an embrace; it was on the contrary a rejection of popular culture and the diffusion of popular imagery through reproduction: an attempt to reconcile representation with the modernist condensation space and architectonic pictorial structure. The immediate precedent for this accommodation between abstraction and a type of representation that was reductive sign as opposed to the fully modeled form of conventional realism, with its fictive space and cast shadows, was the conceptual representation of Jasper Johns, which simultaneously created and repudiated illusionism.

One might say that "bad taste" became for the eighties what good taste represented for the sixties. Since it is in the nature of the avant-garde to be drawn to that which society identifies as "taboo," we ought not be surprised that younger artists should react against the tastefulness of color-field, hard-edge and minimal abstraction which were easily accommodated into interior decorating schemes that were part of the growing American obsession with gracious living. Artists might be painting again, but their subjects and styles would be found as revolting by the arbiters of taste as the artists considered the easily assimilated art of the previous generation an accommodation with philistine materialism. Thus, when Marcia Tucker organized a show of "Bad Painting" at the New Museum in 1978, Neil Jenney's original experiments in the apparently childishly naive style that resembled the hobby art of finger painting, using a few unattractive colors such as garish green and dung-colored brown, offered a new definition of the avant-garde as that which made Matisse's proverbial businessman uncomfortable and ungratified. To compensate for the loss of gratification of pleasing subjects, indeed for their replacement with unsettling subjects such as the existential panic of Susan Rothenberg's runaway horses, chased by their own skeletons, or Guston's ominous Klansmen, artists began emphasizing once again the traditional pleasures of sensuous surfaces and a painterly tactility banned by the puritanical proscriptions of a purely "optical" abstract art.

◁ Joan Mitchell (1926). Before, Again III, 1985.
Oil on canvas. (110 × 78³/₄″)

Gregory Amenoff (1948). Betrayal, 1982.
Oil on canvas. (86 × 74″)
Robert Miller Gallery, New York.

Joan Thorne (1943). Zamba, 1982. Triptych. Oil. (9 × 20′)

Anna Bialobroda (1946). Fugue, 1981. Acrylic on canvas. (60 × 96″)

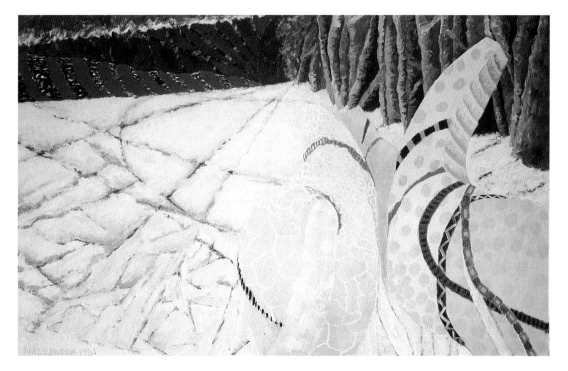

Jed Garet (1955).
Silhouette Valley, 1981.
Acrylic on canvas. (95 × 70″)
Collection John Cheim, New York.

Other painters found pleasure in metaphoric evocations of landscape which also stressed visible brushstrokes and thick paint. Joan Mitchell, for example, a second-generation Abstract Expressionist, had always worked with landscape metaphors. She continued painting with increasing assurance and energy, inspired by the light and colors that initially brought Monet to Giverny, which is near the village where Mitchell paints in her secluded studio. Younger artists like Gregory Amenoff, whose thick paint and rugged forms are reminiscent of Marsden Hartley; Joan Thorne, whose electric, interwoven imagery recalls Pollock; and Anna Bialobroda, whose exotic landscape fantasies pay homage to late Picasso (a primary influence on recent American painting), paint personal, subjective versions of interior landscapes that are metaphoric rather than realistic. In her fantasy landscapes, Louisa Chase combines landscape and anatomy. Among the emergent group of painterly painters dedicated to restoring to painting the full range of its potential expression of subject matter, content and form is Terry Winters. Both his palette and technique are reminiscent of the warm flesh tones of Guston's late paintings; however, his organic imagery and viscous, fluid space also refer to the style of Gorky and Baziotes. Although their work cannot be called surrealist, Chase and Winters, as well as painters like Jed Garet, combine the familiar with the dream-like.

Terry Winters (1949). Point, 1985. Oil on canvas. (101 × 69″)
Sonnabend Gallery, New York.

Louisa Chase (1951). Pink Cave, 1983. Oil on canvas. (84 × 72'')
The Metropolitan Museum of Art, New York.

Larry Rivers (1925). ▷
1924 & Matisse, 1985.
Relief, oil on canvas. (96 × 120″)
Marlborough Gallery, New York.

Malcolm Morley (1931).
The Sky Above, The Mud Below, 1984.
Oil on canvas. (85 × 60″)

Ambitious painting in the eighties looks back as much as it looks forward. New ways of disorienting the viewer have been found by an artist like Malcolm Morley, whose seemingly crude and awkward style conceals a mastery of the medium of oil painting, which has displaced artificial plastic paints as the preferred medium of the eighties. Playing with clichés, both verbal and visual, such as the title of a 1984 canvas, *The Sky Above, The Mud Below*, Morley, who emigrated from England to the United States in 1958, began his career as a Photo Realist. He gradually loosened his style beginning in a series of "disaster" paintings done in the late seventies. Another representational artist whose style is expressionist rather than realistic, Morley has most obviously been influenced by the juicy impasto and painterliness of Soutine. However, his relationship to his subject matter is not straightforward, but oblique and ironic. Trained at London's prestigious Royal College of Art, Morley clearly does what appears to be "bad painting" by choice, not from lack of training or talent. In

his colorful landscapes, there is always the dismal sense that something is off-key, out of tune, as if there is the kind of slippage between subject matter, content and form that one finds in bad color reproductions. Combining a love of painting with a moralist's distaste for what he sees, Morley paints battle scenes, tourist views of former colonial empires, and presumably bucolic landscapes in a heavily textured, loaded-brush style that hints at the filth of muddy enterprises or Freudian primary processes without resorting to the literalness of illustration. Among Morley's greatest gifts is the ability to create the illusion of light pouring from within his paintings which may be interpreted as the redemptive power of the artist's creation.

Larry Rivers' narrative art, on the other hand, has always emphasized the artist's abundant facility as both draftsman and painter. A precursor of Pop, Rivers was painting popular subjects as well as portraits, nudes and genre in the fifties. Like Sam Francis, Joan Mitchell, Al Held, Jack Youngerman, Alfred Leslie and other so-called "second generation" New York School painters, Rivers has continued to evolve his art in the eighties and to keep pace with the innovations of younger artists.

Using cut-outs to literally disengage his figures from their background, Rivers has brought figurative art into line with the literalist demands for real shapes in real space first articulated in Frank Stella's shaped canvases. Beginning in the seventies, Stella took the next logical step of pushing his anti-illusionistic forms forward into the viewer's space, cutting out interior shapes to assemble them in relief-like fashion. Influenced by sculptor John Chamberlain's assembled metal reliefs, Stella used various commercial paints and processes to achieve novel effects notable for their flashiness, which meshed ideally with the eighties' punk taste for all that glitters.

A more serious approach to the shaped canvas is to be found in Elizabeth Murray's oil paintings. Carefully composed in terms of colors and shapes which are not arbitrary but deliberately chosen to create a sense of human scale, Murray employs a vocabulary of organic forms that suggest anatomical or plant analogies, as well as alluding to the processes of growth and evolution first explored by Gorky. Like Murray, Gary Stephan paints abstractions with strong organic or anatomical connotations.

Elizabeth Murray (1940). 1, 2, 3, 1984. Oil on canvas. (124 × 104 × 12″)
Paula Cooper Gallery, New York.

Gary Stephan (1942).
No title, 1985. Acrylic on canvas. (45 × 32'')
Mary Boone Gallery, New York.

Although most of the important American painting of the eighties is either explicitly representational or deals with metaphors for landscape or the figure, energetic abstract art continues to be done by artists in their forties who are also drawing on the legacy of Abstract Expressionism, reacting as well against the cold, reductive and mechanical styles of Pop and Minimal art. Both Howard Buchwald and Dennis Ashbaugh owe a debt to ''action painting.'' However, in both cases, a potentially explosive gesture is held in check by a conceptual intelligence that reveals a sophisticated awareness of the relationship of image to field, and of the potential pictorial consequences of a gestural action. By cutting holes through his paintings, some at right angles, others at acute angles oblique to the picture plane, Buchwald constructs a self-contradictory illusion compatible with the demands of

Howard Buchwald (1943). Behind the Curtain, 1985.
Oil on linen. ($80^1/_4 \times 87''$)

modernist esthetics that the painting proclaim itself as an explicitly flat surface. The incised literal rather than drawn lines at the right of the canvas exercise a similar function of identifying the painting as both object as well as depicted illusion. At the same time, the centripetal force of the sparks of color aimed like arrows toward the corners adds an element of physical excitement.

Like Buchwald, Dennis Ashbaugh also emphatically asserts the surface of his painting by using tactile textures to locate the picture plane, permitting him a wider play of illusion. Like Hofmann, he uses color rather than value contrasts to create pictorial space. An ironic allusion to shadows that are brightly colored and a dramatic integration of black and white as colors also distinguish his work. The aggressive forward thrust of his forms which suggest reductive signs for embattled figures, reminds one of the climate of urban violence that is the context of the New York School of the eighties.

Ashbaugh, who takes his titles such as *Big Relief for a Big Headache* from the headlines and publicity of tabloid newspapers, also infuses abstraction with the kind of physical energy associated

Dennis Ashbaugh (1946). Big Relief for a Big Headache, 1984.
Mixed media on canvas. (108 × 120'')

with action painting. Yet it is evident that he, too, has been affected by the emphasis on preconception. The intellectual analysis of conceptual art clearly left its mark. Recently conceptual artists like Mel Bochner and Jeremy Gilbert-Rolfe have been painting geometric abstractions. This conceptual approach to painterly gesture results in a reining in of spontaneity in favor of a more deliberate approach to structure and an awareness of consequences of action. The new focus on the consequences of action may be interpreted as a moral position as well. The preoccupation of painters like Buchwald and Ashbaugh with the consequences of action may be seen as part of the widespread American scepticism regarding the fifties ideal of untrammeled spontaneity. Both employ chance in arriving at their ultimately highly organized configurations; however, both seem to be making a point regarding the need to consider the result of action and the need to control randomness. Thus, spontaneity and chance are not permitted to become merely excuses for arbitrary attitudes. Scale elements are consistently introduced, permitting monumentality to be perceived in relation to human scale.

Violence, which is psychological rather than physical in this case, also contributes to the unpleasantness of David Salle's figurative mixed media paintings. A literalist who uses pieces of printed fabric, Salle is inspired by the total eroticism of the American Scene through advertising promotion, TV commercials and the increasing spread of pornography. Rebroadcasting the confused signals he receives, Salle reflects rather than criticizes his environment. In this sense, he is heir to both Warhol's deadpan mirroring of social decay and Stella's scale-less, high voltage decor, in which paint, gesture and industrial materials are employed to create the maximum theatrical impact. Of the painters of the eighties, Salle and the ubiquitous Julian Schnabel are closest to Warhol in their cynical dismissal of the basic technical skills of drawing and paint application and their overt desire to gain attention through shock tactics. In the atmosphere of post sexual liberation and wide open uncensored media mayhem, these Dada strategies seem somewhat tired. Like Schnabel, who also uses overlays of images that appear projected rather than perceived, Salle is clearly inspired by Dadaist Francis Picabia's late, deliberately decadent "transparencies," in which the artist used linear overlays of freehand drawing over his figures in a manner that first suggested the projection of images found in photographs or advertisements. Salle's deliberate selection of sexually explicit "x" rated images, together with his inability or unwillingness–it is difficult to know which–to employ the traditional skills of the fine artist may mean that he, too, is making intentionally "bad painting" in an effort to deprive a bourgeois public of its desire for the traditional gratifications that painting has afforded.

The aim of Jonathan Borofsky's environmental art, which includes painting as part of a total experience of contemporary urban chaos, is not to mirror but to criticize that disorder which creates random violence. Unlike Salle's dead surfaces that lack any sense of inner light, Borofsky enlivens his

David Salle (1952). His Brain, 1984.
Oil and acrylic on canvas with fabric. (117 × 108")
Mary Boone Gallery, New York.

Jon Borofsky (1942).
2,841,777 Sing, 1978-1983.
Acrylic on canvas with three polaroids,
neon light, painted aluminum,
stereo cassette player with tape loop.
(Canvas: $127 \times 96^{1}/_{8}''$; overall
approximately $144 \times 96 \times 72''$)
Philadelphia Museum of Art.

environmental compositions with streaks and blasts of light, both literal, such as the neon and reflective aluminum in *2,841,777 Sing*, as well as illusionistic. Calling on the various avant-garde traditions from performance to mixed media for inspiration, Borofsky employs sound, photography and other means to incorporate materials from life into art. In this respect, he is Rauschenberg's logical successor, although his emphasis on hand painting and drawing places him firmly within the context of the eighties, which demands the visible involvement of the artist.

The pun involved in the outline of the singer formed by a metal strip that unites wall to floor is continued within the painting by the self-portrait of the artist who carries the portable stereo from which the cartoon-like blurb containing the word "sing" appears. The result is an image that evokes both the chaos and vitality of urban street culture without, however, pandering to the basest mass instincts.

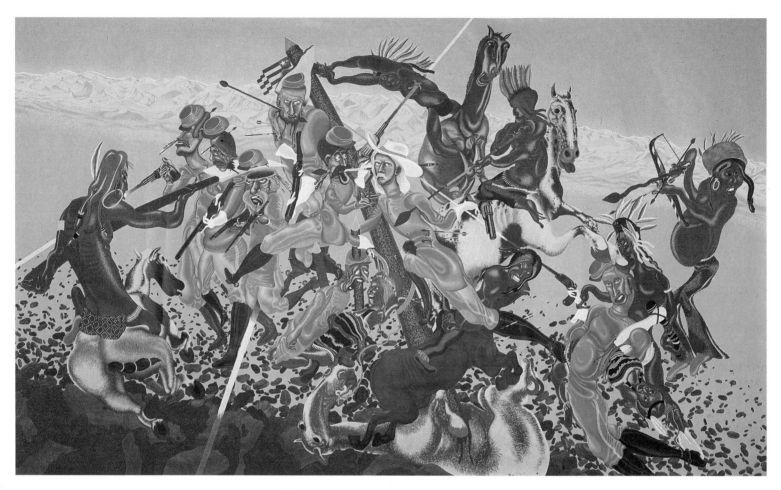

Peter Saul (1934). Custer's Last Stand, 1973. Acrylic on canvas. (89 × 150")
Allan Frumkin Gallery, New York.

Artists like Salle, Borofsky, Ed Paschke, who works in Chicago, and Peter Saul, who paints in Austin, Texas, are the eighties' equivalent of the American Scene painters of the thirties. Although they interpret what they see, what they paint is essentially American history and American reality. It is not surprising to find that Peter Saul's art was formed by the ambience of Chicago, where figurative expressionism and social criticism flourished at a time when such concerns were considered outmoded by the dominant New York School. Indeed, the decade of the eighties marks a return to Regionalism, as government funding through the National Endowment for the Arts had sought to democratize and decentralize the art scene. Strong regional centers have developed in Los Angeles, San Francisco, Houston, Boston and elsewhere as a result of federal aid to local art communities, the spread of information through the art press and mass media, and the augmentation of local art patronage. As a result, new themes and styles inconsistent with the idea of mainstream modernism have emerged.

A pioneer of deliberately offensive subjects and stylistic deformations combined with garish "tasteless" colors, Peter Saul has emerged in recent years as a strong painter of aggressively critical subjects such as his epic painting of *Custer's Last Stand*, which commemorates not the victory of the white man over the red man but the genocide of native Americans, the historical event that permitted European colonization of the continent. If Pop art and earlier Regionalist painting glorified the achievements of the American Dream, current versions of American Scene painting seem to do just the opposite by focussing on its seamy underside. While criticism of American values seldom

Catherine Murphy (1946). Bedside Still Life, 1982.
Oil on canvas. (29 × 19″)

appears elsewhere, visual artists appear to have reclaimed their role as the conscience of race, as James Joyce once defined the responsibility of the artist to society. However, eighties' painters like Peter Saul, John Alexander and Eric Fischl reveal an increasing concern with art historical precedent and an overt desire to regain contact with the tradition of painting weakened in the vanguard movements of the sixties and seventies. *Custer's Last Stand*, for example, is obviously based on Uccello's Renaissance masterpiece, *The Battle of San Romano*.

Observation of the American Scene rather than overt criticism is the content of Catherine Murphy's *Bedside Still Life*. Like Fischl, an observer of the vacuity and poignant alienation of suburban

John Alexander (1945). Confused Princess Dreaming of Her Lost Empire, 1985.
Oil on canvas. (77 × 83″)

Eric Fischl (1948). The Power of Rock and Roll
(from Rooms of the House No. 1), 1984. Oil on linen. (120 × 88")
Mary Boone Gallery, New York.

life, Murphy rigorously constructs her detailed compositions, balancing abstract color relationships and employing perspective to emphasize a sense of spatial illusionism. In her hands the tawdry becomes refined, the vulgar and banal bottles and jars of prescription drugs endlessly consumed by Americans an arrangement of ironic tastefulness. The ghastly peach "princess" telephone, symbol of suburban bad taste, takes on new allure when silhouetted against the equally kitsch machine-embroidered floral patterned doily and the "decorator color" turquoise paint ominously cracking on the wall.

In the eighties, the native talents, given to the few and not the many, of the ability to draw and to put down paint convincingly have been reassigned a place of value and significance they lost once Andy Warhol claimed that art was easy to do and even easier to understand. The capacity to create illusions of space and light are being redefined by a generation of painters who found the closed structures of modernist painting, with its demands for flatness and self-referentiality, too narrow to accommodate an ambitious vision of art. One might say that the most recent developments in American art have reversed the relationship between the avant-garde and the academy as they were defined early in the century. As the middle class has embraced the avant-garde, imitating its experiments with drugs and sex and demanding to express itself creatively, what were once considered academic concerns have regained a place of importance with those artists who echo Cézanne's concern with making an "art of the museums." One indication of the new attitude is that one finds the most ambitious younger artists studying old master art, rejecting the immediate past as shallow and superficial. For example, John Alexander's *Confused Princess Dreaming of Her Lost Empire* is an ironic recollection of the tradition of court portraiture containing an implicit critique of the current obsession with materialism, fashion and nouveau-riche perversion. The expression of shocked innocence of the pouting "princess" uncomfortably jeweled, crowned and costumed in ersatz Renaissance dress sums up a state of cultural confusion as Americans seek to redefine their heritage. It may also be seen as an allegory of the city of Houston, dressed up with nowhere to go in the aftermath of the oil glut.

Eric Fischl's naked rampant plugged-in pubescent boy, surrounded by the accoutrements of the good life–a copy of a classic De Stijl chair, a Noguchi light fixture and an Andy Warhol painting of Marilyn Monroe–is living not in the world of "good taste" provided by his absent parents, but inside his own mind, which obviously contains nothing more serious than pop lyrics. Fischl's homage to the technique and capacity to flood a painting with brilliant sunlight of Edward Hopper, who interpreted the American Scene as classic tragedy of alienation, is as obvious as is his confrontational critique with the mechanically reproduced art of Warhol's silk-screen canvases, which reduced painting to a printed multiple lacking light and life. In the sense that it is analogous to the ambiguity of the historical moment, the struggle between dead, lifeless and lightless static art and painting whose ambition is to communicate a sense of energy, activity, and metaphorical illusion–which today can be seen as the irreducible essence of painting–sums up a crisis in American values that artists, above all, have had the courage to confront and criticize.

In the eighties, the role of content has proven once again paramount, as it was initially among the founders of the New York School, who began by rejecting purist abstraction and non-objective art as meaningless decor, inadequate to express the existential facts of a troubled moment. Summing up their position, Adolph Gottlieb wrote in the December 1947 issue of *The Tiger's Eye*: "The role of the artist, of course, has always been that of image maker. Different times require different images. Today when our aspirations have been reduced to a desperate attempt to escape from evil, and times are out of joint, our obsessive, subterranean and pictographic images are the expression of the neurosis which is our reality. To my mind, certain so-called abstraction is not abstraction at all. On the contrary, it is the realism of our time."

His definition of the artist's role coincides with the ambition of the best American artists, both representational and abstract, of the eighties.

LIST OF COLOR PLATES

Text and color plates printed by
IRL Imprimeries Réunies Lausanne S.A.

Binding by
H.+J. Schumacher A.G., Schmitten (Fribourg)

Printed in Switzerland